Acrylic Painting

FOR

DUMMIES®

by Colette Pitcher

WILEY

Wiley Publishing, Inc.

Acrylic Painting For Dummies®

Published by
Wiley Publishing, Inc.
111 River St.
Hoboken, NJ 07030-5774
www.wiley.com

Copyright © 2009 by Wiley Publishing, Inc., Indianapolis, Indiana

Published simultaneously in Canada

For general information on our other products and services, please contact our Customer Care Department within the U.S. at 877-762-2974, outside the U.S. at 317-572-3993, or fax 317-572-4002.

For technical support, please visit www.wiley.com/techsupport.

Wiley also publishes its books in a variety of electronic formats. Some content that appears in print may not be available in electronic books.

Library of Congress Control Number: 2009925423

ISBN: 978-0-470-44455-9

Manufactured in the United States of America

10 9 8 7 6 5 4

WILEY

About the Author

Growing up in Colorado, **Colette Pitcher** always made art — even if at first folks weren't convinced it was art. She majored in television communication at the University of Northern Colorado but had enough art credits to graduate a year early and did so. Her first job out of college was as a graphic designer for an engineering and architectural firm. Her next job was in New York City for a Fortune 500 company, and she later worked for a well-known children's book author. While in New York, she lived at West Point and attained an MBA from the University of Long Island.

She returned to Colorado in 1986 and started Art Department for companies that didn't have an art department in-house. In the 1990s, she founded the Showcase Art Center in Greeley, Colorado, and filled it with other like-minded businesses and art studios. Activities at the Showcase have included Project Ability, for developmentally disabled artists; a workshop for blind artists to use touch in 3-D artworks; and selling art from Mozambique to fund a kindergarten in that country. The Showcase presents art created by youth to encourage future artists and art by seniors to encourage lifelong creativity. It remains a great place to find art and supplies, framing, art-to-wear, piano lessons, art classes, and art studios.

Colette also sculpts. Her husband Gary, owner of Dragon Casting (a bronze art foundry), is also a creative resource for making the impossible come true daily. Together the couple has installed many monumental bronze public artworks. Colette is the author of *Watercolor Painting For Dummies* (Wiley) and on occasion writes for *PaintWorks* magazine. She also writes and conducts demonstrations for art material manufacturer conventions, including Loew-Cornell, Aamoco, Dynasty brushes, Duncan, Fredrix canvas, and Speedball. She is a Rotarian, a member of Greeley Art Association, a signature member of Colorado Watercolor Society, and an associate member of the National Sculpture Society.

Dedication

This book is dedicated to my mother, Beth Irvine. I can never repay her for all she has done for me; heck, she made me what I am, literally. She encouraged, supported, taught, role-modeled, and guided me through life. I could ask for no more or any better.

Author's Acknowledgments

I want to bless Wiley Publishing for allowing me to work with them again after working on *Watercolor Painting For Dummies.* What I thought was a once-in-a-lifetime opportunity turned into another positive experience. Mike Baker knew better at this point and still asked me to write *Acrylic Painting For Dummies.* Thanks, Mike! My right-hand editor in Holland, Corbin Collins sped through from schedule to completion with nothing but nice comments (I am sure he bit his tongue on more than one occasion). Chrissy Guthrie completed the editing efficiently for the second book (she also knew better, and I am glad we got to work together again). Mary Morrison was the technical advisor. Mary also works for Golden Acrylics as a working artist. She was a blast to take workshops from in Denver and hear her enormous technical and chemical knowledge, besides enjoying her beautiful artistic creations. Megan Knoll was the copy editor and was amazing editing, organizing, and making everything its best for the reader. Clint Lahnen and his team were given just under 400 images to scan and prepare — a large job that was well done! I do love you all.

I have to thank my better-half husband for letting me type all night and weekend. Gary is always the support that an artist needs to really thrive. Whether it is ordering take-out, or keeping the distractions low, he was always doing what needed to be done. I owe you a vacation now!

Thanks to my co-workers who fielded phones and customers, cleaned, and kept the business moving forward while I typed: Carol, May, Linda, Robin, and Lesli.

Thanks to my painting girlfriends (get some of these if you don't have some): Donna, Ann, Patty, Claudia, Suzie, Alaine, Delilah, Jean, Marcey, Cathy, Marilyn, and Norma.

The best part of art is sharing it, getting to know others, and growing together. Art competitions and the marketplace tend to put artists in a competitive mood. The longer I live, the more ridiculous this has become. We are all in this together, and together we can accomplish anything! Love one another.

Publisher's Acknowledgments

We're proud of this book; please send us your comments through our Dummies online registration form located at `http://dummies.custhelp.com`. For other comments, please contact our Customer Care Department within the U.S. at 877-762-2974, outside the U.S. at 317-572-3993, or fax 317-572-4002.

Some of the people who helped bring this book to market include the following:

Acquisitions, Editorial, and Media Development

Senior Project Editor: Christina Guthrie

Acquisitions Editor: Mike Baker

Copy Editor: Megan Knoll

Assistant Editor: Erin Calligan Mooney

Editorial Program Coordinator: Joe Niesen

Technical Editor: Mary Morrison (`www.mary morrison.info`)

Editorial Manager: Christine Meloy Beck

Editorial Assistants: David Lutton, Jennette ElNaggar

Art Coordinator: Alicia B. South

Cover Photos: Photos.com

Cartoons: Rich Tennant (`www.the5thwave.com`)

Composition Services

Project Coordinator: Lynsey Stanford

Layout and Graphics: Carl Byers, Reuben W. Davis, Brent Savage, Christine Williams

Proofreaders: Melissa Cossell, Shannon Ramsey

Indexer: Glassman Indexing Services

Special Help: Clint Lahnen

Publishing and Editorial for Consumer Dummies

Diane Graves Steele, Vice President and Publisher, Consumer Dummies

Kristin Ferguson-Wagstaffe, Product Development Director, Consumer Dummies

Ensley Eikenburg, Associate Publisher, Travel

Kelly Regan, Editorial Director, Travel

Publishing for Technology Dummies

Andy Cummings, Vice President and Publisher, Dummies Technology/General User

Composition Services

Debbie Stailey, Director of Composition Services

Contents at a Glance

Introduction .. 1

Part I: Getting Acquainted with Acrylics 5

Chapter 1: Acrylics Are Awesome! ...7
Chapter 2: Setting Up Supplies: Brushes, Surfaces, and Palettes17
Chapter 3: All About Paints and Mediums ..35

Part II: Exploring Tricks and Techniques 47

Chapter 4: Basic Painting and Finishing Techniques49
Chapter 5: Building Your Repertoire with Quick Tricks and Techniques71
Chapter 6: Drawn to Paint — Even if Your Drawing Skills Need Work85

Part III: Finding the Fun in Fundamentals 101

Chapter 7: Taking a Quick Color Tour ..103
Chapter 8: Design of the Times: Design Elements and Principles123
Chapter 9: Putting the Pieces Together: Composition143

Part IV: Acrylic's Versatile Styles 157

Chapter 10: Letting It Flow: Creating a Watercolor-like Landscape159
Chapter 11: Laying It On Thick: Painting Like the Oil Masters179
Chapter 12: Thinking and Painting Abstractly ...205

Part V: Projects for Different Surfaces 235

Chapter 13: Creating Collages and Transfers ...237
Chapter 14: Cool Projects for All Types of Surfaces255

Part VI: The Part of Tens ... 281

Chapter 15: Ten (Plus One) Genres: Figuring Out What You Want to Paint283
Chapter 16: Ten Ways to Get the Creative Juices Flowing291

Index .. 295

Table of Contents

Introduction .. 1

About This Book...1
Conventions Used in This Book ...1
What You're Not to Read ...2
Foolish Assumptions ..2
How This Book Is Organized...2
 Part I: Getting Acquainted with Acrylics3
 Part II: Exploring Tricks and Techniques3
 Part III: Finding the Fun in Fundamentals.........................3
 Part IV: Acrylic's Versatile Styles.......................................3
 Part V: Projects for Different Surfaces3
 Part VI: The Part of Tens ..4
Icons Used in This Book...4
Where to Go from Here...4

Part 1: Getting Acquainted with Acrylics5

Chapter 1: Acrylics Are Awesome!...7

What's So Awesome About Acrylic Paint?7
 Versatility...8
 Fast drying time...8
 Durable finish..9
 Resistance to cracking...9
Nurturing and Growing the Acrylic Artist in You.................9
 Developing your own talents ..9
 Finding and capturing inspiration...................................10
 Getting in the zone ...11
 Finding your style while expanding your horizons.......11
Project: Painting Your Sketchbook14

Chapter 2: Setting Up Supplies: Brushes, Surfaces, and Palettes17

Brushing Up on Brushes ...17
 Get a handle on it ...18
 Hair today, gone tomorrow ...18
 Get in shape (shaped brushes, that is)19
 Size matters..19
 Brush substitutes ..21
 Beginning your brush collection with the bare essentials.....22
Maintaining Your Brushes...23
 Prepping a new brush ...23
 Avoiding damage ...23
 Washing..24
 Storing..24
 Repairing a worn brush ...25
 Knowing when it's time for a new brush26
Picking and Prepping Common Paint Surfaces27
 Canvas paper ...27
 Canvas..27

 Boards ...28
 Preparing boards and canvases30
 Thinking Outside the Canvas: Alternate Acrylic Painting Surfaces.......31
 Painting on fabrics ...31
 Working with wood surfaces...31
 Taking a shine to metal ...32
 Scratching the surface of glass ...32
 Plastic...32
 Terra cotta ...33
 Walls ...33
 Purchasing Palettes and Other Handy Stuff33
 Palettes ..33
 Other useful supplies ..34

Chapter 3: All About Paints and Mediums ...**35**
 Getting to Know the Different Properties of Acrylic Paints.............35
 Pigments and binders ...36
 Viscosity ...37
 Finish...37
 Drying time...38
 Lightfastness or fading ...38
 Compatibility ...39
 Hues ..39
 Different Types of Acrylic Paint ...39
 Specialty acrylic paints ..40
 Additives, Mediums, Gels, and Pastes..42
 Acrylic medium ...42
 Water ..43
 Flow enhancers..44
 Retarders ..44
 Glaze..44
 Gel mediums and paste..45
 Specialty mediums and finishes46

Part II: Exploring Tricks and Techniques**47**

Chapter 4: Basic Painting and Finishing Techniques**49**
 Setting Up Your Palette and Supplies ..49
 Getting a Grip on Your Brushes: Practicing Various Brush Strokes51
 Crisscrossing..52
 Scumbling ...53
 Stippling..54
 Dry brushing ..54
 Making fine lines with liners ..55
 Scratching with scraffito ..55
 Painting with a palette knife...56
 The Best Basic Painting Techniques...57
 Under painting ...57
 Base coating ...58
 Wet-into-wet and blending..59
 Layering ..59
 Glazing ..60

Finishing with Finesse ...61
 To varnish or not to varnish ..61
 Presenting your paintings: Mats and frames63
Project: 30-Minute Artist Trading Card66

Chapter 5: Building Your Repertoire with Quick Tricks and Techniques71

Ready, Set, Experiment..71
Adding Stuff to Your Paint...72
 Salt...72
 Alcohol or water ..73
 Sand, sawdust, and beyond ...74
Thinking Outside the Brush..75
 Sponges and rollers...75
 Plastic wrap..76
 Cobwebs and cheesecloth ...78
Dripping, Spraying, and Spattering...79
 Jack the dripper..79
 Spray it again, Sam ...80
 Spray stenciling ...81
Project: Combination Technique Abstract82

Chapter 6: Drawn to Paint — Even if Your Drawing Skills Need Work85

Making Thumbnail Sketches ...86
Enlarging Sketches ...86
 Eyeballing it ..89
 Gridding it ...89
 Copying it ..89
 Projecting it ..90
Tracing Your Way to a Great Painting Sketch90
 Finalizing your sketches with tracing paper......................91
 Copying a photograph by using tracing paper..................91
Getting Your Drawing onto the Painting Surface92
Blending with Paint..93
 Making a smooth transition ..93
 Blending to create depth ..94
Project: Create a Still Life ...96

Part III: Finding the Fun in Fundamentals101

Chapter 7: Taking a Quick Color Tour ...103

Looking at Popular Colors ...103
 Red ..103
 Orange..104
 Brown ..104
 Yellow..105
 Green..106
 Blue ...106
 Violet ...107
 White ...107
 Black..108

Deciphering Paint Descriptions ..109
 Common chemicals ..109
 Common descriptors ..110
 Hues ...110
Working the Color Wheel ...110
 Primary, secondary, and tertiary colors111
 Clear as mud: Using color bias to mix colors (or mud)111
Three Color Exercises ..113
 Exploring value with monochrome: The one-color exercise113
 Taking your painting's temperature: The two-color exercise115
 Harmonizing with primaries: The three-color exercise............117
A Few More Color Plans ..118
 Complementary ..119
 Split complementary...120
 Analogous ..121
 Full wheel ..122

Chapter 8: Design of the Times: Design Elements and Principles123

Elements of Design...123
The Principle of Balance ...125
 Balancing color ..125
 Balancing value ..126
 Balancing dots ..126
 Balancing texture..126
 Balancing line ..127
 Balancing shape ..128
 Balancing size ..128
 Balancing volume ...129
The Principle of Contrast ...129
 Contrasting color ...129
 Contrasting value ...130
 Contrasting shape ..131
 Contrasting texture ..131
 Contrasting lines...131
 Contrasting size ..132
 Contrasting volume ..132
The Principles of Repetition, Alternation, and Variation133
The Principle of Direction ..134
 Direction of texture ..136
 Direction using lines ..136
 Direction using shapes ...137
The Principles of Emphasis and Subordination137
 Dominance of color temperature ...138
 Dominance of value..138
 Dominance of dots ...138
 Dominance of texture...139
 Dominance of line ...139
 Dominance of shape..140
 Dominance using size ...140
 Dominance using volume ...141

Chapter 9: Putting the Pieces Together: Composition143

First Things First: Intention and Placement ...143
 Determining and placing the focal point144
 Give 'em room ...146

Off-setting the horizon ..146
Setting the mood ...146
Less is more ..148
More Composition Guidelines ..148
Going with odd numbers ...149
Avoiding tangents..149
Varying your edges to create depth and
to help the focal point stand out ...150
Keeping light and shadows consistent...151
Check Yourself: Analyzing and Revamping Your Composition151
Keying the painting ...151
Thinking in threes ...152
Cropping...154
Implosion and other shapes ..154
Unity: A final checklist ..154

Part IV: Acrylic's Versatile Styles 157

Chapter 10: Letting It Flow: Creating a Watercolor-like Landscape.................159

Born to Run: Thinning Acrylic to be Like Watercolor160
The Sky's the Limit: Painting Translucent Skies161
Riding off into the sunset ...162
Raindrops keep falling on my head ..163
Clouding the picture ...164
Getting Edgy: Defining the Edges of Landscape Objects165
Hard edges..166
Soft and lost edges ...166
Seeing the Forest for the Trees...169
Defining tree edges by painting and spattering.............................169
Making a tree brush out of rubber bands171
Layering Paint for Endless Possibilities ..172
Getting a little perspective ..172
Backgrounds, middle grounds, and foregrounds172
Project: Putting Together a Watercolor-like Landscape......................174

Chapter 11: Laying It On Thick: Painting Like the Oil Masters179

Getting Ready to Create an "Oil" Masterpiece179
Extending your acrylic's drying time to mimic oil...........................179
Choosing and prepping a surface..180
Trying Oil-Inspired Techniques..181
Painting backgrounds with aerial perspective181
Overlapping..183
Creating texture ..184
Simulating depth with shadows ...188
Project: Irresistible Husky Dog..191
Project: Fall Corn Still Life..195
Project: Son of Corn Painting (A Sequel) ...198

Chapter 12: Thinking and Painting Abstractly205

Cruising through Abstract Art Movements: An Overview.....................205
Finding Abstract Ideas in the Real World..207
Creating a cropping viewfinder ..207
Pushing a shape out of shape...209

Abstract Ways to Send a Message in Your Art ..211
 Putting words in a painting ...211
 Looking at what various symbols and elements can communicate211
Handy Products and Techniques for Abstract Art ...223
 Under it all: Starting with grounds and pastes223
 Over the top: Using products that go on top of grounds and substrates226
Planning Your Own Abstract Painting: A Few Questions to Consider.................229
Project: Abstract Extravaganza ..230

Part V: Projects for Different Surfaces235

Chapter 13: Creating Collages and Transfers237

What You Can Use in a Collage ..237
Deciding What You Want Your Collage to Say ...238
Preparing Your Background Surface ...240
Layering Your Collage ...241
 Layering with paper ...241
 Layering in paint ..244
Working with Images and Direct Transfers ...245
 Making a direct transfer ...246
 Transferring drawings ..249
 Making sure your collage doesn't infringe on copyrights...........250
Project: Southwestern Cliffs Collage ...251

Chapter 14: Cool Projects for All Types of Surfaces255

Wild About Wildcats: Painting on Wood and Clayboard................................255
 Wooden wildcat box...256
 Coasters ..261
Grape Art: Painting Grapes on a Violin (Yes, Really)266
Wall Art: Painting a Mural ..269
Art to Wear and Carry: Painting Fabric and Other Materials270
Rock On: Painting on Rocks and Stone ..275
Heavy Metal: Painting on Steel ...275
Odds and Ends: Faux Stained Glass, Bricks, and Candles277
 Faux stained glass ...277
 Painted brick ..279
 Painted candles ...279

Part VI: The Part of Tens ...281

Chapter 15: Ten (Plus One) Genres: Figuring Out What You Want to Paint......283

Chapter 16: Ten Ways to Get the Creative Juices Flowing291

Index ...295

Introduction

*W*elcome to *Acrylic Painting For Dummies*! You're about to embark on a wonderful journey. Acrylic painting is a fun way to communicate through art, and I love to share the "gospel" of art with others. A real dedication to art changes your life — challenges you, inspires you, and is your companion for as long as you let it be.

Acrylic paints are a great painting choice. They're easy to use and simple to clean up with soap and water, dry quickly, have no toxic fumes, allow you to make changes quickly, and offer many surprise tricks. This book is your ticket to exploring these and other aspects of acrylics.

About This Book

Given its title, you're probably not surprised that this book is all about painting using acrylic paint — painting, as in *you* creating paintings. Although you may get an appreciation of the art of painting by reading this book, there's no substitute for doing. You must paint yourself (that is, you must paint; whether you paint a self-portrait or paint on yourself is up to you). It can not only be one of the most satisfying activities you ever do, but it's also the only way to truly appreciate others' work. It can help you *see* art for the first time with a new appreciation of what you're looking at.

So this book helps you do just that — actually paint. Most chapters offer at least one step-by-step project that incorporates the theory and the techniques introduced in that chapter. After duplicating the paintings, you can try the projects again with subjects of your choosing. Although I give you all the instructions to be successful in painting the exercise, you can also make your own choices at any point. Want to change the painting size, surface, or color? Do it. I encourage you to make the projects your own.

Along with all the painting projects, I also show you how to create interesting effects, compose a good picture, and use color to full advantage — all in an easy-to-access and easy-to-understand format. And I don't use art speak — I just tell you in plain English how to plan, compose, design, and paint. That's what you were hoping for when you picked up this book, isn't it?

Conventions Used in This Book

When writing this book, I used a few conventions to make reading easier:

- ✔ *Italicized* text shows up to define words or terms being used for the first time in that chapter.
- ✔ "Acrylic paints" are often described as just "acrylics".

- ✔ "Pigments," "paint," and "color" are often used to mean the same thing.
- ✔ **Bold** text indicates keywords in bulleted lists or the main instructions in a numbered list.
- ✔ The occasional Web site or e-mail address appears in `monofont` to help it stand out on the page.

What You're Not to Read

Throughout the book, you'll see sidebars that appear in separate boxes. The information in the sidebar may be interesting (and I hope it is), and you may want to read it (and I hope you do), but you don't need to read it to understand the topic at hand — so you can skip it if you like (and fortunately, I'll never know if you do). You may just want to flip through the book for the sidebars one day.

The Technical Stuff icons are a similar story — if you like the nuts-and-bolts and historical stuff, check out these interesting tidbits. If you just want to paint already, you can skip 'em.

Foolish Assumptions

The only assumption I make about you is that you're interested in acrylic painting. I give you basic information about art in general and acrylics in particular, so you don't need to know a thing about any art-related topic to benefit from this book. If you picked it up, you're already smart enough.

How This Book Is Organized

I arranged this book into six parts that contain chapters with information related to a common theme.

Although the book reads and leads you logically in order from the beginning to the future of your art, you don't have to read it in order. You can skip around to work on stuff that interests you. Techniques explained in different chapters are cross-referenced so that if you need some technical how-to information, you can turn to that chapter.

You can also use this book as a reference book. You can go to the table of contents or index, look up what you need, and go straight to the relevant page(s). In art you get a lot of information upfront, but you may not be ready for it until you experience that problem. So you may want to read information again after you have painted for a while. You may be painting along when you suddenly realize, "That's what she meant!" Then you can go back to read a section or a chapter to cement the concept in your memory. You'll have many aha moments in your painting career.

Part 1: Getting Acquainted with Acrylics

If you've never painted, this part is the place to start. If you have painted, this section may be a good refresher and an explanation of the tools and techniques I use. Every artist has a different setup and approach. In these chapters I share mine and tell you what techniques and practices have worked well for me.

I know you can't wait to get started, so Chapter 1 has a project right away. In Chapter 2, I cover the materials and products you can get in an art store and give you the information you need to ask intelligent questions when choosing your supplies. The world of acrylics includes many additives, mediums, and enhancers, and Chapter 3 sorts out all of those.

Part 11: Exploring Tricks and Techniques

Reading this part's chapters and practicing the projects in them gives you a firm grasp of fundamental acrylic skills. Chapter 4 describes basic acrylic techniques (and these skills are actually appropriate with almost any paint) and finishing needs. Chapter 5 launches into fun experimental techniques that yield interesting textures. Chapter 6 gives you a fast drawing course, including the drawing-transferring process you need throughout the book.

Part 111: Finding the Fun in Fundamentals

Wonder why some paintings win awards? Hopefully, it's because the artist uses strong design and composition (although sometimes I can't figure out why they win, either — as the adage says, there's no accounting for taste). Design and composition comprise core knowledge or fundamentals that give you the language to discuss art and improve your artistic planning and execution.

The chapters in this part show you how to mix and use color (Chapter 7) and how to use the rules of design (Chapter 8), and then I put it all together to help you make a strong composition (Chapter 9).

Part 1V: Acrylic's Versatile Styles

You can use acrylic to imitate several kinds of styles. Chapter 10 explores using acrylic paint like a watercolor: loose, liquid, and in layers. Chapter 11 uses the paint thick and generous like an oil painting, and Chapter 12 lets it all hang out by exploring abstract art.

Part V: Projects for Different Surfaces

Acrylic paint has special properties that allow you to use it as glue, so I explore the art of collage in Chapter 13. Many other kinds of paint have to be paired with certain surfaces, but not acrylic. You can use it on a variety of surfaces, so I discuss the versatile surfaces of decorative arts in Chapter 14.

Part VI: The Part of Tens

The chapters in this part are the icing on the cake. Chapter 15 suggests and describes subjects you may want to paint, and Chapter 16 gives you ideas for jump-starting your artistic passion.

Icons Used in This Book

Like any *For Dummies* book, I've tagged some information with icons to direct your attention to specific text. The icons I use include the following:

This icon tips you off to historical or particularly technical info that's plenty interesting but not essential to the topic.

The text next to this icon shares a tidbit that helps make your art activity easier. Trust me, I've made every mistake already for you, and I want to save you some energy by not having to make the same unnecessary mistakes.

When you see this icon, get out your paints, brushes, and paper to either duplicate a small painting project or try a technique.

This icon gives you a heads-up to remember certain information that may be covered elsewhere but is important to keep in mind.

Nothing you can reasonably do in painting can hurt you (okay, don't eat it), but you may want to avoid the things this icon points out just to preserve your artistic sensibilities and the beauty of your paintings.

Where to Go from Here

This is a *For Dummies* book, so you can start anywhere you like and jump around as you like. But if you're a complete newcomer to art or painting, I suggest you turn to the chapters in Part I. If you want a refresher on art supplies, and what to buy, these chapters can help. If you want to jump right in and get your paints wet, turn to any of the chapters in Part II for painting techniques of all descriptions. Part III takes off with improvement and design skills. Part IV gives you plenty of projects to try some different styles. Part V pushes acrylics into new directions of collage and decorative arts.

You're about to set sail on a journey that can last a lifetime. Painting can take you anywhere, show you anything, elevate your spirit, and calm your soul. Art provides a way to communicate when you can't find the words. It's a companion whenever you require one. Art will take you wherever you let it lead you, so welcome aboard!

And remember: You learn and discover most by doing. The best advice I can give you is to paint, paint, paint!

Part I
Getting Acquainted with Acrylics

The 5th Wave By Rich Tennant

"No, my 5-year-old painted the landscape. The other one is a valuable example of neo-urban impressionism."

In this part . . .

Amazing acrylics await you! These first chapters are all about the acrylic *medium* (another word for type of paint) and the brushes, surfaces, and additives that make acrylic work for every occasion. These three chapters offer a basic understanding of all the supplies you need, as well as the properties of acrylic paint and the plethora of paint choices you face. And, of course, they start you painting.

Chapter 1

Acrylics Are Awesome!

In This Chapter

▶ Discovering the wonders of acrylic painting

▶ Uncovering your artistic instincts

▶ Jumping right in to get painting

*H*ave you ever thought, "I could paint like that" (or, "I wish I could paint like that") as you walked through an art show? If so, you've expressed a desire to delve into the arts — even if only by looking at this book. There's a romantic view of artists as paint-covered, canvas-focused geniuses drawing inspiration from some beautiful muse. And why not? Often that's exactly what an artist is doing.

In this chapter, I show you a few of the reasons acrylics are amazing as well as explore what subject types make interesting paintings. You discover how to develop your talent and style and collect the images that interest you. Finally, you even personalize a sketchbook in order to get familar with your acrylic paint (and then give you a place to collect sketches for painting ideas).

What's So Awesome About Acrylic Paint?

Have you walked into a well-stocked art supply store recently? It's very exciting, but it can also be a bit overwhelming to see all your choices. You're bombarded with watercolor, tempera, oil, water-soluble oil, heat set oil, casein, gouache, inks . . . and acrylic paints.

Acrylic paint is a perfect choice for beginners and experts alike. Why? You can apply it in layers, which means you can make changes easily. It dries fast, so you don't have to wait long between layers. Cleanup is easy — just soap and water; the lack of harsh, smelly solvents means acrylic paint is better for your health than oil. Acrylics adhere to most everything (and when they don't, you can get special products to help fix that), so you can paint on a traditional canvas or a decorative box. They can be used straight from the tube or bottle, but you can also add mediums, gels, and pastes that can change the paint's thickness or finish to make it do just what you want it to do. For safe, easy, flexible, permanent, versatile painting, acrylic paint is a fantastic choice.

The following sections give you more information on just what is so great about acrylic paints.

Versatility

Acrylic paint is versatile. You can thin it with water to make it resemble watercolor (see Chapter 10 for more on mimicking watercolor painting with acrylic paint). You can also paint it on thick to give the impression of an oil painting (see Chapter 11 for that). You can paint it on many surfaces; it works fine with watercolor paper, canvas, and wood, among other things.

Acrylic is such a master of disguise that it may be difficult to decipher what a finished artwork was painted with. It's all in the hands of the artist — you. The paint does whatever you ask of it.

Acrylic painting also creates quality works no matter how much time you choose to spend on a painting or what mood you're in. If you have time and want to paint detailed precise paintings, you can work slowly and carefully to do just that. If you want to achieve a looser look and simplify the detail, acrylic still looks great. Take a look at the two styles of paintings in Figure 1-1. I love to paint flowers. The two styles in that figure indicate what mood I was in (and the amount of time I spent) when I painted each painting. I painted the sweetheart roses by taking my time and paying close attention to detail. Notice the heart-shaped dewdrop on the lower petal. The wheelbarrow was a quicker, faster-flowing painting. When I stopped, I thought I hadn't finished it, but when I came back to it, I decided it didn't need any more. Acrylic paint will accommodate either style and amount of detail.

Figure 1-1:
Two styles
of painting:
one is
tight and
realistic,
one is loose
and soft.

Fast drying time

Acrylic dries quickly, so you don't spend a lot of time waiting for it to dry. That lets you paint layers much more quickly than you can with oil paint. You can even manipulate the drying time if necessary for a particular project. (In Chapter 3, I discuss attributes and additives of acrylic paint.)

Because acrylic does dry quickly, get into the habit of soaking acrylic paint-loaded brushes in water when not in use. If you leave wet paint in brushes to dry, they become useless.

Durable finish

Acrylic is also *lightfast,* meaning it doesn't fade significantly over time. You don't want to sell your masterpiece for beaucoup bucks and then have it disappear before the client's eyes. Plus, acrylic's tough finish means you don't necessarily need to frame your finished acrylic artwork behind glass — even if it's a work on paper. If you varnish your finished acrylic masterpiece, you can frame it without a *mat* (a cardboard-like border) or glass. In fact, many viewers complain that glass creates a glare. Another bonus is that this easier framing is also less expensive framing because you don't have the extra expense of mat and glass. Chapter 4 discusses the final presentation of acrylic paintings.

Resistance to cracking

Acrylic is *thermoplastic. Thermo* indicates "heat," and *plastic* means "moveable." Basically, acrylic paint becomes flexible when it gets warm. This flexibility is helpful compared to other kinds of paint because acrylic is less likely to crack when dry. However, with flexibility comes caution: Acrylic paint also runs the risk of becoming tacky when warm. So don't stack thick paintings face to face in a hot attic or garage because they may stick together. The good news is acrylics also become stiffer in cold environments. If your paintings become stuck, simply transfer them to a cool place (such as a basement) and wait for them to release.

Nurturing and Growing the Acrylic Artist in You

Whether you want to be a full-time artist or just start a new hobby, acrylic painting is a perfect way to explore the world, fill some time, challenge your limits, focus your energy, impress friends and family, and learn to appreciate the beauty that's all around you.

Developing your own talents

Have you ever heard the warning "You must have talent" and felt like that was an obstacle keeping you from even trying? Well, I'm here to tell you that that kind of talent is mythical, fictitious nonsense. Show me someone who can draw and paint and I will show you someone who has spent much time getting there. Talent doesn't fall from the sky onto your lap. I do give the good Lord credit, but talent is developed and nurtured here on Earth. When I started, I wasn't very good. But I wanted to be good badly enough that I continued to

hone the craft — practicing my skills — so I could eventually say, "I am an artist." All you *do* need to succeed in art is aptitude and perseverance. You have to *want* to be an artist. The rest is practice, study, practice, reading, practice, observation, and practice. The good news? Practice is fun.

Nurture your aptitude (or talent, or whatever you want to call it) to develop it. Look at art books, art museums, and art shows every chance you get. Look for art that you like, and try to understand art that may not appeal to you at first. Study the old masters, and find living artists who can guide your own spirit. Don't underestimate the importance of talking with like-minded individuals, because nonartists may not understand. If you can, find a mentor. Even the old masters apprenticed with a master artist of the time. The master imparted wisdom and inspiration to the next generation of artists to keep the arts flourishing.

Finding and capturing inspiration

What inspires you? You may get jazzed by beautiful figures of other people, the perfection of nature, patterns, animals, or something especially meaningful to you. It may even be painting itself: I find that I'm inspired more by *how* a painting is done than by what it is. For example, a beautiful flow of colors describing a simple grass meadow may be truly inspiring. The subject of the grass meadow isn't the exciting part; the brush work, color, and execution are what elevates the painting. The way that light and shadow fall on a subject often is the inspiration for artists. Look for what excites you when you see a subject suitable for painting. Start to collect the ideas for painting subjects.

You don't need anything elaborate to get started. If you have a pencil and a little pocket notebook, you're in business. Draw in that little notebook every day — whatever you see. Collect shapes. Look outside and collect trees, bushes, and anything else that catches your attention. When you get around to designing paintings, you can refer to your collection of shapes and arrange them into a painting. Chapter 6 has more tips on drawing.

Cameras are wonderful tools to collect painting ideas. I am never without my camera, just in case something pops up that's photo-worthy. However, don't replace drawing with using pictures. Nothing approaches the unique exploration that happens when you really look at an item and try to re-create it on paper. You spend more time seeing relationships between curves, angles, and parts of the object. You learn. You may have seen that item a million times, but until you try to draw it, you don't realize that you've never really looked at it.

Art as stress relief

More good news: Drawing and painting can make your stress disappear. A Zen-like feeling comes over you when you sit down and take time to observe and recreate. When I prepare to paint, I gather my materials, get out my canvas, get the lights right, and put the kettle on for some tea. I am preparing my mind for what is coming next. It's almost like yoga. If you can turn off the phone, maybe put on some music (preferably instrumental), and control any other interruptions, drawing and painting are perfect ways to relieve stress.

Getting in the zone

I recommend instrumental music as a background soundtrack for your painting session. Why listen to music without words? It's all about using your right and left brain to their full advantage. Not to get all scientific on you — this is an art book, for crying out loud — but studies do show that the left hemisphere of the brain controls analytical functions (speech, numbers, time, organization, and so on) and the right hemisphere houses the creative functions (spatial relationships, colors, problem solving, and so on). Instrumental music stimulates your creative right brain without awakening your speech-controlling left brain with lyrics. Of course, you're not really only using half of your brain when you're drawing or painting (although I'm sure you know many half-brained people), but you do get "in the zone." Have you ever been traveling and realized that time has flown by and you don't remember how you got to your destination? The same thing often happens while doing a creative project — you're so busy doing right-brain work that left-brain time considerations fall by the wayside.

You want to be in this spirit when you paint — so avoid the things that stimulate the left brain, like conversations, talk radio, and listening to music with lyrics. Instead, try some Mozart.

Finding your style while expanding your horizons

You'll probably go through many stages in your art career. The first stage may just be to get something recognizable down in a painting. Can the viewing public decipher what animal your wildlife painting depicts? Later, when it's obvious that what you've drawn is, say, a hippopotamus, you may become very interested in the way the light and shadow fall on the animal, and then in getting just the right color combination, and then in being able to sum up the hippo in the fewest possible lines, and so on. You can derive an endless amount of inspiration from your artistic progression.

How do you make this progression? Be curious. Experiment. You must be interested in the world. Collect images of subjects that are intriguing to you. Find out as much as you can about them and then explore them in your artwork. Perhaps you're interested in fantasy or science fiction. Or flea markets. Or train travel. Or basketball, fishing, musical instruments, beekeeping, or upholstery. Art is there for you, too, if you look for it. I've expanded my interests lately to racing cars and birdwatching. That's pretty diverse, but I find that both interest areas provide plenty of painting topics. For example, Figure 1-2 is a car painting; for added interest, I've painted a close-up for a slightly unexpected view. You can make any interest of yours come to life through art. You can own any vehicle, building, landscape, or zoo animal. You can make the world as you want it to be. What power!

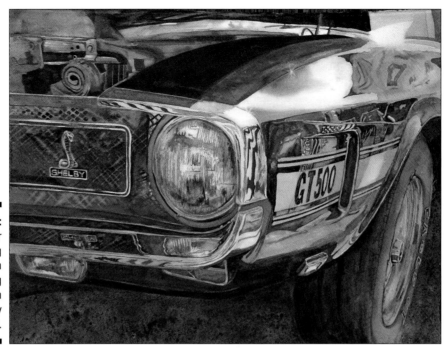

Figure 1-2:
This car painting presents an interesting angle on an everyday subject.

Genre is a term used in painting to refer to different kinds of paintings. Here are some of the most popular genres:

- **Landscape:** *Landscapes* (which portray earth elements such as trees, skies, grass, and mountains) may be the most popular genre. Figure 1-3 shows a typical landscape painting, and Chapter 10 lets you try your own hand at landscape.

- **Still life:** *Still lifes* are composed of arranged elements such as pots, fabric, fruit, flowers, and knick-knacks, usually positioned on a table. You can paint still lifes in Chapters 6 and 11.

- **Portrait:** *Portraits* re-create faces and identifiable images. A portrait of a house is a real, specific house.

- **Wildlife:** Wildlife paintings portray domestic and wild animals, birds, and fish. Chapter 4 gives you a wildlife project.

- **Abstract:** *Abstract* is another name for nonrepresentational art. Chapter 12 is all about abstract art.

What's *my* style?!

Style is a word that gets tossed around a lot. Some styles are loose, like many of the Impressionists. Some styles are tight, like the Super Realists. Don't worry about developing a style right away. It's important to try as wide a variety of techniques as possible to begin with so you can tell what you like and what you don't. Your style will follow — you don't want to force it. With patience, your style will evolve, and one day you'll notice that your paintings look similar — because they all have your style.

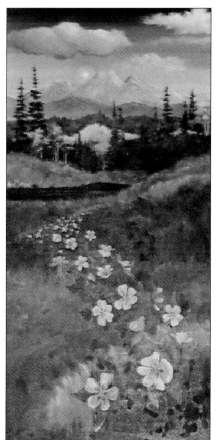

Figure 1-3:
Living in
Colorado
provides
subject
matter for a
beautiful
landscape
everywhere
you look.

✔ **Collage:** A *collage* attaches papers, paints, photographs, and other similar items in layers to create unique effects. Chapter 13 discusses and walks you through collage projects.

✔ **Mixed media:** A mixed media work blends different paints and drawing materials together in one work.

I talk about all of these acrylic painting genres in this book (especially in Chapter 15), and you can find step-by-step projects for most of them. The projects here are just to give you a taste — an idea for you to take and run with using your own imagination. When you try your hand at the projects in this book, think about how you can apply those techniques to what interests you.

You may try all the projects in this book and find that you excel at one of them more than the others. That may become your specialty. Many artists focus on just one particular genre, developing a style and reputation for painting just that kind of thing. Such specialization is often good strategy; in fact, most gallery owners prefer artists who are recognizable for a specialty. Say you dig aliens in purple spaceships. If that's all you paint, you'll become so good at that niche that when people see an alien in a purple spaceship at a gallery, they'll recognize it as yours.

Project: Painting Your Sketchbook

The rest of this fine book contains lots of details about everything having to do with acrylics, but I know you're anxious to get started. So why not jump right in and try out some paint? For now, just get some acrylic paint, a can of water, a paintbrush, and a sketchbook with a stiff cover. I like sketchbooks with heavy, unfinished cardboard covers. The size is your choice; I found a 6-inch square book that I liked. I also usually choose a sketchbook with a spiral binding because it lies flat when opened.

Earlier in this chapter, I suggest that you collect ideas and put them in a sketchbook. When you're done with this project, you'll *want* to sketch in your new acrylic-embellished sketchbook. By painting a plain, inexpensive spiral sketchbook, you'll want to pick it up, show it off, and — most importantly — fill it up.

Choose a few acrylic colors you like — three should be plenty. I used three colors in this example: Iridescent Bright Gold, Quinacridone Nickel Azo Gold, and Iridescent Copper (fluid acrylics by Golden) — plus a Titanium White from a tube. I used a 1-inch flat brush; if you feel like making some lines or details, you may want a #8 round brush. (Chapter 2 gives you the skinny on brushes). Fill your water container (a recycled tin can is fine) and have some paper towels handy for spills.

If you want to embellish your cover further, you need a few other items: acrylic gloss medium (Chapter 3 describes mediums in detail) and some pretty scrap papers, such as tissue or decorative papers. Sometimes you can even recycle the interior of envelopes. Did you ever notice the nifty patterns inside junk mail envelopes? If you're on a budget, these scraps work fine.

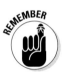

You *can't* do this project wrong. No pressure. You're not even painting from a palette. All you want to do is get a feeling for the paint and get started enjoying the possibilities. Just follow these steps to your own inspirational painted sketchbook:

1. **Prepare your painting area by covering your painting area in newspaper and corralling your supplies.**

 Place your sketchbook on the newspaper. I also put another sheet of newspaper between the sketchbook cover and the sketchbook pages to protect the pages from paint.

2. **Squeeze a dollop of white paint directly on the cover and spread it to create an even coat.**

3. **If you're using multiple colors, squirt them onto the cover while the white paint is still wet and pull the brush through it to create a marbled look.**

 I pulled the brush through the paint only a couple of times because I wanted the variety of colors to remain unblended, but you can play with the paint as much as you like. Use the brush to make textures, marks, and lines. I completely covered the surface with the brush strokes all going the same direction, and then made a scalloped line by pulling the brush through the smooth paint.

 When you like the result or the paint begins to dry, stop. Figure 1-4a shows the plain sketchbook and Figure 1-4b includes an added coat of paint.

Figure 1-4:
The sketchbook before (a) and after (b) a coat of paint.

4. **Let the cover dry completely, keeping your brush in the water while you're not using it.**

 You may speed up the process with a blow dryer or let it dry naturally for an hour or so.

5. **Stop there if you want, or embellish by going on to Steps 6 through 9.**

6. **Embellish by painting a Chinese character (or whatever you feel like).**

 Use a round brush to make marks that resemble a Chinese character. Push down to make a wide stroke or pull the brush to make a line, lifting the brush as you pull to reduce the width of the line.

 Practice your characters on another sheet of paper until you're confident enough to do them for real on the cover. If you don't like your first cover attempt, wipe it off with a damp paper towel and try again. You can also make the character less prominent by covering it with paper (Step 7) in part or entirely.

 Rub-on letters are available at the craft store. Figure 1-5 shows rub-ons by American Traditional Design. You can rub these onto a surface and paint over the top of them to get an accurate character.

7. **To embellish with papers, paint acrylic medium over the area you want to paper, add the paper, and then paint another layer of medium.**

 Gather some paper scraps. I tore some Japanese rice papers into strips and rectangles. Try using paper with images or graphics; I added a reproduction of *Mona Lisa* as a final indication of what will go inside the book. You can also sprinkle glitter at this time. I put big metallic pieces on called Gildenglitz by USArtQuest.

8. **Let everything dry.**

9. **Repeat Step 3 to paint the inside cover.**

 The cardboard cover may bow a little from the moisture. By painting the inside, the fibers of the cardboard bend back and lie flatter.

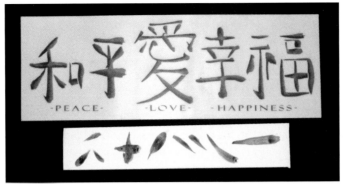

Figure 1-5:
Use rub-ons as a guide to creating accurate characters.

Figure 1-6 shows a couple of embellished books. The *Mona Lisa* is a blank sketchbook, and the larger one is a self-bound date book using a vinyl cover painted with Chinese characters and embellished with Japanese papers. What a way to go around the world with art: Italian paintings, Chinese words, and Japanese paper with an American assemblage. (And if you liked this project, you definitely want to check out Chapter 13 on collage.)

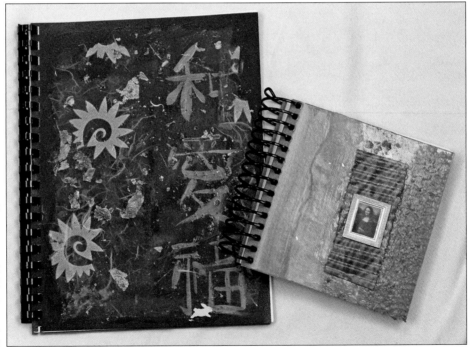

Figure 1-6:
Transform a plain sketchbook into a work of art using acrylic paint.

Don't forget to clean your brushes with soap and water when you're done. You don't want to have to throw your brushes away after your first project!

Chapter 2

Setting Up Supplies: Brushes, Surfaces, and Palettes

In This Chapter

▶ Distinguishing between brush shapes and the marks they make

▶ Checking out popular and alternative painting surfaces

▶ Gathering up some other goodies to get started

Chapter 3 covers the wide world of acrylic paint, but paint's not all you need to get started painting. I'm talking about brushes, painting surfaces, a palette to put the paint on, and a few other items that make you look and feel like an artist. Selecting the right painting paraphernalia is nearly as bewildering as choosing your paint, so in this chapter, I talk about what you will need in the way of brushes, surfaces, palettes, and other supplies so you can make good decisions and ask informed questions when you're at the art store. You may even be lucky enough to have some supplies around the house. Gather them up and start there. If you read about something that you think you want to add to your collection, reward yourself.

Brushing Up on Brushes

Finger painting may have been your first painting method, but it's too messy for acrylic paint; therefore, brushes naturally come in handy when applying your paint to surfaces. Brushes keep your hands out of the paint by using a handle attached to hairs by a metal tube-like covering called a *ferrule*. You dip a brush into the paint to cover about half the hair.

Take care to avoid dipping into paint as high as the ferrule — it's harder to clean. And cleaning is the name of the game when it comes to brushes; after paint dries in the hairs, especially around the ferrule, it ruins the shape of the brush. Finally, be sure to thoroughly dry your cleaned brushes; drops of water clinging to the ferrule can drip onto your painting when you least expect it.

In this section, I discuss the various aspects of a paintbrush, different types of brushes available, and even a few other alternative means of getting paint onto your surface.

Get a handle on it

Brush handles come in two sizes: long and short. You can use either length of handle when painting with acrylics; it's merely a matter of preference. A long handle is a good choice for painters who like to hold the back end of the brush, fully extending their arm and painting from a standing position. A long handle also makes it easier to step back and view the painting from more of a distance. A short handle is easier to paint with while sitting down at a painting lying flat on a table.

You can get two kinds of paintbrush handles: wood or plastic. Wood is the more common material; you can get brushes that have plastic handles, but they're usually lower quality. Wood handles are nice but can disintegrate if you leave them in water. I have favorite brushes in each category. Some handles have a chiseled end opposite the hairs that's good for scraping and drawing in the paint (called *scraffito*). You can scrape with any other tool as well, but having a chisel-ended brush is just so easy when your brush flips over to have a chisel end that does the job. Figure 2-1 shows a range of brush handles.

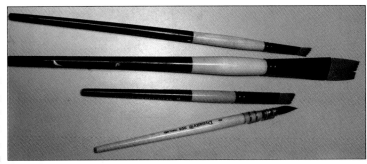

Figure 2-1: A variety of brush handles.

Hair today, gone tomorrow

The non-handle end of the brush — the business end — is obviously the hairs. You may notice two distinct kinds of hairs on brushes: soft and stiff. Stiff bristles are best for manipulating thick paint. They often leave brush stroke marks; think of Vincent Van Gogh's style — those marks were left by stiff brushes. Soft hairs are better for detail and blending because they don't leave such visible stroke marks. Figure 2-2 shows both stiff-bristled and soft-bristled brushes. The stiff brushes have the light-colored hairs.

Both soft and stiff brushes come in natural and synthetic varieties:

✔ **Natural hairs:** Natural brush bristles come from animals — the stiff bristle brushes are made from the bristly hairs of a boar. That's right; you're painting your masterpieces with the coat of a wild pig. The hairs on soft brushes typically come from the sable, a mink-like creature that lives mainly in Russia. Natural brushes can be very expensive but are of exceptional quality.

> ✔ **Synthetic hairs:** Manufacturers have figured out some pretty nifty synthetic knock-offs. The reward for artists is that the price is right and the quality is not compromised. It's a win-win for everyone: You get to keep more of your hard-earned money, and the animals get to keep their hair.

Acrylic paint is pretty hard on brushes. Even if you keep them clean, acrylic has a way of stubbornly attaching to hairs and handles. For this reason I recommend using synthetic brushes rather than the very expensive natural hair brushes. The final painting won't show what price your brushes were.

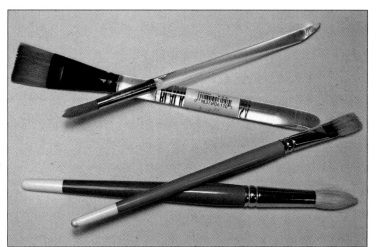

Figure 2-2:
Stiff- and soft-bristled brushes.

Get in shape (shaped brushes, that is)

You'll also notice a vast variety of *shaped* brushes. Every time an artist needs a specific kind of stroke, some manufacturer creates a brush specifically for that stroke — in hopes, naturally, of selling more brushes. Some shaped brushes are quite useful, but more are gimmicky. You do need some basics: For example, *flats* (which have hairs squashed along a row) and *rounds* (which have a full, round arrangement of hairs on the tip) are essential. You may find other shapes that you really like and that save you time while painting. I, for one, must have a *liner brush.* This brush has longer hairs than a normal brush. Not surprisingly, a liner brush makes long, thin lines good for such things as tree branches, grass, and slats in fences.

Figure 2-3 shows several shaped brushes, along with the kinds of paint marks they make.

Size matters

To paint effectively, you need various sizes of brushes. Although different manufacturers and countries use different numbering systems, the width of most flat brushes is measured in inches: ⅛-inch, ¼-inch, ½-inch, ¾-inch, and 1-inch sizes. Big brushes are 2, 3, 4, and even more inches wide. Figure 2-4 shows a few flat brushes.

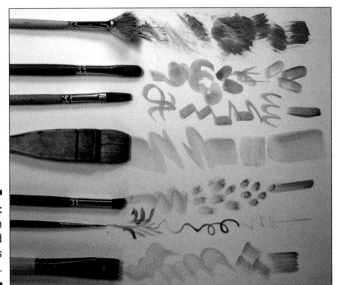

Figure 2-3:
Brush shapes and the marks they make.

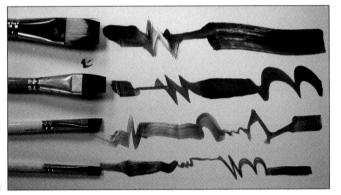

Figure 2-4:
Some sizes of flat brushes and the marks they make.

You definitely need a couple of small flats in different sizes and maybe a big one for large areas. The bigger you paint, the more you need bigger brushes.

Other brushes, such as the round ones, have sizes indicated by number. With round brushes, the smaller the number, the smaller the brush. When they get down to 0 (zero), they get smaller by adding more zeros: 00, 000, and so on. Some miniature brushes go down in size to a single hair.

TIP

Although you can compare the numbers, I've noticed that brush size varies even among shipments of the same brand and size; use your eyes to decide what you want. In choosing a good round brush, look for one that has a nice pointed tip. I often use anywhere from a number 10 to 14; this size may sound big, but the tip tapers to a tiny point. That brush paints fine detail using the tip but paints a large area quickly when pressed harder — a very versatile brush. Figure 2-5 shows some round brushes.

When a project recommends a specific brush size — not just in this book but anywhere else — you can probably fudge a little and use something you already have that's similar. Please don't automatically rush out to buy a new brush unless you determine that you really need it. If a workshop or class issues a supply list, ask whether you must have the *exact* supplies. Many students buy more than they need in hopes that all those brushes will produce better paintings. *Practice* is the way to make better paintings. Wear out the brushes you have and then buy new brushes.

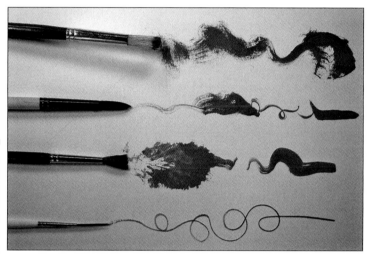

Figure 2-5: Some sizes of round brushes and the marks they make.

Brush substitutes

Brushes aren't the only way to apply paint. A couple of alternatives:

- ✔ A *palette knife* is a miniature trowel you use to apply paint. Scrape into the paint with the knife and slather the paint on the surface like spreading butter on toast. Palette knives are especially handy for mixing because they clean easily — just wipe them off with a paper towel — and therefore waste less paint.

 Knives come in all different shapes. I like ones with a pointy diamond on the end; they make great lines and can get in little places to add detail. You can get cheap plastic knives or fancy wood-handled knives. If you use a palette knife a lot, you probably want one that's nicer and can stand some pressure. Figure 2-6 shows palette knives and the marks they make.

- ✔ *Sponge applicators* are good for painting large areas that need less detail. Sponges come in different shapes; you can pounce on paint and stamp the shape onto the surface, or use a roller to uniformly cover a background. (A 1- or 2-inch wide roller is also great for applying gesso, covered later in this chapter.)

 Figure 2-7 shows several different painting sponges; the bottom sponge is actually a make-up applicator, which *crafters* (decorative painters who paint surfaces like wood, metal, and walls) often use to apply paint. Grab the top of the triangle and load different colors on the bottom of the sponge. (Head to Chapters 5 and 13 for sponge painting activities.)

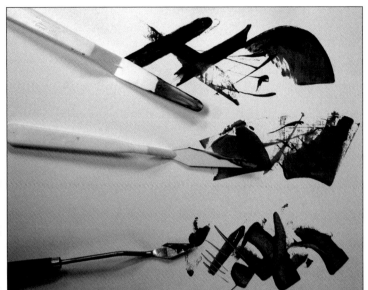

Figure 2-6:
An assortment of palette knives and their marks.

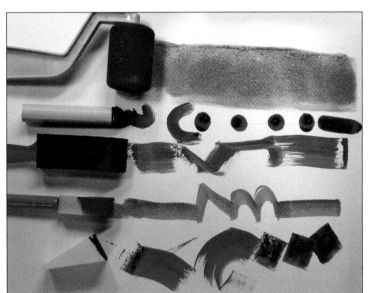

Figure 2-7:
An assortment of sponge applicators and their marks.

Beginning your brush collection with the bare essentials

If you're really on a budget, you can get by with one brush — a pointed round #10 can paint a lot of territory. Ideally, you want to start out with a couple of sizes in each shape of brush. Two sizes give you one brush for small areas and one for quicker coverage of big shapes. I give you some good sizes, but different brands vary, so just be sure you get some variation in sizes. Here's a shopping list of my workhorse favorites:

- ✔ **Rounds with a fine point:** #2, #8, #14
- ✔ **Flats:** ¼ inch, ½ inch, 1 inch, 3 inch
- ✔ **Liner:** #000, #1

After you build up your essential collection, you can treat yourself with some specialty brushes that interest you.

Maintaining Your Brushes

If you treat your brushes with care, they can last for years. I still have the first nice brush that I bought in college some 10, er, 30 years ago. But you have to really take care of them. In this section I dispense tips for getting the longest wear from your brush investment.

Prepping a new brush

Sometimes new brushes are shipped with a stiffener applied to them to protect the hairs until you use them. The stiffener is water soluble, so after you buy the brush and are ready to use it, just dip the hairs in clear water and roll them along on a water-safe surface to work the stiffener out of the hairs.

Always respect the shape of the brush and work to maintain it so that the tip remains pointed or the flat doesn't start fluffing up out of alignment. Never scrub or grind to the extent that the hairs get all out of shape unless you're ready to buy a new brush.

At first some hairs may fall out; don't worry — that's normal. The shedding should stop with prolonged use, though some really cheap brushes may continue to shed. If a hair comes off and gets into the paint, the easiest thing to do is let it dry and then pull it off. You may be tempted to chase the hair around, but remember that the paint goes with it and makes a mess.

After the hairs are wet, lay the brush horizontally to dry. Storing the brush vertically allows water to drip down the ferrule onto the handle, loosening the glue and the handle's finish. After the brush has air dried, you can store it in a number of methods (see "Storing" later in this chapter).

Avoiding damage

Brushes are interesting. When you look at them you may be tempted to touch the hairs. Don't. Remember the old adage "oil and water don't mix": Your hands are oily — even if they don't particularly feel that way to you — and acrylic paint is water-soluble. Transferring hand oil to your brushes changes the way they handle paint. Similarly, try not to use the same brushes for different paint media. I keep my acrylic brushes separate from my oil or watercolor brushes.

A new brush usually comes with some kind of cover or protector on it; some have a clear plastic tube pushed down onto the ferrule and covering the hair. After you buy a brush, throw away the tube. You may be tempted to put it back over the hairs for protection, but doing so often bends a hair or two and damages the brush forever. If this happens, you can try trimming the stray hairs to tame them.

Washing

After using your brushes you should wash, dry, and store them. During painting, be very careful not to let the paint dry on the brush. After acrylic paint dries, it's a permanent plastic capsule for the hairs of your brush — in other words, time for a new brush. Get in the habit of wiping excess paint off onto a paper towel, rinsing the brush in your water container — which you keep beside your palette — and then laying the brush on the table to use again or dry.

At the end of your painting session, take the brushes you used and wash them in running water. Special brush soaps and cleaners are available, but plain old soap (liquid or bar) and water is sufficient to do the job. Roll the brush hairs in the palm of your hand with some liquid soap till the water rinses clear. Respect the shape of the hairs so as to not damage the tip or shape by grinding and smooshing unnecessarily. Or keep a bar of soap for your brushes and paint the bar until the brushes are clean. Make sure to get the paint out of the *heel* (the hairs right next to the ferrule), where it's most obstinate. Lay brushes flat on a paper or cloth towel to dry.

Storing

Brushes are most vulnerable to damage when they're wet. If brushes dry mushed, they stay that way, so if you travel with art supplies (as you may when going to and from a class), you need to protect your wet brushes from getting smashed. Pointed brushes especially need protection if you want to keep that fine pointed tip — after all, that's the reason you bought that brush.

If you like the protection idea, go to a florist and get one of those plastic, rubber-capped test tubes that holds water for a single flower stem; these covers really protect a brush when traveling. Insert the blunt (nonbristle) end of your brush through the inside of the cap so the clear tube fits over the hairs and attaches to the cap near the ferrule. I like this method for my #10 round or a skinny liner brush, but really big handles don't fit, of course.

Figure 2-8 shows a brush with its disposable shipping cover (top) and one protected by a floral tube cover (bottom).

Getting a *brush case* is another way to protect several brushes. Cases are usually zippered so brushes don't fall out. You can also find unzippered *brush holders* that have pockets to insert brushes and keep the hairs straight so they don't get damaged when wet. Some roll up like a bamboo mat and let air circulate to dry hairs. Some fold open and display brushes for choosing. Some are made of fabric, and others are plastic or wooden boxes.

Figure 2-8:
Two
different
brush
covers.

 If you don't have to move the brushes and they can stay in your studio (or on your kitchen table, depending on how fancy your setup is), you can store them — when thoroughly dry — upright in a can or similar container. I put sand in the bottom so the brush stands up straight; this way, you can spread the brushes out and see all the shapes in order to choose one quickly.

Figure 2-9 shows many of the brush storage containers you can find at art supply shops.

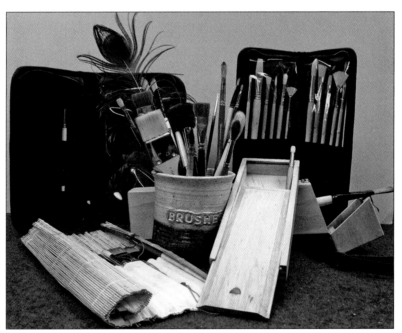

Figure 2-9:
A variety
of brush
storage
containers.

Repairing a worn brush

Try as you may to keep it clean, you still may have a brush go bad. If paint dried in the hairs, you can try soaking them in denatured alcohol and working the paint out with your fingers.

If a brush loses its shape — for example, the point on your round brush doesn't point — dip it in gum arabic (available in the watercolor section of art stores). *Gum arabic* is actually the stiffener used to ship the brushes (and the *binder* — the goo-glue that holds pigment together to make paint — in watercolor); it's

a sticky liquid that dries in the brush's hairs and eventually becomes hard. Before it gets hard, sculpt the hairs back into the shape you want (as shown in Figure 2-10). Let them dry hard and leave them indefinitely to train the brush back into shape. After a month or so, remove the gum arabic as you would with a new brush and see whether it has retained the shape. If not, try again.

Figure 2-10:
Repair a
brush with
gum arabic.

If you can't save your brush, you can take scissors and snip it into a really sparse brush perfect for painting wonderful grasses and hairs on animals.

Knowing when it's time for a new brush

You know you need to replace your brush when

- ✔ The round point on your brush can't make fine line details. Demote it to a scrub brush and buy a new one with a sharp tip.
- ✔ You forget the brush in the water overnight and the bristles have a permanent *L* shape.
- ✔ The brush continues to shed hairs and drive you nuts.

Toss these over-the-hill brushes in a drawer for a recycle project and splurge to get one that does not frustrate you.

Picking and Prepping Common Paint Surfaces

A fancy name for what you paint on is *substrate*. For most painting needs, you want a flat, fine-art surface to paint on — typically paper or canvas. Because acrylic paint uses water, a regular old plain paper substrate buckles when wet. So you need something a bit more rugged to endure all the dampness, not to mention scrubbing.

Acrylic paint sticks to most surfaces, but for those that resist it (such as glass and ceramic), you can get special additives (described in Chapter 3) that make acrylic adhere to glass and ceramic, and even candles and fabric. Some cool projects in Chapter 14 use some of these surfaces.

Most surfaces, however, are absorbent. Think of painting on tissue — the paint would spread uncontrollably into the fibers. In order to make a surface (except for preprimed canvas and canvas paper) ready to accept paint, you have to prime it. In the following sections, I discuss various conventional substrates and give you instructions on priming unprimed painting surfaces.

Canvas paper

Canvas paper comes in a variety of pad sizes, from small (2½ x 3½ inches) to large (16 x 20 inches). It has a specially coated surface, with a linen weave texture that accepts either oil or acrylic paint. Canvas paper is fairly inexpensive and easily framed, so I recommend buying a pad and using it for the projects for this book. (If you want to use something else, go right ahead. Make it your project. Just make sure it's a sturdy, water-resistant surface.) You can use canvas paper without any further preparation. Cut it to the size you want with scissors or a paper cutter. Figure 2-11 shows some pads of canvas paper.

Canvas

Canvas, made from linen (finer texture and more expensive) or cotton (more texture and less expensive), has been used for centuries in oil paintings, and it also works well for acrylic paint. You typically stretch canvas tautly onto *stretcher bars* (strips of wood arranged in a frame) and staple it into place before you paint on it, but you can also just back it with a board, creating a rigid panel to paint on. Some artists like the bounce of stretched canvas, and some prefer a rigid surface. Canvas is normally rectangular or square but can be round or oval shaped; it comes *raw* (unprimed) or *primed* in a variety of finishes, from very smooth portrait canvas to rough textures.

The good news is that prestretched and -primed canvas is available in sizes from 2 x 3 inches to 30 x 40 inches. For the more ambitious, you can buy canvas in rolls about 52 to 72 inches wide x 6 to 100 yards long and stretch it yourself onto frames.

Figure 2-11:
Various
canvas
papers.

I buy prestretched and preprimed canvases — I'd rather be painting than preparing. Some artists enjoy making their own canvases (and even paint), but I think the manufacturers do a great job more efficiently than I do.

Boards

Though canvas is good for folks who like a little give to their painting surface, use board if you want a firmer, more rigid surface. *Boards* can be mat boards, thicker illustration boards, foam boards, or gator boards. They do need to be prepared, which you can do by following the instructions in "Preparing boards and canvases" later in this chapter.

Acid-free mat boards

Mat board is a four-ply paper-type board used in framing and presenting art; it comes in a gazillion color choices, though only one side has color — the other side is usually white. You may be familiar with mat board because of its popularity in framing artwork, but it's great to paint on as well — it has a nice rigid surface that doesn't buckle when you add water or paint. You can paint acrylic paint directly on mat board, prime it and then paint, or coat it with painting grounds or pastes (covered in Chapter 12) to make different textures before painting.

Your art or frame store can sell you big sheets (30 inches x 40 inches or 40 inches x 60 inches) of mat board; frame stores also may give you a deal on all the little pieces they accumulate. Mat boards have a variety of surface textures: linen, smooth, and embossed patterns. Some mat boards are the same color throughout, and some are *color cored* so the back is another color. When the board is cut at a 45-degree angle, the core color shows. Check out a picture of mat board in Figure 2-12.

Figure 2-12:
A variety of surfaces to paint await you.

You can get two types of mat boards: *paper mat* (regular mats treated to be acid neutral) and *acid-free* (100 percent cotton rag content). Older paper mat board often has an acid content in the core that can leach acid to anything it touches, leaving a yellowed surface. Modern paper mats, on the other hand, are buffered neutral by the addition of calcium carbonate, so they don't harm artwork. Acid-free is always a better conservation choice, but costs a little more. You may hear the term *rag content,* which refers to a product's acid-free cotton material; most quality acid-free products have 100 percent cotton rag content. I use only acid-free products and leave the paper mats to posters or temporary signage.

Don't be tempted to use newsprint, masking tape, or cardboard in your artwork, because they turn yellow and brittle with time and exposure. Have you ever left your newspaper in the driveway for a few days only to have it turn yellow and brittle? That's because newsprint is very acidic; so are masking tape and cardboard. Rather than risk ruining your masterpiece, use acid-free alternatives in tape, paper, and boards.

Illustration boards

Illustration boards are similar to mat boards but only come in white. They measure 30 x 40 inch or smaller and can be different thicknesses: *Single thick* is .05 inch thick, and *double thick* measures .085 or .095 inch thick. Illustration boards don't require priming and are available in fine art or drafting supply stores; they come in several different surface finishes:

- ✔ **Hot press** has a smooth surface and is good for detailed paintings such as portraits.

- ✔ **Cold press** is slightly textured (similar to watercolor paper) and works well for landscapes.

- ✔ **Pebble finish** has a regular, bumpy surface; use it whenever you want an interesting textured surface.

Foam boards

Foam boards have white or black paper on the front and back and a foam core ⅛, ³⁄₁₆, or ¼ inch thick. The foam in the center makes them very rigid and lightweight. Watch out — they dent easily.

Gator boards

Gator boards are stronger and more rigid than foam boards and less prone to damage. They're also more expensive. They come in ¼-inch and ½-inch sizes and are much lighter weight than boards made from wood. (Check out "Working with wood surfaces" later in the chapter for information on painting on wooden boards.)

Figure 2-12 shows several kinds of paint surfaces available.

Preparing boards and canvases

Primed painting surfaces come prepared for you, but raw surfaces need a surface preparation (though experimental artists even skip the priming and work with the very absorbent surface, thus staining it. Anything that works goes.)

The most common primer, or *ground,* is gesso. *Gesso* (pronounced *jess*-oh) is a combination of acrylic polymer emulsion, calcium carbonate, and Titanium White (as the coloring agent). It's a liquid ground for preparing a surface to accept paint or *gilding* (applying gold-leaf, as in gold-leaf frames, for example).

Gesso is an Italian term meaning "gypsum;" however acrylic gesso has little relation to gypsum but the name.

Gesso is available in smaller jars or gallon cans. To prepare a surface with gesso, follow these steps:

1. **Use a large flat brush or a sponge roller to apply it to your surface.**

 For smoother surfaces that have little or no texture, you may want to add a little water to the gesso.

2. **Let the gesso layer dry and sand it smooth with fine sandpaper.**

3. **Repeat Steps 1 and 2.**

 If you accidentally sand through the layers, add another layer of gesso and repeat Step 2.

 You can make textured surfaces by using thick gesso (meaning less or no water) and not sanding — leaving the brush stroke patterns visible. You can apply really thick grounds with a spatula or plastic spreader. The pattern you make stays when dried. (Check out Chapter 12 for more on creating textured surfaces).

Gesso comes white, clear, or black. If you like the look of painting on velvet, black gesso is for you. You can also change the color of your gesso by adding acrylic paint.

If this process is all too much labor and mess for you, you can buy preprimed surfaces, but many artists like to prepare their own surfaces to save money, control the surface texture, or just create something unique. With the bargains on supplies offered today, I'm not even sure saving money is a reason to prime for yourself anymore.

Thinking Outside the Canvas: Alternate Acrylic Painting Surfaces

Acrylic is great for many surfaces beyond the typical fine art applications described in the previous section. Because acrylic doesn't have to "breathe" like oil paint (which takes a long time to dry), there is less reason to use canvas with acrylic than with oil. Acrylic works to paint fabric, wood, metal, terra cotta, glass (with some prep), and more. Solid surfaces are less flexible than canvas, therefore preventing the cracking of paint.

Painting on fabrics

Canvas is usually the fabric of choice to paint a flat painting on, but think like a designer and you can paint on any fabric to wear as a garment or use as a decorative item (like a pillow cover). Fluid paints work best for fabric painting because they're more liquid and penetrate the fibers more readily.

For items that you plan to wash, you want to add some *fabric medium* (an additive to help paint penetrate the fibers). Acrylics work on fabric without the fabric medium, but it really helps keep colors from fading and cloth from getting stiff after you wash it. Check the label of your fabric medium for mixing guidelines.

After the fabric painting has completely dried, heat set the paints with an iron or in a hot dryer (see the fabric medium bottle label for exact directions). Then you can launder the fabrics without color fading. Compare this process to projects with fabric dyes, which you need to steam to set the dye.

If you're ready to start painting fabric, you can find a fabric project in Chapter 14.

Working with wood surfaces

Hardwoods such as oak, ash, and maple are better than soft woods (pine), which dent and tend to ooze out more resin. Woods in general contain acids, lignin, and resins that can escape into your paint and change the colors; some wood panels, like particle boards and masonite, are constructed with glues that can also leach out and discolor your work. This situation is known as *support induced discoloration* or SID; to prevent SID, be sure to seal your wood panel before applying any gesso. One product that seals wood panels is Golden's GAC 100, a thin, clear

polymer; simply paint the sealant on, allow to dry, and then paint the panel with gesso. How many coats of gesso you use is up to you; gesso covers up the texture of the wood, so the more coats you use, the smoother the surface is. But one to three coats is usually sufficient to create a nice painting surface.

Taking a shine to metal

Water cans, metal trays, and buckets are a few metal objects you can decorate with paint. If the metal doesn't accept the paint, paint a layer of water-soluble varnish or clear gesso on the metal surface before painting with acrylic paint. A light sanding also may give the unprimed metal enough tooth for paint to adhere.

Scratching the surface of glass

Glass is one of the nonporous surfaces that acrylic can't stick to without help. But with a couple of tricks, glass can become acrylic's substrate too.

One method is to buy acrylic paints made specifically for glass. In the craft section of your supply store, look for acrylic enamels for painting on glass, tile, and ceramic. Follow the label instructions for whatever product you buy, but generally speaking, you paint the surface, let it dry for 7 to 21 days, and bake for one hour at 350 degrees Fahrenheit in your home oven. One brand suggests *top coating* (crafter talk for varnish, explained more in Chapter 4) with clear glass or satin glaze. If you're using Plaid FolkArt Enamels, the painting should be dishwasher safe on the top rack.

If you don't want to buy a bunch of special paints, here are a couple of tricks to use your regular acrylics on glass that can hang in a window (just don't eat off it):

- ✓ **Paint the glass with water-based varnish first to provide some tooth for the paint to hold on.**
- ✓ **Use a *glass etching cream*.** Etching makes the glass look frosted and gives it enough tooth to hold on to the acrylic paint. Paint the area you want to cover with glass etching cream, let it sit for the time recommended on the label, rinse, and then paint the etched area. You can buy the cream at your art or craft supply store.

Plastic

You can improve cheap plastic items with a painted facelift. For big areas and backgrounds, you can get an aerosol spray formulated just for adhering to plastic.

Both acrylic paint and plastic are polymer based, so they should stick together. If regular paint doesn't stick, try first spraying the surface with *matte fixative* (a protective spray for preventing smeared drawings). This trick works well to give a slick surface enough tooth for the paint to grab.

Terra cotta

Paint some cute outdoor planters with flowers, insects, stripes, or whatever you want. You can try using your regular acrylics if you first clean, dry, and seal the item with gesso or primer. Then paint the terra cotta, dry, and seal the item with a water-based varnish. You can also get yet another special line of paints in the craft store for outdoor items like cement and terra cotta, called Patio Paint.

Walls

Most walls are painted with acrylic latex paint, but you can paint them with acrylic too. Make sure the wall is clean so that it accepts acrylic paints. Wash walls with soap and water to remove dirt and grease — even fingerprints leave grease spots. You can see examples of murals I've painted in acrylic, plus get more guidance on painting your own, in Chapter 12.

Purchasing Palettes and Other Handy Stuff

Like any pastime, acrylic painting has its share of miscellaneous basic accessories (like palettes and water containers). And like any pastime, acrylic painting offers souped-up versions of these supplements to help you take your hobby up a notch. The following sections detail some of the equipment you need and its cool variations, plus a few other supplies to help keep everything clean and tidy.

Palettes

A *palette* is a mixing area to prepare your paints. It can be as simple as a paper plate; when the plate gets too gunked up with paint, let it dry and then toss it and replace it with a new one. If you're looking for something sturdier, you can purchase several types of palettes. Some palettes — the classic ones from film and TV depictions of artists at work — have a hole in them so you can grip the palette in your nondominant hand. These palettes come in a variety of shapes and sizes, mostly ovals and rectangles. Other palettes have no hole and sit on a table beside your painting area. Most palettes are white in order to judge color accuracy, but some are clear or wood colored. Some palettes have little wells to contain puddles of paint.

Disposable palettes

These palettes come in pads and are similar to waxed paper. The slick surface doesn't let water permeate, so you don't have to worry about paint soaking in. Like the paper plate, simply tear off the top sheet when it's gunked up to reveal a fresh one.

Stay-wet palettes

The stay-wet palette is a box with a thin sponge on the bottom and an airtight sealing lid. The sponge is covered with a special heavy, disposable, reusable paper; dampen both the sponge and the paper and place acrylic paint on the paper. The sponge keeps the paints wet while working, and the lid (if sealed) keeps paint from drying for about a week. I use a large stay-wet palette (about 18 x 24 inches) for big projects and a half-size one (9 x 12 inches) for smaller projects. Another, similar kind of palette has little plastic containers with lids for larger mixes of paint. The containers are like fast-food condiment containers and are replaceable.

Nonporous palettes

Glass, high-density plastic, and acrylic plastic palettes are also available. Because acrylic paint doesn't stick to nonporous surfaces, you can just peel dried paint off of these palettes. Not all plastic is high density, though — check palette labels to make sure the palette is good for acrylics.

Most white plastic palettes in the art store are for watercolor, not acrylic. Acrylic sticks to these materials and doesn't clean off.

Other useful supplies

Paint is messy, and these items help you control that mess to some extent.

- **Water container:** You need clean water to rinse brushes, and you need some sort of receptacle to hold that water. Any can (even an old coffee or soup can) works — just be sure to thoroughly wash anything that previously held food before using. You can also use an everyday cup or bowl (just don't plan to eat from it again).

 Many commercial water containers are available in art stores. They come in various shapes and feature a multitude of accessories: brush holders, cleaning ridges, foldability (for storage), inflatable walls (for lightweight travel), and even a toilet-like flusher (for replenishing fresh, clean water). Of course, these containers come in a variety of colors to entice artists to choose their favorite.

- **Spray bottle:** Misting the paint on your palette periodically with clean water from a spray bottle allows you to paint for hours — just keep those paints on the palette hydrated! On a very hot, dry day you'll need to spray more often. Just remember, once the paint is on the palette, evaporation begins and you must keep the paint moist to keep it workable.

- **Paper towels or newspaper:** Use some cheap paper towels or newspaper (after you've read it, of course) to wipe the excess paint off brushes before you rinse them clean. This step helps you avoid running too much paint down the drain and contaminating the groundwater. If you feel wasteful using paper towels, you can substitute cloth rags. Make sure the paper towels are dry before you dispose of them, so wet paint doesn't get into landfills. You can even save your paint-crusted paper towels and use them for the collage projects in Chapter 13.

- **Apron:** Save your clothes by wearing a protective apron; acrylic paint has a way of landing where you may not want it. You probably don't want to wear your best white cashmere sweater while you paint either.

Chapter 3

All About Paints and Mediums

In This Chapter

▶ Choosing among the wide varieties of acrylic paints

▶ Changing paint properties with additives, mediums, gels, and thinners

When you go into a well-stocked art supply store, the dazzling array of choices in acrylic paints can make your head spin. You can find a good choice for just about any application you can think of. On the other hand, if you simply want a reliable paint that works on just about any surface, that, too, is definitely available.

In this chapter, I run through some of the different properties and varieties of acrylic paints and mediums (which you can add to the paint to make it do what you want). The following sections give you information on what each product is designed for and what to look for when choosing one for your particular purposes.

Getting to Know the Different Properties of Acrylic Paints

As you're paint-shopping, you'll probably notice an enormous price range among acrylic paints. You can buy a whole set of inexpensive paints for the same price as a single tube of another, higher-grade kind. You may also wonder how in the world a gallon of house paint can cost the same as a tiny tube of artist's paint. Art paint costs more than house paint because it contains far higher quality pigment, is ground finer, has no unnecessary filler in it, and is formulated not to fade.

You'll also notice, though, that prices and other factors differ even among art paints. In this section, I walk you through various paint properties that can affect paint prices. The primary reason is that art paint's pricing corresponds with the pigment content. Other pricing factors include brands, the amount of refinement, rarity, and purity.

Pigments and binders

Pigment is a powdered coloring material held together by a *binder;* together, pigment and binder make paint — you can't paint with pigment alone. Pigment can be animal, vegetable, or mineral in origin. For example, traditional earth

colors like brown and ochre (pronounced *oh*-ker) pigments are extracted from rocks and minerals. I have even collected special rocks and ground them into a powdered pigment. Newer pigments, developed within the last 50 to 60 years, are synthetically reproduced in labs. These newer pigments, like Quinacridone Red, are more transparent and brilliant than traditional pigments. You can purchase most pigments, both sythethic and traditional, in art supply stores.

Binder is the liquid that (surprise!) binds the powdered pigment into a paintable consistency. Oil paint uses oil as a binder, and watercolor uses a sticky liquid called *gum arabic.* (Thought it would be water, huh?) Acrylic paint uses polymer emulsions as binders. *Polymer* is a plastic, and *emulsion* is a liquid slurrylike mix. Manufacturers sometimes use fillers like extra binder to make more paint with less pigment. Higher quality paints have no filler.

Pigment is pricey stuff, so the more pigment in the paint, the more expensive it is. You can find two main grades of paint:

- **Student-grade paint** is less expensive because it has less pigment, coarser grinding, and more filler.

- **Professional-grade paint** is more expensive because it has more pigment, finer grinding, and less filler.

When first starting to paint, you may be tempted to buy cheap materials because you're just practicing. If possible, however, you should buy the best grade of materials that you can afford. Besides getting better results, you may turn out a masterpiece after all (isn't that the idea?), and it would be a shame to have it fade. Check out "Different Types of Acrylic Paint" later in this chapter for more on paint grades. Go ahead and start with student grade, but treat yourself to a tube of professional grade when you need a reward. Then replace your student-grade paints with higher quality when you can.

Viscosity

Viscosity is the thickness of a liquid. Water is very thin and therefore has low viscosity. Acrylic paint is available in three viscosities:

- **Fluid or soft body acrylics** come in a bottle. They have a low viscosity (typically ten times thinner than heavy body paint) and a creamy consistency. (Chapter 10 explores the watercolor-like performance of fluid acrylic paints.)

- **Heavy-bodied acrylics** come in a jar or tube. These acrylics were originally formulated to have the same feel as oil paints. The paints in jars have such a high viscosity that you need to scoop them out with a palette knife (check out Chapter 2 for more on palette knives and other tools). In fact, the paint is so thick that it can hold a peak and can be used to paint in an impasto style. (No, that's not an Italian dish. *Impasto* is thick, three-dimensional paint.) Figure 3-1 shows an example of an impasto painting done with heavy-bodied acrylic paint.

Figure 3-1:
Impasto style created with heavy-bodied acrylic paint.

Finish

Acrylic paint has one of two finishes when it dries: *glossy* (shiny) or *matte* (dull). In general, acrylic paint looks glossy when it dries. You may notice subtle differences in transparency or opacity due to the type of pigment (mineral or modern/lab-produced) used to make the color. Because some artists prefer more of a matte look to their paint, some of the larger manufacturers now offer matte lines of their colors. These acrylics have a matting agent added (silica) to reduce the glossy finish of standard acrylics.

You can also alter the final look of a painting with a finish spray varnish or a final coat of medium in a surface choice of matte, semi-gloss, or gloss.

Drying time

Acrylic paint dries quickly. For that reason, be sure to replace screw tops on the tubes and lids on paint jars after you've put your paint out on your palette. You can control how fast paint dries in four ways:

- **Thickness of paint:** Thicker paint takes longer to dry.
- **Humidity:** Paint dries more slowly in humid conditions.
- **Temperature:** A hot environment dries paint more rapidly than a cool one.
- **Air flow:** Moving air evaporates paint more quickly. A blow-dryer really speeds up drying time.

Sometimes the paint dries before you want it to, but you can use some tricks to slow the drying time. Try applying the additives described in the next section of this chapter. You can also mist the paint on your palette with water from a spray bottle and mist the air to make it more humid. On a larger scale, you can run a humidifier in the room where you're painting.

Recently, a few of the more innovative paint companies have developed new, slower drying acrylics. This new type of acrylic paint stays wet up to ten times longer than traditional acrylics. If you want more time to blend paints, you may consider using these longer-drying paints. Look for "slow-drying" or "longer open time" on the label.

A dark *color shift* may occur when your paint dries — that is, the painted area may look darker when it dries than it did when you applied it wet, especially if you use dark colors. Why? The binder in paint is slightly milky when wet, so paint is essentially tinted slightly white when wet. (A *tint* is any color with white added. More on colors and tints in Chapter 7.) However, the milkiness disappears as the paint dries, and thus the end result appears darker. If you think this color shift will detract from your desired end product, you may want to slightly lighten the colors you're painting with a bit of white paint to compensate.

Lightfastness or fading

All acrylic paints are rated for *lightfastness,* or how much they fade over time. A paint that fades is known as *fugitive* — in other words, it'll disappear on you. Most tubes of paint feature a code rating the paint's lightfastness from I to IV. Paints rated I are the best — they don't fade at all. Paints rated IV are fugitive. If you want your paintings to be around for a while, choose acrylic paint rated I or II.

Compatibility

Artists like to mix and match their paints (sometimes just because they're cleaning out their closets), but be forewarned that you can't just throw all of your paints onto a canvas and automatically expect a great result. All acrylic paints and mediums are workable together. In addition, you can use some other kinds of paints over dried acrylic paint. For example, you can use acrylic underneath an oil painting. Many artists paint a quick-drying acrylic *under painting* (a layer that blocks in colors without details) and then paint slow-to-dry oil paint on top of it.

Don't try to mix acrylic and oil paints (as you know, oil and water don't mix). And don't apply acrylics over oils. Oil paints emit some gases that you don't want to trap underneath.

You can paint acrylic over watercolor, but you probably shouldn't bother painting watercolor over acrylic. However, you can draw *pastels* (pigment in stick form — either as chalk or oil pastel) over thin acrylic under paintings. Most stretched canvases are preprimed with acrylic *gesso* (pronounced *jess-oh*), and they're suitable surfaces for oil and acrylic paintings (more on surfaces to paint on in Chapter 2).

Stick to acrylic products all the way through and you'll be safe for sure.

Sometimes you may leave a painting for a long time and want to paint on it again years later. Go ahead! Dust it off first, because dust isn't a good adhesive surface. If you varnished it, check the label of your varnish; if the varnish was *workable,* you can add more paint on top. Otherwise, you may need to remove it. Head to Chapter 4 for more varnish details.

Hues

Manufacturers are always looking out for artists' needs. Isn't that nice of them? Because certain pigments are so costly (cadmiums for instance) and other pigments are toxic (such as lead-based paints — like a true Naples Yellow — that have been found to be neural toxins), paintmakers have introduced some synthetic choices called hues. (***Note***: Don't confuse these hues with those covered in Chapter 7 — this is a different use of the word). In this case, a *hue* is a copy of a more expensive or dangerous pigment. The paint may be called something like Cadmium Orange Hue or Naples Yellow Hue, and it looks just like the color it's replacing.

Different Types of Acrylic Paint

As I mention at the beginning of the chapter, acrylic paint comes in a wide variety of types, consistencies, and qualities. The following sections break down the more common kinds you're likely to find in the art supply shop.

Artist-grade or professional acrylics

Artist acrylic is another name for professional-grade paints. Usually, artist-quality paint contains more pigment and less filler than student grades and is, of course, more expensive because of that. If you can afford it, this is the kind of paint you want to buy.

Student grade acrylics

Student-grade paint is less expensive. It's an okay place to start, but if you're serious about painting and want your paintings to last, use the best grade of paint you can afford. You get what you pay for: lightfast, pigment-rich paint.

Acrylic gouaches

Gouache (pronounced gwash) is actually a matte watercolor, but you can get acrylic products with added matting agents that offer the same effect. The difference between acrylic and watercolor is that acrylic paints dry

permanently (versus watercolors, which you can reanimate with water). Acrylic gouaches are popular choices when painting craft, decorative projects and folk art. For more of these types of projects check out Chapter 14.

Craft acrylics

Craft acrylics are the paints that come in little bottles with pop-up tops. Though craft acrylics are usually inexpensive, Plaid brand says its gold-topped Americana bottles are the same professional quality grade pigments as professional quality tubes. I use craft acrylic paint for decorative painting and murals (head to Chapter 14 for more on decorative painting). The paint is a creamy consistency, so it paints a smooth surface (not transparent but not three-dimensional). It can drip and run, so use caution when painting a wall or vertical surface.

Specialty acrylic paints

Specialty acrylic paints allow you to create unique effects. These paints can add a bit of fun to a fantasy painting, a shine to a butterfly wing, and some POP to whatever else you can think of adding them to; they're available in both inexpensive craft bottles and professional grade. The following sections give you the lowdown on various kinds of specialty paints.

Iridescents

Iridescent paints, shown in Figure 3-2, look like the colors of various metals, typically gold, silver, copper, and aluminum. In addition, you may also find a pearl iridescent paint. They can add sheen and shine to an otherwise flat surface; they don't fade, and they get even sparklier with gloss varnish as a final coat (more on varnish in Chapter 4). Plus, you can mix iridescents with other acrylics to add a little sheen and sparkle to nonmetallic colors.

Figure 3-2: Iridescent paint.

Interference paints

An *interference color* is a color that shifts depending on how the light strikes it. *Interference* is a phenomenon in nature where light waves are reflected and refracted at the same time — in other words, interfered with! Think about the rainbow effects you see in parking lot puddles. Or you may have noticed the paint jobs on those nifty cars that are one color when they drive toward you and another color after they've passed. This effect is the interference property at work.

Interference paints look even more dramatic when painted on a dark surface —
they're very transparent, meaning they're affected by what is beneath.
They're especially useful in painting fantasy scenes or nature scenes like but-
terflies and the heads of mallard ducks. Check out Figure 3-3 for some
swatches of interference colors; notice how the colors change when painted
over black and white.

Figure 3-3:
Interference
paint.

Fluorescents and glow-in-the-dark paints

Remember the '60s? (If you do, you weren't there, right?) Even if you don't,
you can make your own memories. *Fluorescent* colors are eye-poppingly
bright colors that glow under a black light (see Figure 3-4). You can also
get glow-in-the-dark acrylic paints, but unfortunately (or fortunately,
depending on your aesthetic values) they aren't permanent and both do
fade with time.

The fluorescent colors and glow-in-the-dark paint are great for Halloween
scenes, signage, and anywhere you want to grab some attention. You're not
restricted to canvas, either; consider them for your Halloween costumes and
haunted houses as well.

Figure 3-4:
Fluorescent
paint.

Glitter paints

Need even more sparkle (who doesn't)? You can find paint containing big and
little mica chunks in a number of colors. Figure 3-5 shows just how sparkly
the glitter paint can get.

Figure 3-5:
Glitter paint.

Acrylic enamels

Acrylics stick to just about anything including metals, plexiglass, and wood, but they don't stick to glass or glaze-fired ceramics. *Acrylic enamels,* however, are made to adhere to glass and ceramics. You can use them to paint your own set of stemware, for example. The glassware in Figure 3-6 was painted with acrylic enamel.

Some of these paints require long drying times (up to 21 days) or that you bake them in the oven to cure them. Read the paint labels for specific instructions.

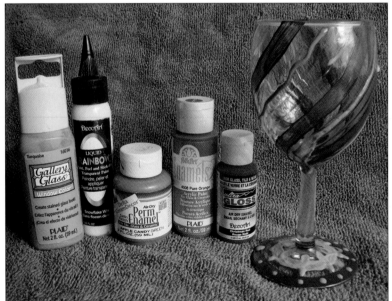

Figure 3-6:
Glassware painted with acrylic enamel.

Additives, Mediums, Gels, and Pastes

You can change the qualities of a paint by putting stuff in it. This stuff you add is either an additive or a medium, gel medium, or paste.

Additives (like retarder and acrylic glazing liquid) allow the paint to move or dry in a different way. *Mediums* (which are pourable), *gel mediums* (which are thicker), and *pastes* (which are really thick and usually contain texture

additives) change the paint's consistency to be either thinner or thicker and are basically like colorless paint. In general, mediums are thin enough to be pourable, and gel mediums and pastes aren't. Though water isn't technically an additive or medium, you can use it to thin acrylic paint as well; however, using mediums or gels gives better results (more on that later in this section).

The thicker the paint, medium, gel, or paste, the more time it takes to dry. Be prepared to apply thick stuff and let it dry overnight before painting on top.

Acrylic medium

You use *medium* to change the viscosity (thickness) of the paint to make it flow or run more easily. Medium makes paint more liquid and transparent so that it requires fewer brush strokes to cover an area. Unlike water, medium has the same molecular structure as paint, so it doesn't weaken the paint as it thins it (see the next section for more on thinning with water). When you add clear medium or gel, the paint becomes easier to see through. Think of medium as colorless paint. When first added to wet paint, medium looks a little milky, but it turns clear when it dries.

Never confuse medium with *paint thinner*. Paint thinner is meant for oil-based paint.

In this book, *medium* refers to the basic binder used in acrylic painting, which is polymer (acrylic) medium. However, the word *medium* is a widely used term and also indicates the choice of art material an artist uses — as in, "What medium do you use?" "My medium is acrylics" (or oil, or charcoal — whatever you use to create your works).

Medium comes in different viscosities. Generally, if an acrylic product is just called a *medium,* that means it's pourable, on the runny side. Medium typically comes in bottles or jars; gel and paste come in jars because they're thicker and need to be scooped out with a palette knife. Figure 3-7 shows many different sizes of medium containers.

Water

Always have a little bucket of water nearby when you paint. Clean your brushes in it by swirling them in the water and laying them flat to dry. You can also add water to acrylics to thin the paint. Some art purists think that distilled water is better than tap water to paint with, but where I live the water straight out of the tap is great.

Water makes paint run — a lot. If you use a lot of water rather than medium, paint with your painting lying flat on a table (instead of propped up on an easel) to avoid unexpected drips (although you may like the drips — they can be cool). But if you're using just enough water to loosen the paint, easel painting is no problem.

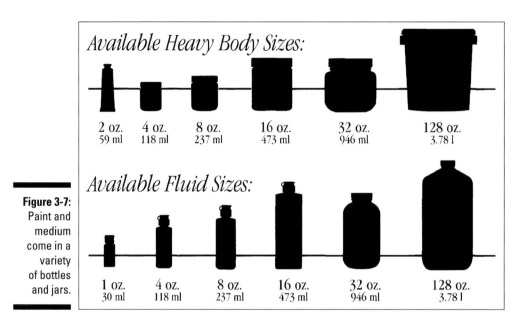

Available Heavy Body Sizes:

| 2 oz. | 4 oz. | 8 oz. | 16 oz. | 32 oz. | 128 oz. |
| 59 ml | 118 ml | 237 ml | 473 ml | 946 ml | 3.78 l |

Available Fluid Sizes:

| 1 oz. | 4 oz. | 8 oz. | 16 oz. | 32 oz. | 128 oz. |
| 30 ml | 118 ml | 237 ml | 473 ml | 946 ml | 3.78 l |

Figure 3-7:
Paint and medium come in a variety of bottles and jars.

According to the manufacturers, you can thin acrylic paints with either water or acrylic medium. Just remember that your final mixture shouldn't include more water than paint. Why? If you use more than 50 percent water in your paint (and that's a lot of water), you're upsetting the molecular structure and weakening the paint's bond; paint that weak may not properly adhere to the painting surface, and you may end up with blotchy or uneven color.

Acrylic medium is a better choice than water if you're greatly altering the consistency of the paint, like really thinning it for a wash-like effect. But for most applications, water is the easiest product to use.

Flow enhancers

Having trouble blending? Add a little flow enhancer or blending medium. It has a similar effect as water but also provides a slickness. Flow enhancer has a lower viscosity than most mediums. See what the addition of flow enhancer does for paint in Figure 3-8.

Figure 3-8:
Flow enhancer really lets color move.

Retarders

Acrylic paint dries fast — sometimes too fast. If you need a bit more time to blend your paint, check out the special products made to slow the drying times: retarder and acrylic glazing liquid.

Be careful when using retarders. Don't use more than 20 percent retarder to 80 percent paint, or the paint stays tacky for weeks, maybe longer!

You can use acrylic glazing liquid in any proportion, and it dries completely, usually within hours. Drying times vary depending on the air temperature and humidity where you're painting. You can also use it as a glaze (discussed in the next section).

Glaze

A *glaze* is a transparent layer of colored paint that you can use over an area when you don't want to lose the color underneath. Mix a glaze by adding acrylic glazing liquid or medium to acrylic paint to make it more transparent. For example, you can paint dark glaze over the ground in a painting to make a shadow, and the ground color still shows through the glaze. You can even buy premixed products called *acrylic glazes*. Premixed glazes may save you time if you find the color you like. If premixed glazes don't have the exact color you want, you can make any color you need by mixing your own glaze. (Head to Chapter 4 for more on glazing techniques.)

Gel mediums and paste

Gel medium, usually just referred to as gel, is thicker than acrylic medium (not pourable) and may have things added to give texture, such as glass beads or pumice.

You can use gel medium in three different ways:

- ✔ **As a paint additive to change viscosity:** For a very thick look, add extra heavy gel to the paint to get a really thick texture. Add soft gel to loosen up the paint for smoother brush strokes.

- ✔ **As a money saver:** You can *extend* paint by adding any clear gel or medium to a quantity of paint to increase the amount of paint. Paint (pigment) is more expensive than clear gel, so extending is a good way to stretch your painting dollar.

- ✔ **As a *ground* (primer) to paint over:** Some gels have an interesting texture and provide good painting surfaces. For instance, fine pumice gel spread (or brushed) on a painting surface dries to a gritty surface similar to sandpaper.

The following sections describe more about gel mediums as well as pastes.

Gels that add texture

Some gel mediums have actual grains and clumps of stuff in them. Sure, you can make your own textures by adhering your own objects with plain medium, but the commercial products are tested and won't break down, disintegrate, or get old prematurely. A few of the textured mediums available include fibers, sand, glass beads, flakes, and pumice. You can apply these products as a ground and then paint over them, or add paint to make colored mixtures. They can be very experimental or help add texture to a realistic painting. (More on experimental painting in Chapter 12.)

Gels that add thickness

Some gels are formulated to be very thick and heavy, as well as clear, flexible, and non-yellowing. When mixed with colored paint, a heavy gel medium changes the viscosity to make the paint stand up and get noticed.

You can use these heavy gels to really enhance a painting. Instead of painting a shadow, add a little thick gel and the paint casts an actual shadow. Refer to the painting in Figure 3-1 for an example of thick paint used on the closest flower petals. Because the flowers in the front are three-dimensional, they catch light for a real highlight and cast a real shadow.

Pastes

The thickest goo yet, pastes are formulated with different additives for a variety of effects. In general, pastes are heavier than the gel mediums and aren't clear (because of their additives). Some examples are Fiber Paste, Molding Paste, and Crackle Paste. You can sculpt Hard Molding Paste into shape, and it dries to a very hard finish, at which point you can carve, sand, and paint it. Like gel, you can either apply it first, let it dry, and paint on the surface or mix paint color to it and apply it.

Gel and paste examples are shown in Figure 3-9.

Figure 3-9:
Gloss, matte gel, pumice, and paste are examples of acrylic additives.

Specialty mediums and finishes

You can also find special mediums that aid in making paint adhere to different surfaces. In art supply shops and craft stores, you see mediums that enable you to paint fabric, glass, candles, metal, stones and rocks, and even soap. Put a drop or two of one of these mediums in acrylic paint, and the paint sticks to things that normally are too slick or nonabsorbent to paint on. Specialty mediums allow you to paint even waxy, glass, and washable items. (More on these cool items in Chapter 14.)

Part II
Exploring Tricks and Techniques

The 5th Wave By Rich Tennant

"I love the splatter effect you got with the green. What brush did you use?"

In this part . . .

These chapters show you how to properly set up your painting area and give you basic (and not-so-basic) techniques for painting. I also explain how to draw a thumbnail sketch and transfer that drawing onto your painting surface. Then you can also try the projects to put it all in motion.

Chapter 4

Basic Painting and Finishing Techniques

In This Chapter

▶ Setting up your area for painting

▶ Brushing up on brush grips and brush strokes

▶ Treasuring some tried and true techniques

▶ Navigating the presentation options

▶ Creating your artist trading card

*T*his chapter helps you get your painting area set up, including your palette and brushes, and then dives into introducing general techniques of painting. I walk you through arranging paint on your palette and then cover the basic brush strokes that will serve as the foundation for your own evolving, personal technique. I touch on the foundations of the painting process and cover cleanup. And what do you do with your finished masterpiece? Why, you present it as attractively as possible, which is why I discuss varnishing, framing, and matting. Finally, I show you how to create your own artist trading card, which will allow you to participate in a growing phenomenon in the art world.

Setting Up Your Palette and Supplies

Because acrylics dry so quickly, you have to set up your palette anew each time you paint. (Chapter 2 describes the different types of palettes available, and Chapter 3 talks about the paints that go on them.)

Set up the palette in a position that lets you paint comfortably without risk to your painting. In addition to your palette, you also need the following items:

✔ Container of water for cleaning your brushes and thinning your paint

✔ Cellulose sponge to blot excess liquid off your brush

✔ Spray bottle to keep your paints from drying out as you're working

You don't have to be fancy. The items can be as simple as a paper plate for a palette, a clean tin can full of water, and a cellulose sponge. On the other hand, upgraded versions are surely available at your art supply store.

Put these items together on the side of your dominant hand (Figure 4-1). That way you don't have to reach across the painting for any of them, meaning you won't drip anything on your painting.

Figure 4-1:
Proper palette placement for a right-handed painter.

You may work with a limited palette, and in that case you don't need to put out every color you own. Your personality will govern your palette; some artists like to put out the colors they use in a certain order, some use a color wheel (discussed in Chapter 7), and some arrange colors according to value (from light to dark, for example). Some have a messy palette that has no order at all.

If you need a fuller spectrum of colors, I recommend the color wheel method. By placing colors in a circle around the perimeter of the palette in the order they occur naturally in the light spectrum, you make it easy to create good mixtures. You also put white and black paint on your palette; you'll probably need more white than other colors — it just seems to disappear quickly. If your painting is light in value, place white in the center of the circle of colors. I suggest mixing a color bridge from the white to each color on the circle. The bridge creates a slow gradation of white to each pure color, giving you a number of color choices, like spokes on a bike wheel.

Here's how to make such a color wheel on your palette. Don't worry if your palette gets a bit unorganized — just do your best to make the colors you need.

1. **Use a palette knife to scoop dime-sized blobs of each color you need on your palette, wiping the knife with a paper towel between colors.**

 In Figure 4-2, I'm using the three colors Yellow Ochre, Phthalo Blue, and Burnt Sienna. In the center I put some white and black.

 The paints I use here are a muted set of primaries. For a bright set of primaries that produces clean secondary colors, use Hansa Yellow, Phthalo Blue, and Quinacridone Red.

2. **To create lighter or darker versions of each color, make color bridges between the colors and white or black.**

Mix white with each color by using the palette knife to slide a bit of white toward the color to be lightened. Then slide the color toward the white. Mix the two like you're buttering toast until you like the subtle transition of light to pure color. For darker transitions, repeat the process by using black rather than white.

You may also want to bridge between Burnt Sienna and Phthalo Blue to make a dark brown.

Figure 4-2:
Color bridges for more color choices.

3. **Add more paint wherever needed.**

 You may use up all your color in a mix. Just get the tube of paint out and add another bit of paint to the missing area. Add small amounts as needed because you can always add more later. Here I had to add more white.

If you take time to make a palette like this, use a stay-wet palette (discussed later in this chapter and also in Chapter 2) and keep the colors misted by spraying with clear water from your spray bottle so they don't dry out too quickly. If drying is an issue, here are a few other things you can try:

✔ Use slow-drying acrylics, which take 24 hours to dry. See Chapter 3 for more on choosing paints.

✔ Limit how many colors you put out at one time, using only the color(s) that you can get onto your painting before it dries.

✔ Add a retarder to slow down the drying time. See Chapter 3 for more on retarders.

Getting a Grip on Your Brushes: Practicing Various Brush Strokes

The mark your brush leaves is called a *brush stroke*. Brush stokes can be evident or completely hidden. For example, the Impressionists of the 19th century

allowed their brush strokes to show, using bits of unblended colors to simulate light effects. Rembrandt, on the other hand, completely blended his strokes so that very little brushwork shows. Though the consistency and chemical makeup of your paint may affect whether your strokes show, brush technique is the main factor.

Holding your brush in different ways can achieve a variety of effects. I rarely hold the brush like a pencil, although that position can allow you to make detailed marks. Often I hold the brush more toward the back of the handle for a freer stroke — like a conductor directing a symphony. Sometimes I hold the bush nearly parallel to the surface and skim the painting to add texture. Experiment with different ways to see what feels correct for you. Figure 4-3a shows holding the brush parallel to the surface to scumble rough texture by lightly grazing the edge against the surface. (See "Scumbling" later in this chapter for more on this stroke.) Figure 4-3b demonstrates holding the brush near the end to place dots and lines more loosely. This technique also lets you stand away from the painting to get a more inclusive view. Figure 4-3c shows a pencil-style grip for adding detail in a controlled manner.

Figure 4-3:
Holding brushes in different ways yields different results.

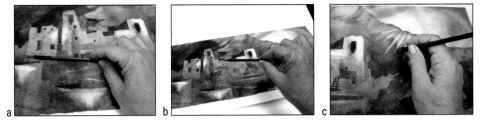

a b c

In this section I discuss some brush stroke techniques.

Crisscrossing

A *crisscross* is exactly what you think it is: an *X* shape. Applying paint using this method is efficient and distributes the paint in *X* patterns. I use this method to cover an area quickly. A big shape like the sky is a good place to quickly lay in crisscross brush strokes (like in Figure 4-12 later in this chapter). You can leave it that way or blend it (described next) with a soft brush.

To make a crisscross stroke, use a flat brush and follow these steps:

1. **Make an *X* shape by starting at the top right-hand arm of the *X* and pulling the flat part of the brush down toward you, making the widest stroke possible as you move down to the bottom.**

2. **Turn your hand over so the palm is toward you and the brush is flipped over and pull another slash to finish the *X*, again starting at the top and painting down (Figure 4-4a).**

 Imagine describing a melody with this lilting hand movement. Make a whole row of imaginary crisscrosses to get the feeling.

Continue making the *X* shapes till you fill the area (check out Figure 4-4b). If you want a smooth transition, take a dry flat brush and sweep from side to side to get the blended effect in Figure 4-4c. This is similar to the blending technique in Chapter 5.

Figure 4-4: Crisscross marks quickly distribute paint for easy blending with a soft brush.

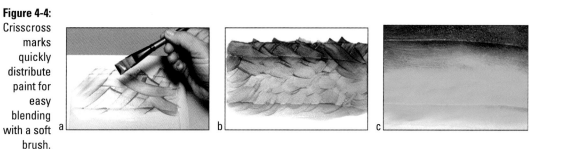

Scumbling

Scumbling is what it sounds like: random, stumbling movement. To get this effect, simply push the brush in different directions, letting the paint touch the surface randomly. Roll the brush as you go. This rambling, haphazard application is good for producing texture in roads, grassy areas, mountains, tree foliage, or wherever you want some texture with loose detail.

Point your hand in different directions when holding the brush so the paint goes on in a variety of angles. Figure 4-5 illustrates scumbling.

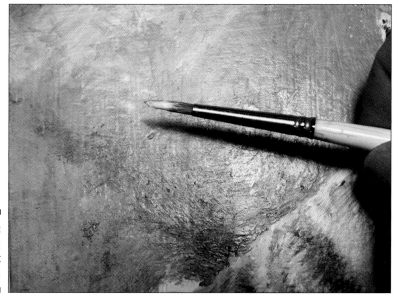

Figure 4-5: Scumbling paint technique.

Stippling

Stippling is pouncing the brush up and down, leaving little dot patterns (see Figure 4-6). Some stippling can appear very uniform, with perfect circles for dots (look at aboriginal tribal art or George Seurat's *Sunday in the Park*); other stippling can be much more random like bouncing colors in a meadow for wildflowers. You can make whole pictures by stippling light to dark patterns. Even just a few dots make your subject sparkle. Sparkling light on the water, polka dots on a dress, fur, grassy texture — you may find many subjects that benefit from stippling.

Apply the paint to the surface with a gentle pounce. Round handle brushes and tips work best. You can also use the handle end of your brush to make the little perfect dots, keeping the brush vertical and dipping the end opposite the hairs into the paint.

Figure 4-6:
Stippling
leaves small
dots of
paint.

Dry brushing

The "dry" in "dry brushing" is a relative term. *Dry brushing* uses wet paint, but the wet isn't very juicy or liquid. You typically use this stroke with small brushes for details such as adding the hairs to a wildlife painting. You may want to pounce your brush on a paper towel to dry it. Then you can drag it over an area quickly to produce ghost lines that aren't too pronounced. You can use whatever brush does the job. A liner gives you a single line, and a fan brush lets you cover a large area like a grassy meadow. You can use this technique to slowly place the final details.

In Figure 4-7, I use a *rake,* a ratty brush with spaces between the hairs that allows you to quickly paint groups of lines. This specialty shaped brush creates realistic animal hair and is also handy for painting grass. You can use a rake to give the impression of complex areas like hair and grass without spending a lot of time defining every hair or blade of grass.

Figure 4-7:
Dry
brushing
using a
rake.

Making fine lines with liners

To get a straight and even line, I recommend using a *liner brush* (a brush with thin, long hairs perfect for lines). Load the liner brush with paint thinned to the consistency of ink; as you pull the paint along the surface, roll the brush in your fingers to deliver the paint evenly and prevent your line from tapering off. Figure 4-8 shows precise lines painted with a liner brush. Mastering this stroke takes practice, so don't get discouraged if your early lines aren't quite up to snuff.

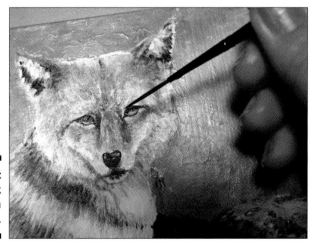

Figure 4-8:
Line work
done with a
liner brush.

Scratching with scraffito

Scraffito, scrafitto, or *sgraffito* (skrah-*fee*-toh) is the practice of scratching into wet paint with some instrument, such as the end of the brush handle. Figure 4-9 shows an example of scraffito.

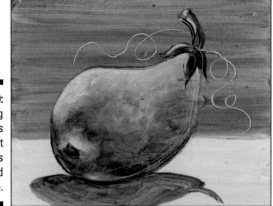

Figure 4-9:
Scratching
lines
through wet
paint is
called
scraffito.

Some brushes have a chisel-like end made especially for scraffito. You can also use anything else you have handy, such as a credit card corner or a palette knife.

To quickly achieve the scraffito look, flip your brush around and scrape the handle end into wet paint to make lines and scribbles. You can get a multicolored look by letting one color dry, painting over it with a second color, and then scratching the area so that the first color shows through. If you don't paint a color first, the canvas shows through.

Painting with a palette knife

Palette knives aren't just for paint mixing — they're extremely handy, versatile tools that come in different shapes and sizes. Try using your palette knife to apply paint or scratch into paint for scraffito (discussed in the previous section). To paint with the palette knife, pick up a bit of the exact shade you want on the underneath side of the knife's tip and tap or drag it onto the painting.

You can also use the edge of the knife to make a thin line. Scoop up some paint, like a little roll of paint along the edge, and then place the edge on the surface and pull in the direction you want your line. Play with it; palette knives are fun for smearing colors, scraping away areas, and making shapes by pushing and pulling paint. And they're easy to clean — just scrape the paint off on a palette edge for reuse and wipe the knife clean with a paper towel. (Check out Chapter 2 for more on palette knives.)

Some artists paint entire paintings with a palette knife. That's right, no brushes at all. The colors tend to go on purer with less blending. Figure 4-10 illustrates painting with a palette knife.

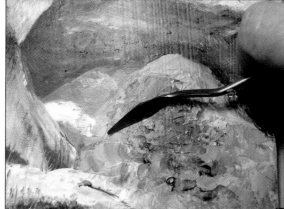

Figure 4-10:
Painting
with a
palette
knife.

The Best Basic Painting Techniques

You'll use some painting techniques over and over, so I've highlighted them here. Base coating and under painting get you started, wet-into-wet adds excitement, and layering and glazing will let you build up to the level you want in your painting.

As you paint, be sure to leave some space all around the border edge of your painting — don't put important detail within a half inch of the edge, and make sure your signature is well within this limit. Remember that a frame will cover about a quarter inch of the border, so you lose any detail you paint there to the frame.

Under painting

Under painting or *toning the canvas* is similar to base coating (covered in the next section) but involves covering the entire canvas surface. Many artists like to under paint rather than just paint on a stark white canvas, which can seem a bit intimidating. You can under paint using the color that will be dominant in the final painting (which aids in better design and leads to unity — more on design and unity in Chapters 8 and 9), or you can use the opposite color of what you paint on top (which makes the final colors brighter because they contrast with the opposite color). (I talk about opposite or complementary colors, as well as color temperature, in Chapter 7.) For example, a picture of green trees may have a red under painting.

The entire painting in Figure 4-11 was under painted in pale blue, although you may not notice it because I used white and light-colored paint on top of the blue. The blue peeks through the painting and makes a nifty blue appearance all over.

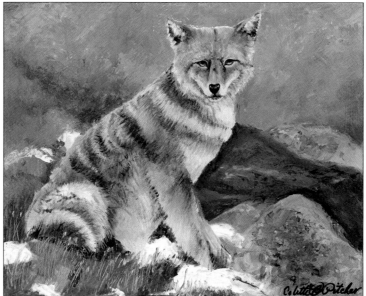

Figure 4-11:
Under
painted
coyote.

Base coating

Base coating is like underwear for your painting. A *base coat* of paint is the first layer of paint (not counting any under painting you do), used to define shape. The base coat may or may not show through after you apply another layer of paint on top. The base coat is often the ugly stage of a painting, but remember that all the lovely details will cover it up. Base coating is simply putting down a flat (no modeling or shaping) color to reserve the shape within the whole painting. Base coat an area, shape, animal, or whatever to roughly define the space that form will occupy in the painting. Sometimes I base coat in a dark color so the light colors pop out when applied over it; other times, I make the base coat light so dark details show up. Most of the time, the base coat is completely covered up by the layers of details and won't show, but little bits may peek through depending on how many layers you have.

Figure 4-12 compares a base-coated painting with its final product. Figure 4-12a is the base coat that defines the shapes for Figure 4-12b, the final still life of peaches.

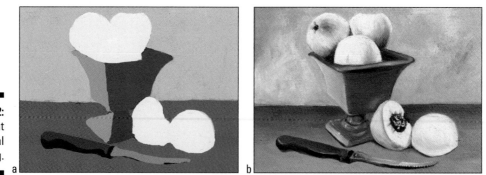

Figure 4-12:
A base coat
and its final
painting.

a

b

Wet-into-wet and blending

Wet-into-wet is exactly what it sounds like: You put wet paint into a wet background. When you add new, wet paint to already-applied paint that's still wet on the canvas, the colors run into each other and don't form hard edges. You can then blend the colors right there on the canvas. It may feel a bit out of control, but the unexpected swirls are part of the fun. The background in Figure 4-12 was painted wet-into-wet and softened by blending with a wide, soft brush. *Blending* is using your brush to create a slow, smooth transition by gradually mixing one color into another.

To blend, use a large, soft brush to go back and forth over wet paint till the edges disappear. You can go over your paint with horizontal, vertical, or crisscross movements — or use all three. The goal is to get a smooth, gentle change from one color or value to another without being able to see where the change is happening (see Figure 4-13).

You may have to clean the brush if it starts dragging around too much paint. Chapter 6 contains a good blending exercise.

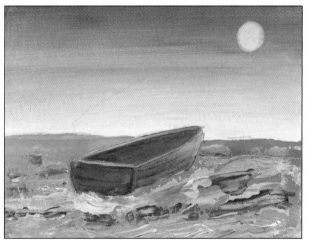

Figure 4-13:
Completely blended paint achieves a smooth transition from one color to another.

Layering

Layering (painting different levels of a painting on top of each other) helps create the illusion of depth. Paint one area or shape (even the base coat) and let it dry. After the first layer is dry, you can add more paint on top in other colors to define a shape, to add details, or change a color. Let that layer dry and keep adding more layers till you are satisfied. You can also layer with things other than paint; Chapter 13 layers papers and pastes to create depth and interest in collages. Layering thin, tranparent glazes of paint is a good way to add shadows and create perspective. (More on glazing in the next section.)

Layering is a way of developing the painting — each layer defines and refines more till the final product is complete.

Layering is a great salvage technique. If you don't like your painting, you can paint another layer to cover the bad spot.

The old masters painted very thin layers of thinned, transparent paint, often making paintings so exquisite it seems you can look deep into them. Some paintings have 40 or more layers of paint; I know one artist who paints 100 layers on a single painting. But whether you use 2 or 20 of them, layers are a good way to build up paint. And because acrylic paint dries so quickly, the process of layering is fairly fast, too.

Glazing

A *glaze* is a transparent (that is, see-through) layer of paint. *Glazing,* therefore, is the process of using thin paint to create gazillions of effects: subtle color changes, unity, shadow, and depth are just a few. You can make your own glaze by adding medium or water to the paint to make it more transparent, or you can buy glaze ready to go at the art store. (Chapter 3 talks more about glazes).

Figure 4-14a shows a painting of petunias. To make one petunia stand out, I glazed all the other petunias in light blue to get Figure 4-14b.

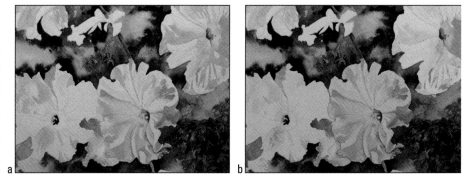

Figure 4-14:
A blue glaze over most of the petunias allows one petunia to stand out.

a b

Make a glazing chart to see what happens when you glaze one color over another. You can make your chart as elaborate and as many squares of colors as you want to explore. Figure 4-15 shows three colors glazed with dark green mixed with a medium; I added more medium each time to make the paint more transparent. Before the top paint dried I made some scraffito lines in the layer with a palette knife to get familiar with the paint and tools. (See "Scratching with scraffito" earlier in this chapter for more on the scraffito brush stroke.) To make your own glazing chart, follow these steps:

1. **Paint a square of color on a scrap of canvas paper using a ½-inch flat brush.**

2. **Let it dry.**

3. **Wipe the excess paint from the brush on a paper towel and rinse your brush in clean water.**

4. **Choose another color and paint a square on top of the first color.**

 Leave a little of the bottom color showing to remind you what was underneath.

5. **Scraffito a line with a palette knife in the top color.**

6. **Repeat with another square of paint, but next time add medium to the top layer.**

7. **Repeat with another square of paint, and add even more medium to thin the paint for the top layer square.**

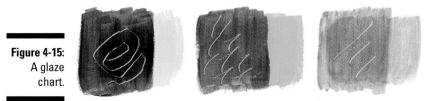

Figure 4-15:
A glaze
chart.

Once you understand glazing by making a chart, how do you use this information in a painting? One of my favorite ways is to visually "push" and "pull" objects with a glaze. Push subjects back in a painting by painting over them with a cool (blue would work) glaze. Just like the example in Figure 4-14, one petunia is left bright white and the others are pushed back a little by glazing over them with a cool blue glaze. Conversely, pull items forward by covering them with a warm glaze like yellow. By making the colors transparent glazes, you can paint over other layers without obliterating what is underneath. In Chapter 10, you use a glaze to apply a shadow in the same manner.

Finishing with Finesse

When you create a painting you're happy with and want to display, you have a few more decisions to make to truly finish it. Do you want to varnish it? If so, what kind of varnish will work best for this painting? Do you want to mat it? Frame it? Hang it on the wall? The following sections walk you through these important considerations.

To varnish or not to varnish

After you finish a painting, what next? Well, that depends. I had been told (by people who should know) that acrylic paintings don't need *varnish* (a protective clear layer painted over the entire surface of a painting). But manufacturers suggest that they do indeed need varnish. Whom to believe? Well, a little background may help you decide.

When paint dries, a skin quickly forms over the wetness and seals it off while squishy paint is still trapped beneath. If you got out a microscope, you'd see that the skin has tiny holes in it that allow air to penetrate and further dry what lies beneath. But thick acrylic paint takes up to two weeks to dry, and dirt and pollutants eventually find the holes.

That's where varnish comes in. It seals the holes in paint and thus protects a painting over time from dirt and grime. Some varnish contains ultraviolet light blockers that protect against sunlight and help keep the colors from fading. Some varnish is good for paintings that are for indoor use, and some varnish is tougher and made specifically for using outdoors to protect against harsh sunlight. Plus, varnish helps save your outdoor murals from being ruined by graffiti. If a mural gets sabotaged by something like graffiti, the offending tag is painted only on the top layer of varnish, not on the original painting. You can just remove this layer of varnish, allowing you to restore the mural to its former glory.

You can either paint or spray varnish onto your painting, depending on what works best for you and your piece. Make sure you use acrylic varnish for acrylic paint. Read the labels on any varnish you buy and test the product on a practice piece before administering it to your priceless masterpiece.

Varnishes come in three different surface finishes: matte, semi-gloss, and gloss. Matte varnish provides a more natural, less shiny finish good for landscapes; gloss varnish gives your painting a shinier finish that really pops the colors, which is ideal for portraits; and semi-gloss creates a middle-of-the-road finish perfect for still lifes. The examples are merely suggestions; you can mix and match your own choices for your own reasons. One coat of brush-on varnish is usually sufficient. You may want to do more than one layer; keep in mind that more layers of varnish intensify whatever finish you've chosen. I recommend a couple of light coats of spray varnish (with an hour of drying time in between) to protect the painting.

To compare all three finishes directly, paint a patch of each on a piece of black cardstock and let it dry. Keep this chart as a reference. Figure 4-16 shows all three on black. Making your own tester lets you tilt the paper and really examine the finishes.

Go to galleries and talk to artists. See what others are doing with varnish and go with what you like. Artists are both blessed and cursed with the number of choices available. Have fun experimenting. Personally I like a gloss spray varnish. Gloss brings up the colors and seems to make the painting sparkle with life. You can't get brush marks by using a spray either.

Figure 4-16:
Matte, semi-gloss, and gloss varnish on black.

Presenting your paintings: Mats and frames

Instead of storing your work under the bed, mat and/or frame the finished paintings you're most proud of and hang them on the wall in a place of honor. Typically works on paper should get a *mat* — a thick, sturdy border made out of an acid-free, cardboard-like substance — that should be covered with glass and held together by a frame. Works on canvas are usually varnished and only need a frame. (See the previous section for more on varnish.)

Gallery wraps and cradled boards

Some stretched canvases, called *gallery wraps,* are neatly wrapped around the sides so that no staples show (see Figure 4-17). The sides can be different depths, usually one or two inches deep. You can paint the sides, and no outside frame is required. Some artists paint the sides all black, and some extend the picture around the sides.

Figure 4-17: Gallery wraps are great because they allow you to extend your painting to around the edge, and they don't require any framing.

Cradled board is a wooden painting surface with finished reinforcement bars on one side. The coyote in Figure 4-11 was painted on a cradled board, and I painted the sides by simply extending the scene. You can also paint directly on the back of the cradled board — the cradle serves as a built-in frame. Figure 4-18 shows the side and back of the cradled board.

Figure 4-18: Cradled board, side and back.

a

b

Choosing a frame

Choosing a frame is a matter of personal taste. I have owned a frame shop for nearly 20 years, so it's an area near and dear to my heart. I think choosing the right frame is important. Many times the way an artwork is presented helps sell the painting. At art shows, I hate to see artists demeaning their art with a recycled frame that says, "I think my painting should join the garage sale I bought this frame at." The frame should elevate the art.

You can pretty safely choose a simple frame with clean lines. Too much ornamentation may distract from your picture; the masterpieces in the art museums are very ornate, but in most modern art shows, a similar frame would be a distraction.

Budget has a lot to do with the frame-choosing process, I understand. But don't be afraid of your neighborhood framer. Framers often have deals, and they're on your side when it comes to making your art look its best. My frame shop has a "bargain basement" of good-quality, affordable frames — proof that you don't have to sacrifice quality for thriftiness. Look for a framer that produces frame designs that you like. The frame designer can guide you to choose mats and frames that will show your work to its full advantage.

Going with a mat

If you want to mat your canvas-paper painting behind glass, choose a neutral mat color in a different width than the frame molding width. As always, keep variety in mind; variety in sizes creates more interest than monotony does. You may even consider a *double mat*, which is a mat inside of a slightly different sized mat. Not only does the double mat look nice, but the added depth also gives a good amount of air space between the art and the glass for proper conservation.

If the art touches the glass, it will eventually stick to the glass and and potentially peel off the paper and adhere to the glass permanently. Moisture-rich atmospheres are especially susceptible to this process.

In general, the total mat width should be 3 or 4 inches. Inside or interior mats are usually ¼ inch; however, they can be ⅛ inch to 1 inch for effect. As with all art, you can always do something other than the norm.

Figure 4-19a shows a framed painting with a single mat; Figure 4-19b is a double mat — the inside mat is ¼ inch.

Neutral colors are common in matting because most art shows allow only white and off-white mats. However, you can use any color that makes the picture look its best. If you're hanging your painting in the living room and want to match the mat to your couch, go ahead.

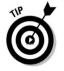

My formula for choosing mat colors (besides going neutral for shows) is this: The inside quarter-inch mat should be the color of the *center of interest* (where I want you to look) in the painting. The outside mat is more neutral (white, black, gray, or off-white) to complement the picture.

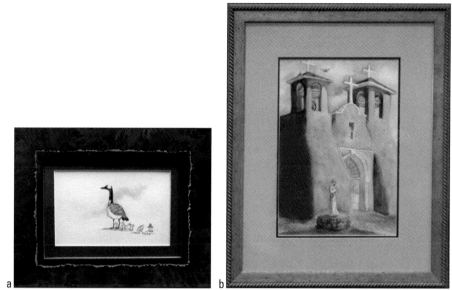

Hanging it up

Before you hang your painting, you want to mount it if needed, and seal up the back with a dust cover (optional), using acid-free products (see Chapter 2 for more on the benefits of acid-freedom). If the painting is a work on paper, it must be *mounted* or attached to something a little sturdier like backing board to protect it and keep it rigid. Anything that is limp, such as paper or fabric, needs to be mounted. Your framer will attach the paper to the backing board using linen tape or acid-free mounting products. Backing board is usually special acid-free ⅛-inch-thick board. This board is then stapled or nailed in the frame to secure it. A *dust cover* is paper that seals the back of the frame so no dust gets into the art and makes it look nice on the back.

Canvas is often painted while on stretcher bars or onto hard board. It is already mounted in this way. The stretcher bars remain on the painting, and a frame is added. The frame should be deep enough to do this. A dust cover is optional. A wire should be attached on the back for hanging.

Figure 4-20 shows the back side of a framed artwork. The dust cover is black paper, the wire is wrapped tight around D-rings, and there are bump-ons at the bottom corners to help the piece hang straight and not tip.

I like to cover my paintings with *conservation glass,* which prevents ultraviolet light from penetrating and fading the colors. Use D-shaped rings screwed to wooden molding to hold heavy-duty wire against the back to hang the picture. And place little round bumpers on the back bottom corners to help keep the art straight on the wall.

Figure 4-20:
The back side of a frame has wire hanger, dust cover, and bump-on corners.

Project: 30-Minute Artist Trading Card

One hot trend in the art world right now is *artist trading cards,* or ATCs. They're tiny, original works of art that are traded among artists like baseball cards. In fact, artists often collect and store them in plastic sleeves as they would baseball cards. An ATC is small: 2½ x 3½ inches. You can buy pads of paper in that size or cut your own. You can trade them online or start a swap with your local art buddies.

This project takes you through creating an ATC. For this example, I paint a miniature version of the coyote from Figure 4-12. You can do your own thing, or you can follow my lead for your first one:

1. **Get a piece of canvas paper 2½ x 3½ inches.**

2. **Trace the drawing in Figure 4-21 and then place a sheet of transfer paper between the drawing and the canvas paper and retrace the lines of the drawing.**

 See Chapter 6 for more on transferring drawings with transfer paper.

3. **Prepare your palette with small amounts of Burnt Sienna, Yellow Ochre, Phthalo Blue, white, and black, and make three Burnt Sienna color bridges (to Phthalo Blue, white, and black).**

 You won't need much paint for these tiny works — a dot about the size of half a penny of each color should do. See "Setting Up Your Palette and Supplies" earlier in this chapter for instructions on creating color bridges.

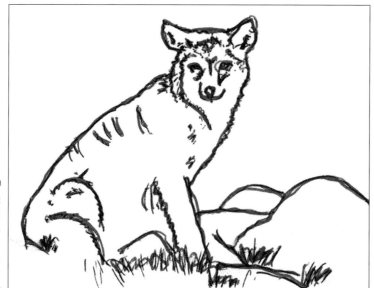

Figure 4-21:
Trace and transfer this coyote to your canvas paper.

4. **Paint the rocks using the palette knife.**

 A. Use the knife to spread some gray-brown from the bridge between Burnt Sienna and Phthalo Blue on the area of the rock as if you were spreading peanut butter on toast.

 B. Pick up other colors like Yellow Ochre and Phthalo Blue and tap some more color onto the rocks with the flat part of the knife, keeping lighter colors toward the top of the rock and the darker colors toward the bottom where light would be blocked.

 I tapped the wide bottom of the palette knife onto the rock colors a few times to release excess paint. This technique also makes the paint stand up in little peaks and gives the rock texture.

 C. Blend the colors by brushing over them with a clean, damp, soft brush.

 D. Keep manipulating the color till you like your rocks.

 You can gather more paint by scraping the knife into the palette paint colors. I even picked up several colors at once. Tap on more colors if desired. Scrape some scraffito grass lines in the rock while it's still wet (see Figure 4-22).

5. **Using a small (#4 or so) brush, base coat the coyote with Burnt Sienna and a dark brown from the Burnt Sienna–Phthalo Blue bridge.**

 Use Burnt Sienna for most of the coyote and dark brown for the dark edges of the coyote (see Figure 4-23). See "Base coating" earlier in this chapter for more on base coating.

Figure 4-22:
Palette knife
painting
rocks.

6. **Use a ¼-inch flat brush to crisscross some sky colors behind the coyote and then soften those strokes with a clean, damp, soft brush.**

 I used Phthalo Blue with white mixed in to lighten it. I also crisscrossed some lightened brown from the Burnt Sienna–white bridge. I made some areas darker in order to make a place for the white of the coyote to stand out later (see Figure 4-24a). Loosen any edges by softening the paint while wet (see Figure 4-24b). See "Crisscrossing" and "Wet-into-wet and blending" earlier in this chapter for instructions on making the crisscross and blending brushstrokes.

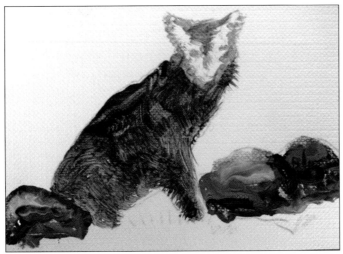

Figure 4-23:
Base
coating the
coyote.

7. **Use a ¼-inch flat rake brush to paint the white and dark coyote fur (see Figure 4-25).**

 I pulled dark brown paint (from the Burnt Sienna–Phthalo Blue bridge) through the areas of fur. You can alternate using the dark brown paint and light or white paint to make the fur. If white is too bright, tint some brown by adding white paint until it's light brown. Pull the fur lines in the direction that the fur naturally grows.

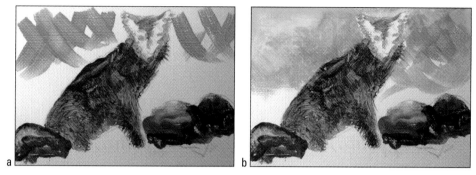

Figure 4-24:
Painting the
sky area.

a b

8. **Use a liner brush and black paint to outline the dark details of the coyote face: eyes, nose, and inside the ears.**

 If the lines get too wide, you can clean up edges with white paint after the black dries.

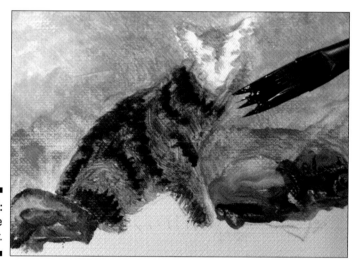

Figure 4-25:
Adding the
coyote fur.

9. **Paint Burnt Sienna, Yellow Ochre, and dark brown masses in the foreground near the front, scraffito some grass in the paint while it's still wet, and then use a liner brush to add some grass lines using Yellow Ochre and Burnt Sienna.**

10. **Finish the details.**

 Glaze some transparent yellow (add water to dilute) over the scraffito grasses. Use a liner brush to make more grass if desired. Put Yellow Ochre in the eyes (the coyote's, not yours). Paint any light areas of the coyote with white. I like to save white till last for the sparkle. White is most dramatic if you place dark next to it. Figure 4-26 shows all these details in the finished product.

Figure 4-26:
Final ATC —
wanna
trade?

Chapter 5

Building Your Repertoire with Quick Tricks and Techniques

..

In This Chapter

▶ Using additives to change the properties of the paint

▶ Manipulating paint without a brush

▶ Creating a monoprint

▶ Putting experimental techniques to work

..

Society today is all about instant gratification — people want everything now and without a lot of work. Fortunately, some painting techniques give you just that; some of the tricks I reveal in this chapter create details that make it seem as though you spent hours making them happen. Your audience will be amazed. (Don't tell them it was fun and easy. They wouldn't believe you anyway.)

This chapter covers fun and quick ways to get some interesting effects in your painting without spending hours working on little details.

Ready, Set, Experiment

For now, I want you to forget about making anything that looks like something real or natural. That's right. The pressure to make perfect drawings or render identifiable objects is *off* for the time being. In experimental, nonrepresentational work — the kind explored in this chapter — you simply enjoy the colors, textures, and surprises that happen when you play with the paint. *Play* is a good word. It sets the mood for how you should explore these techniques.

Sometimes these experimental techniques just don't work, and sometimes they work better than you planned. That's why they're called *experimental,* and it's just the nature of the beast. Not every work of art succeeds. But having that aha moment when you see something you like in one of your experiments makes all your effort worth it.

Set up your palette and paint area as I explain in Chapter 2 and get some 5-x-7-inch canvas paper ready. Use one sheet for each experiment technique in this chapter. You're not wasting the paper: When dry, put all the experiments in a folder or big envelope. You can refer to them later for painting ideas (like the project at the end of this chapter).

These projects are best done laying flat on a table. If the paint is thick enough that it won't run, you can work using an easel. But most of these experiments will drip, so you're better off at a table.

Adding Stuff to Your Paint

In today's instant gratification world, everyone likes quick results. Artists are no different. If an artist can toss a little magic dust on the painting to have something appear instantly, why wouldn't she? Below are some magic-dust tips to try. These tricks can be fast ways to make texture, backgrounds, or even entire paintings.

The magic time to use the tricks in this section is just as the shine is leaving the paint — when it's temporarily damp. When paint dries, you're too late; it's set, and you've lost your magic window. And they don't work if the paint is too wet, either — the tricks just wash away.

Salt

When you sprinkle regular table salt onto damp paint, it makes lighter-colored, ragged-edged dots when the paint dries.

Think *grains* of salt, not tablespoons — less is more in this case. Use salt sparingly. Too much salt will stick to the surface and make actual texture when you really just wanted little sparkles of dots for texture that brush off when dry.

Here's how to spice up your paint with salt:

1. **Choose a color of paint and thin it with enough water to be transparent.**

 It should resemble the consistency of ink.

2. **Paint it on your paper in any shape you like.**

 For best results, the paint should be evenly spread and fairly transparent, with no puddles.

3. **When the painting is damp, pick up a pinch of salt between your index finger and thumb and gently sprinkle it into the area where you want the dot pattern to occur.**

 You have to sprinkle the salt when the wet shine of the paint is just beginning to turn dull. If the paint is dry or too thick, you don't get the right results. Leave the salt in place until the paint dries.

4. **When the painting is dry, just brush away the salt.**

 Sometimes the salt adheres to the paint, especially if you sprinkled it on too thickly or when the paint was too wet. In that case, you have a real texture, which may or may not work for your purposes.

See Figure 5-1 for an example of this technique.

Figure 5-1:
Salt
provides
texture.

Alcohol or water

Alcohol acts similarly to salt when you add it to paint. Sprinkling rubbing alcohol onto damp paint leaves ragged dots of lighter color behind when the paint dries. The method works with water or your favorite booze as well. Each liquid makes a slightly different dot pattern, but all are similar; use what you have on hand. You may even experiment and find something brand new.

You may want to practice first, using water on a tabletop to improve your aim (make sure the table or whatever surface you use can take water). Squirt water until you get the desired pattern of droplets, then wipe it up and you're ready to try it on paper (or other surfaces).

Here's how to apply alcohol or other liquid to paint:

1. **Paint on your paper in any shape you like.**

 For best results, the paint should be evenly spread and fairly transparent, with no puddles.

2. **Pour about ½ inch of the alcohol (or other liquid) in a shallow dish at least 3 inches wide.**

3. **When the paint is damp, put all your fingers together like you were picking up a feather and dip them into the liquid.**

4. **Flick your fingertips out, against the thumb, to spray the liquid toward the paint.**

 You should get small, irregular dots of liquid on the paint.

5. **Allow the paint to dry.**

 When it does, check out your (hopefully) awesome pattern.

Figure 5-2 shows an example of the liquid-flicking technique.

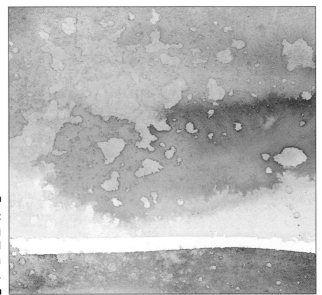

Figure 5-2:
Flicking liquid creates a nice effect.

Sand, sawdust, and beyond

Because wet acrylic acts like glue, you can make real textures by sprinkling something like sand onto wet paint, to make a kind of sandpaper. For example, would your beach scene benefit if it had real sand in it? Check out the seascape in Figure 5-3, which features real sand. Perhaps you can make a rough tree bark even more real by adding some sawdust to the paint. Use your imagination!

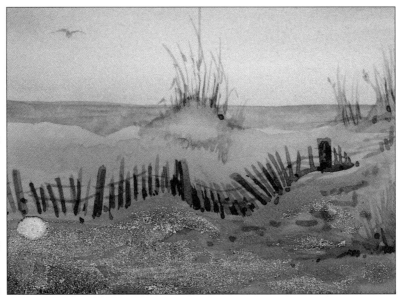

Figure 5-3:
This seascape contains real sand from the beach that inspired the art.

You can add just about anything you want to paint. One artist painted memorials to commemorate a deceased loved one and actually added that person's ashes to the paint. Talk about realism!

Thinking Outside the Brush

You can work with paint in a lot more ways than just brushing. Sponges, for example, are a great way to apply paint, and they come in a variety of shapes and sizes. Sponges can be a fast way to cover a large area with an irregular texture. You can make a tree full of leaves in a couple of pounces. Rollers and plastic wrap also add variety to your paint's texture.

Sponges and rollers

When painting with sponges, use paint that you've diluted a little bit with water. If the paint is too thick, sponging doesn't work well.

1. **Wet the sponge with water.**

 Wring it out so that it's just damp.

2. **Dip a portion of the sponge into the diluted paint.**

3. **Apply to the surface of the canvas paper (discussed in Chapter 2).**

 Try different application methods to see different textures: pounce up and down, drag sponge across paper, touch sponge to paper and twist.

Note: You can dip different parts of a sponge into more than one color to produce multicolor areas.

Check out Figure 5-4 to see some of these tools and the results you can obtain.

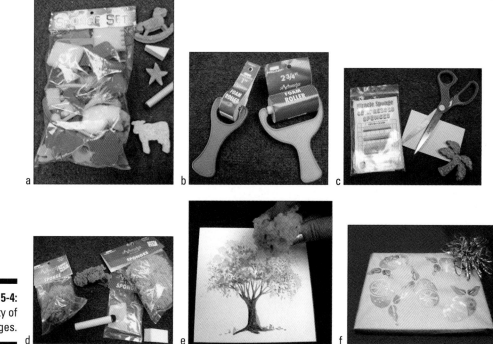

Figure 5-4:
A variety of sponges.

Natural sea sponges

Natural sea sponges cost more than your typical synthetic sponges do, but both do the job well. Because of their different-sized holes, sea sponges leave empty spots when you apply paint with them. Simply tap the canvas with the sponge to leave the paint on the surface. Repeat as many times as necessary.

For a more random, natural look, turn your hand so that the sponge touches the surface at different angles. If you touch at the same angle each time, you produce a more patterned look.

With just a few pounces, you can make all the foliage for a tree. It'll look like you spent days painting all the little leaves and details.

Shaped sponges

These sponges can be shaped like anything from circles to teddy bears. They work like rubber stamps for repeated images.

You can make your own wrapping paper or wallpaper by stamping a repeated image with a shaped sponge. The ideas you come up with may be inspired by the shapes you find. Or create your own shaped sponge by taking scissors to a plain old rectangular sponge (which I discuss further in the next section).

Compressed sponges

If you can't find a sponge in the shape you want, the best way to make your own is to use *compressed sponges*. Because they're about ⅛-inch thick when dry and new, you can easily cut them into your own shapes with regular scissors. When you soak them, they expand to ½-inch thick or so. Of course, after the sponge gets wet it stays puffed up forever, so when you're buying compressed sponges, you may as well buy a lot of them.

Rollers

Sponge rollers in 1- or 2-inch-wide sizes are awfully handy for covering larger areas quickly. They also work well for applying *gesso* (surface preparation primer; see Chapter 2 for more) to surfaces to get them ready to paint.

Sponge rollers are great for skies. Base coat a big blue sky quickly with a sponge roller. The rolling sponge usually slips off the handle for easy cleanup with soap and water.

Plastic wrap

Any plastic wrap, such as sandwich wrap, is a cool tool for painting.

It works like this: When the paint on your canvas paper is still damp, press your wrinkled plastic into it and leave it there to dry. Drying takes a while — after all, you just covered the paint with plastic. When the paint dries, the wrinkles from the plastic are imbedded in it. You can reuse the plastic, too, though probably not for sandwiches.

Here's how to paint with plastic:

1. **Get some plastic wrap or tear up pieces of plastic grocery bags.**

 Make the pieces easy sizes to handle: Tear up about six rectangles measuring 4 x 6 inches or so.

2. **With a ½-inch flat brush, use the colors you've chosen to paint the area you want to cover.**

 For Figure 5-5 I used Burnt Sienna, Burnt Umber, Ultramarine Blue, and some Yellow Ochre. I changed the color every inch or so to have lots of variety of color.

3. **Before the paint dries, wrinkle the plastic wrap so it has lots of texture and press it right onto the painted area.**

 If the plastic is too stiff and won't adhere to the paint, set something on top of it to weigh it down so it makes good contact. Feel free to manipulate the plastic to get lines and shapes any way you want. The plastic turns dark where it touches the paint. The light areas are the lines that will be left darker (fully painted) when you remove the plastic. The dark areas will be lighter when they dry because some of the paint will come off on the plastic.

4. **Let it dry.**

 It's okay to peek: Carefully lift an edge of the plastic. If the shapes remain, you can remove the plastic entirely. If the color runs, wait some more — the longer, the better. If you have time, leave it overnight.

5. **Remove the plastic and paint on top of the area to develop more detail (if desired).**

This technique makes great rocky textures when you do a landscape.

Figure 5-5:
Texture created by using plastic wrap.

Cobwebs and cheesecloth

Around October (or even July, it seems), the stores start stocking Halloween goodies. Pick up a package or two of fake spider webs to use in your painting. When you pull the polyester webbing apart and embed it in wet paint, it leaves a crystal-like pattern when you remove it. Other loose woven fabrics also make unusual textures. In fact, you can put cheesecloth, lace, and anything else you may think of into paint to create an effect. Whatever you use, tear it up or stretch it out so you have open spots.

Here's one technique:

1. **Prepare three colors of paint on your palette.**

 Add enough water to the paint to make an inky consistency.

2. **Apply paint to an 8-x-10-inch piece of paper.**

 Cover the paper quickly with all three colors so the colors can mingle their edges but still be identified as separate color areas. Keep the paint moist by using a spray mist of water if necessary.

3. **Pull cobwebs apart so thin strands of threads show, and then place the cobwebs onto the wet painted surface.**

 Cover the entire paper.

4. **Add more paint on top of the cobwebs.**

 By wetting the cobwebs, you help them stay down on the paper better. You can manipulate the paint, cobwebs, and water on the paper till you're satisfied.

5. **Let the work dry in place.**

 This process may take an hour or overnight, depending on how wet it got.

6. **After it's dry, peel off the cobwebs to reveal the textured painting.**

 You can use this product as the final project or put another layer over the top. Figure 5-6 shows the cobweb technique in action.

This technique makes great backgrounds, but sometimes it turns out so well I don't want to cover it up.

How cold is too cold?

One year, a painter friend and I vowed to paint outside once a week all year. It was an ambitious goal considering the winter weather in Colorado. One particularly cold day we were just finishing a landscape when my paint must have hit the freezing temperature — it crystallized in my sky. Unfortunately, my palette also turned to an ice-cream-like consistency. We decided that some temperatures are in fact too cold to paint outside.

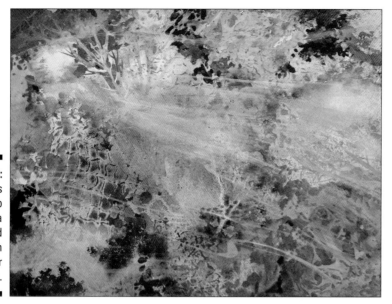

Figure 5-6:
Imagine this cobweb texture as a background for an underwater scene.

Dripping, Spraying, and Spattering

Not only can you use plenty of tools besides a brush to apply paint to a surface (as I demonstrate in the previous sections), but you can also use nothing at all! That's right; the following techniques involve applying paint through thin air.

Jack the dripper

Wet paints just ask to drip — so let them! If you accidentally drip, make a bunch more drips so the original looks like you did it on purpose. Jackson Pollock painted dripping abstract masterpieces in New York during the 1940s. Figure 5-7 shows a couple of examples of my own Pollock-inspired artwork.

My art friends once even threw a Pollock Frolic party. Give it a go! Rent the movie *Pollock* to get in the mood. Serve ice cream with toppings in squeeze bottles to create a Pollock dessert.

Here's how to make your own Jackson Pollock:

1. **Thin your paints so the paint can drip onto the canvas or paper.**

 If the paint is too thick, it may not spatter. Try thinning it more with water.

2. **Dip a paintbrush into the thinned paint.**

3. **Hold the brush upright and snap your wrist downward to throw paint onto the surface.**

Figure 5-7:
A Pollock-inspired painted light switch and window shutter in my studio.

Another way to make drips is to hold your paint-loaded brush in your dominant hand, and a pencil in your other hand. Then tap the paint-loaded brush against the pencil over your paper. The shock should disperse paint onto the paper.

If you don't want to mess with thinning your paint, you can also use *fluid acrylics,* which are ten times thinner in viscosity than regular acrylics. Fluid acrylics come in bottles and are the perfect consistency for dripping.

Spray it again, Sam

Spray bottles can be important painting tools; I spray water from the bottles to create texture. I also spray paint from bottles to add color to an area. *Trigger sprays,* which you squeeze, produce a firm jet. *Pump sprays* (like the kind found on a bottle of hairspray) make an irregular pattern good for foliage and other odd textures. *Atomizers* produce a very fine spray, like an airbrush. You can make a cheap airbrush by diluting paint and using it in a spray bottle to apply a mist of color rather than water.

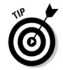

If you use acrylic paint in a spray bottle or airbrush, be sure to clean the container and nozzle well after each use. If the paint dries, the nozzle is a goner. Some commercial paint cleaners and solvents (available in any good art store) can help dissolve dried paint, but the best method is prevention. Keep it clean.

Figure 5-8 shows a spray pattern and the bottle that created it.

I also keep a spray bottle full of water near my acrylic paint at all times to mist the palette to prevent it from drying too quickly. I also use spray to move paint on the painting, to soften an edge, or to allow more drying time. If the color is too dark, thick, or hard-edged, a quick spray of water can lighten, thin, and soften it. See Chapter 10 for more on acrylic "watercolor."

Figure 5-8:
Spray bottles come in a variety of shapes and produce different spray patterns.

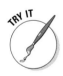

Spray stenciling

Here's how to make a spray stencil:

1. **Find some stuff you can ruin, like old doilies, soiled lace, or nuts and bolts.**

2. **Dilute various colors of paint in inexpensive pump spray bottles.**

3. **Arrange your objects on your paper.**

4. **Spray the paint over the objects onto the paper.**

5. **Allow it to dry and then remove the objects.**

 You've just created a stencil. The objects masked the areas from receiving paint.

6. **Rearrange the objects and spray another layer.**

 Make as many layers as you like.

7. **Stop whenever you like the finished product.**

Figure 5-9 is a great little restaurant piece. Or maybe it works better for the kitchen?

Figure 5-9:
Kitchen utensils are the theme for this stencil spray sample painting.

Project: Combination Technique Abstract

Project time! Get out all your experiments. Lay them all out on a table. Enjoy for a moment. Which ones worked well? Do you think you can use different colors, different amounts of water, more or less pressure in your sponge pounces? You may want to leave your sample exercises out to inspire you as you work on this project.

For this project, use the techniques you liked best in order to make an abstract work of art. *Abstract* art doesn't have to look like anything. It just has to please you in some way. (I discuss abstract art more in Chapter 12.)

So, free your mind from thinking that this project has to be anything recognizable. You may see things in the paint later, like seeing objects in clouds. The steps I outline are just to get you started; you can repeat, move, change, or eliminate steps as you like. You can redo this project as many times as you want. I guarantee no two will look alike.

1. **Prepare your palette.**

 Choose your colors (or mimic mine; I went for Cobalt Blue, Sap Green, and Lemon Yellow). Squirt a quarter-size circle out onto the palette. Pick up a bit of color on a ¼-inch flat brush and place it on the (clean) palette mixing area. Dip the brush in water and add enough water to the paint to make a smooth cream consistency. Repeat with each color, using a clean brush. You should have a puddle of each separate color. Spritz water from the spray bottle as needed to keep paint from drying out.

2. **Choose an 11-x-15-inch piece of acrylic paper.**

 I like to place the paper on a piece of newspaper so I can paint to the edges and not get paint on the table.

3. **Dampen the part of the paper you want to work on first.**

 Wetting and working the whole paper may be too big of an area to control before it dries. Brush some water onto the upper left quarter, using a ½-inch flat brush, so that it's damp but doesn't have puddles. (You can absorb puddles with a damp brush or tissue).

4. **Change brushes.**

 Rinse the flat brush and lay it down to dry or use again later. Pick up a round #10 (or so) brush to paint colors.

5. **Apply blue to the damp area.**

 Dip the #10 round brush into the blue puddle on your palette to cover the tip (to about half the length of the brush head). Stroke into the damp area of paper and let the paint disperse into the wetness. Place as much blue as you like. You may leave areas blank.

 Don't put paint past the metal piece (called the *ferrule*). It's harder to clean.

6. **Clean your brush between colors.**

 Clean off the paint by swirling it into clean water. Test it on a scrap to see whether it's clean before dipping into another color. When you're finished with the brush, lay it on the table to dry.

7. **Add any other colors while the paint is wet.**

 Pick up a different color and touch the tip of the brush to the wet paper to make a circle of color. Pull the brush across the paper to make a line. Squiggle and wiggle as much as you want to achieve as many marks as you like. If the paint starts to dry too quickly, mist it with the spray bottle of water.

8. **Apply the technique of your choice.**

 While the paint is still damp, you can add plastic wrap, salt, alcohol, cloth, cobwebs, sand, and/or sawdust. You can spatter before or after the paint dries. After the paint is dry, you can spray more paint through stencils.

9. **Let the area dry.**

 After the area is dry, remove any additives (such as plastic wrap or salt).

10. **Repeat Steps 3 through 9 in another quarter of the page till you have the entire page filled.**

Try to look for shapes in your painting. Abstract paintings often make good backgrounds for something to be painted on top. Figure 5-10 shows a house painted over a background created by plastic wrap.

You can't do this project wrong. Some paintings, of course, look better than others. Mastering design and composition skills improves your paintings; check out Chapters 8 and 9 for more on these topics.

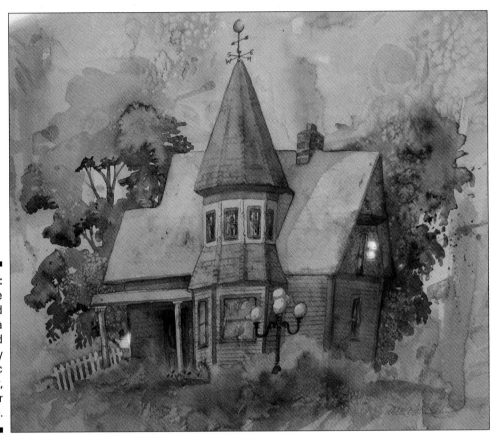

Figure 5-10:
A house painted over a background created by using plastic wrap, salt, and spatter techniques.

Chapter 6

Drawn to Paint — Even if Your Drawing Skills Need Work

In This Chapter

▶ Sketching out your ideas

▶ Scaling up your sketches

▶ Discovering the benefits of tracing

▶ Transferring your drawing to the canvas

▶ Using blending to create effect

▶ Creating a still life that uses these skills

*I*f you want your paintings to look like something recognizable, you need to do some sketching and drawing. Drawing is the skeleton, and paint is the flesh. You can always work on improving your drawing skills — check out *Drawing For Dummies* by Brenda Hoddinott (Wiley) for lots more about this essential basic art skill.

You can spend lots of time learning to draw (and you should if you want to develop as an artist), but this chapter gets you going fast. After all, you bought this book because you want to paint. Don't be afraid to tap into available tools to help. You enjoy many technological advantages that the old masters lacked: Photography, digital images, computers, and projectors are just a few of the tools that make drawing easy today.

But begin with the simple tools: good old pencil and paper.

Making Thumbnail Sketches

A little preplanning makes your paintings more successful. I like to make mini sketches, called *thumbnails,* to plan how my painting will look when finished. But I make them a bit bigger than a real thumbnail.

To make a thumbnail drawing plan, follow these steps:

1. **Get a piece of 8½-x-11-inch white paper and a pencil.**

 Any pencil is fine.

2. **Decide which shape you want your painting to be and draw the 2-x-3-inch outline of it.**

 You may choose a horizontal rectangle *(landscape orientation),* vertical rectangle *(portrait orientation),* square, oval, circle, or some other shape (as long as you can find a canvas that shape).

3. **Use simple lines to divide parts of the thumbnail into smaller shapes that represent the elements in your painting.**

 Do you have a horizon line? Draw it. Use circles and scribbles to represent complex shapes — all you're doing is finding a place for shapes and deciding where they look best. This process should only take a minute; it's just a trial drawing for your eyes only, a quick and useful map for you to see where things should go.

4. **Repeat Steps 2 and 3 to create six or so thumbnails, drawing different shapes and rearranging the placement of the elements each time.**

5. **Choose the best thumbnail plan from your six choices to enlarge for a painting.**

Now that you have a map, you can execute your plan more easily when it comes time to paint. See the example in Figure 6-1.

A digital camera is a handy tool to try out different thumbnail arrangements. For example, find an apple (or whatever you have on hand) and a camera and take some photos rearranging the subject, horizon, and surrounding space in different configurations like you would for a thumbnail sketch. Figure 6-2 shows some different arrangements, using an apple.

Enlarging Sketches

When you have a thumbnail nailed down, you need to make it larger to fit the size of your final painting. The trick to enlarging your thumbnail is making sure the big sketch is proportionate to the smaller one.

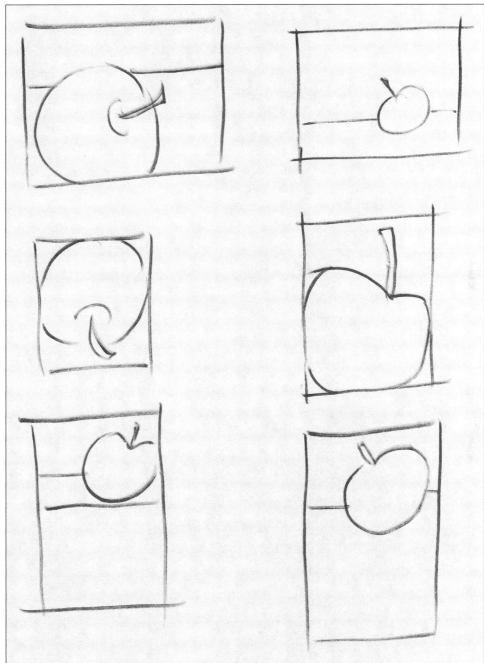

Figure 6-1:
Thumbnail
sketches
help map
out the
journey
toward a
successful
painting.

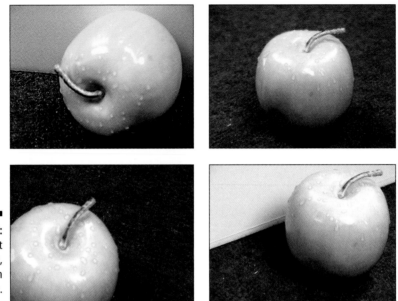

Figure 6-2:
Different
photo plans,
using an
apple.

Here's a quick way to determine the proper proportions of the big painting:

1. **Cut out your thumbnail (or redraw it) and put it in the lower left-hand corner of a new piece of larger paper.**

2. **Take a ruler and lay it across diagonal corners of your thumbnail sketch.**

3. **Using the pencil, extend the line beyond the sketch.**

 The top corner of the enlargement can land anywhere along that line, and it will have the same proportional height-to-length ratio of the thumbnail sketch. Refer to Figure 6-3 for an example.

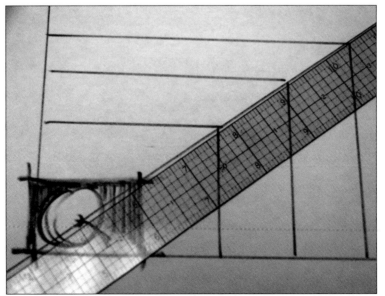

Figure 6-3:
Enlarge a
sketch to
the same
proportion
by using
a ruler.

The proportion ratio (height to width) you just figured out will help you determine the shape of your canvas or other substrate. Is it vertical, horizontal, rectangular? A standard size or something else? Now, decide what size you're going to make your painting. You could extend your proportion line all the way to the same size of your canvas to make sure the proportions are the same. After you know the final size you want, you have several ways to enlarge your sketch. You can wing it by drawing a new, larger sketch directly on the canvas or surface. You can also use an enlargement method, such as a grid, or a tool such as a computer or projector. The following sections discuss these options.

Eyeballing it

One way to enlarge your drawing is to just observe the drawing and sketch it larger. This method works well if you have good hand-eye coordination, if you draw well, or if your shapes are simple. Natural objects or scenes, like flowers or landscapes, can vary from the original a lot without anyone knowing. When you paint it, you paint the feeling or essence of the object and try not to stress about the accuracy of painting every detail exactly like it appears. After all, you're interpreting the object, not making a photograph.

Buildings, on the other hand, need some realistic form so they look habitable. One reason artists like old buildings and barns is because they're more forgiving in their structure. If something is crooked, it just adds charm. Portraits also need to be pretty accurate because if not, they may not look like the person. Of course, if you want to paint like Picasso, you can rearrange eyes and noses however you want. If you're comfortable drawing freehand, you should be fine; if not, you may consider some other methods for enlarging your thumbnail into a final piece. Read on for more options.

Gridding it

A good way to enlarge a sketch more accurately is to use a *grid* method. Divide the thumbnail sketch into smaller squares. If the drawing is simple, divide the thumbnail in half vertically and horizontally. Then divide your large painting surface likewise in both directions. Transfer the drawing by seeing where the drawing lines intersect the dividing lines and copying that on the larger scale.

If your drawing is more complicated, further dividing the space into more squares is beneficial — the more intersections you can use for gauging where images go, the more accurate your transfer will be. You can draw a handy grid on see-through *acetate* (clear plastic) with a permanent black marker. Place the gridded acetate over the sketch and then draw the same number of squares on the final canvas (adjusting for the larger size of the canvas). Transfer the drawing lines into the squares, using the thumbnail as reference.

Figure 6-4 shows an example of this enlargement method.

Copying it

Another method of enlargement may be to use a copier or computer printer to enlarge the thumbnail. If you have a scanner, you may be able to do this

process yourself, depending on your software and hardware. If not, your local print shop can also help you figure out how much to enlarge your thumbnail to fit your painting — be sure to know your final dimensions when you go to the print shop.

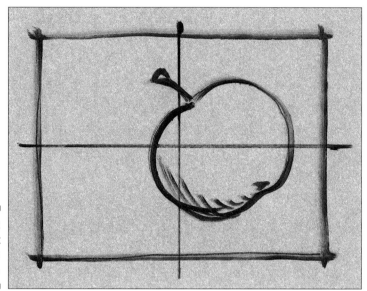

Figure 6-4:
Enlargement by using a grid system.

Projecting it

You can find special projectors that enlarge drawings; these contraptions are especially handy when you need a large drawing on a wall for a mural, for example. Slide projectors are an endangered species, but they're great tools for projecting an image onto any surface if you can get your hands on one (check your local garage sales). Nowadays, you can get digital projectors as well. These projectors are great if you want to enlarge the exact image, but they aren't cheap.

Tracing Your Way to a Great Painting Sketch

Tracing paper (the thin, frosted, see-though paper) can make your painting life easier. Because tracing paper is so thin, you can place it directly on top of an image and still see what's below, allowing you to easily trace that image. Tracing paper also lets you tinker with your image until you get a design you're happy with.

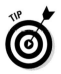

Tracing paper is inexpensive — buy and use lots of it. You can find rolls and pads of it in all sizes at any art store; you can use clear mylar and acetates in the same way, but these products are a little more expensive.

Finalizing your sketches with tracing paper

Tracing paper can be a wonderful tool for quick fixes. For example, maybe your enlarged sketch is pretty rough and you want to clean it up. Get a piece of tracing paper of the same size and cover the enlargement. Redraw it on the tracing paper, using the sketch beneath as a guide. Voilà — a clean copy.

Not quite happy with the placement of the shapes in your sketch? Tracing paper lets you move mountains! (Well, sketched mountains anyway.) Simply cut out the offending shape on the tracing paper and move it to a better place. Tape all your cutouts together, and then put another piece of tracing paper over all that and redraw. Now you're thinking like a designer, and better design makes better paintings. (I give you lots more design tips in Chapters 8 and 9.)

Copying a photograph by using tracing paper

You can create an image you want to paint by tracing a photo that inspires you (because you should always be taking lots of photographs of subjects you may want to paint). An outline of your photo's crucial shapes (called a *cartoon*) lets you know where to put paint in different colors. To make a cartoon, simply place a piece of tracing paper over your photo and trace the important lines that will help you make your painting. Don't limit yourself to one photo. You can trace a sky in one photo, a tree from another photo, and a lake from yet another and rearrange them all into a new grouping.

You may also want to make lines to indicate shadow edges, but you don't have to transfer all the lines in the photo. The cartoon is your outline, not the final image; it simply guides you to where you want to put the paint. You paint the details on the canvas. If your traced photograph is smaller than the size of painting you want to do, enlarge it by using one of the methods described earlier.

Organize your photographs for use as painting reference materials. Keep folders or files of subjects: clouds, flowers, rivers, trees, birds, whatever you want to paint. When you need an idea, go to your file and see whether it inspires a painting. I have both a tangible file like a shoebox that I can flip through, and also digital folders that I can look at on the computer. Both methods work well for me.

Beware of the optical distortion that often occurs in photography, because some photographic lenses distort vertical lines. For example, the edges of a tall building may curve slightly and appear to converge as they go toward the sky. If you don't want your painting to look like you used a photo directly, correct these distortions when drawing out the image before painting.

Getting Your Drawing onto the Painting Surface

I prefer to make my outline cartoon drawing (discussed in the previous section) on paper first and then transfer it to the final painting surface. Why? If you draw directly on the painting surface, any erasing or changes you make can compress surface textures and create spots that resist paint. Keep the painting surface clean and pristine by making all your changes on a separate piece of paper and then transferring it to the painting surface.

Transfer the drawing by placing a sheet of *graphite paper* (paper that transfers marks, easily found at art stores) between the drawing and the painting surface. By retracing the lines on the drawing, the graphite under the graphite paper transfers to the painting surface everywhere you traced. Figure 6-5 shows you a graphite transfer.

Using a red (or other color) ballpoint pen to draw over the original sketch helps you tell where you have traced.

Don't press too hard while you're tracing — you don't want to make an indentation in the painting surface by adjusting the pressure on the pen.

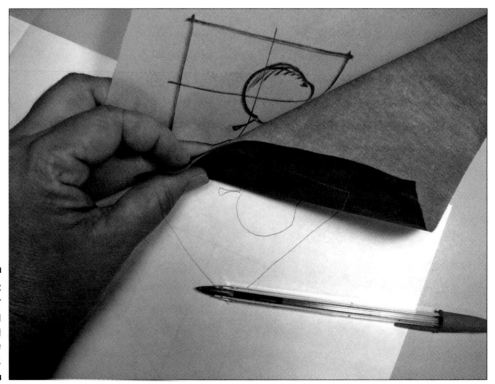

Figure 6-5:
Transfer
a drawing
by using
graphite
paper.

But I can't draw!

Don't panic if your drawing skills leave something to be desired; you're not resigned to painting stick figures for the rest of your life. The following tips are easy ways to improve your drawing and thus add variety to your painting:

✔ Don't put your subject itty-bitty within the painting. Make it big. Think of a camera's zoom lens. Let it run off the edge (or even three edges) of the page.

✔ Don't settle for the typical view — look for original and interesting perspectives.

✔ Read and try the examples in Chapter 9 for composition tips.

✔ Draw every day.

✔ Take drawing workshops and classes.

✔ Read and do the exercises in *Drawing For Dummies* (Wiley).

✔ Sketch the most important points that you want in your drawing first. If you don't want to run out of paper at the edges, plot those items where you want them and work inward.

✔ Draw, draw, and then draw some more. Okay, you get the idea.

✔ Draw some odd-shaped items. Draw something unfamiliar so you draw only what you see, not what you're familiar with seeing. This technique helps you focus on shapes, angles, and relationships because you have few preconceived notions about your subject. You can sharpen these same skills by *inverting* your object (drawing it upside down).

✔ Look at your drawing in a mirror to check for accuracy. Doing this reveals mistakes because you see the drawing in a new way. (This system also works for paintings.)

Blending with Paint

Put away the pencil — you're ready to draw with paint. Here are some exercises to get ready for drawing this chapter's project in paint.

Making a smooth transition

Blending refers to making a smooth transition from one color to another, such as a light to a dark or a cool to a warm. (More on blending in Chapter 4). Making a smooth transition between colors and values is an important skill for your painting career. If you were using a pencil to make a drawing, blending is a way of transitioning the pencil strokes when shading a form. When painting, you are still drawing with a brush, but it is much easier and faster to blend large areas because the wider path of the brush hairs blends quicker than the fine tip of the pencil.

Practice painting a smooth transition from one color to another.

1. Choose two colors of paint.

In Figure 6-6, I use Scarlet Red and Ultramarine Blue.

2. **Get a piece of acrylic paper that measures at least 4 x 4 inches.**

 Any scrap works.

3. **Prepare your palette.**

 Set up your paint by adding enough water to make the paint move and mixing to a creamy consistency with a ¼-inch flat brush. You need a quarter-sized puddle of each color of workable paint.

4. **Paint a vertical stripe of one color on the left side of your paper; stroke a few more slightly overlapping adjacent vertical stripes, each one lighter as you move to the right.**

 Dip your flat brush into the puddle of paint so the hairs are coated halfway up and apply the paint to the paper. Rinse the brush if necessary in order to have the paint get lighter with each stripe. Figure 6-6a shows you this sequence.

5. **Rinse the brush clean in water.**

6. **Paint the other color in a stripe on the right side of the paper.**

7. **Before the two colors dry, use the flat brush to paint more stripes toward the other color, rinsing the brush between colors to keep each color pure.**

 If the paint gets too dry, add a little water to keep it blendable. If it's too wet on the paper, blot with a paper towel.

8. **Let the two colors mix in the center by manipulating the color with your brush (see Figure 6-6b).**

 What you see in the middle is the blending of the colors. In Figure 6-6b, the two sides have blended into a purple middle.

9. **Blend as smoothly as possible by stroking the flat brush through the paint.**

 You may still see streaks in Figure 6-6b, but I blended these colors very quickly. You can eliminate streaks by taking a little more time and making more strokes till it is as smooth as possible. Another trick is to let the first coat dry and put another coat on top so that it blends more completely with a second layer.

Blending to create depth

One of the fun things to do in a drawing or a painting is to create the illusion of depth. In a painting, you create depth by blending light and dark areas. You can apply the blending technique to make a ball appear round, for example. The light and dark areas represent the shadow and light. The shadows and light areas have specific names: The lightest spot where light strikes the three-dimensional object is the *highlight*. The darkest part of the object farthest from the light is the *core shadow*. Sometimes light bounces off near objects and lightens it in an area called *reflected light*. The diagram in Figure 6-7 shows the exact placement of these art terms on a sphere. A *sphere* is simply a drawn flat circle, but with the addition of blended light and shadow, it's transformed into a sphere. The painting surface remains flat, but it looks round — magic!

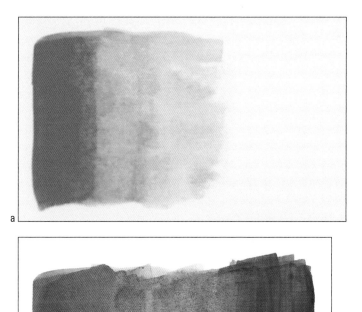

Figure 6-6:
Blend two
colors for a
smooth
transition.

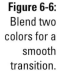

Follow these steps to begin blending for depth in your painting:

1. **Use the same paint from the blending exercise in the previous section and a 4-x-4-inch scrap of acrylic paper.**

 You also need to add white paint to your palette.

2. **Paint a 3-inch circle with a pointed #6 round brush.**

 I used red paint in Figure 6-7.

3. **Paint a dime-sized circle of white in the upper-right section of the circle you just painted.**

 This white spot is the location of the highlight.

4. **Rinse your brush in clear water.**

5. **Mix your two colors equally together on the palette and paint a crescent-shaped stroke around the center of the ball where the core shadow is located.**

6. **Add more of the color you used to paint the initial circle in Step 2 to the core-shadow color from Step 5 and blend paint to the bottom out-line of the circle.**

 Blend following the crescent shape of the core shadow. Using a lighter value toward the outside of the circle creates the reflected light area.

7. **Add the color from Step 2 to the upper edge of the core shadow and blend toward the highlight.**

 Rinse your brush as necessary to be able to blend clean colors. Blend a smooth transition between the white in the highlight and the color above the core shadow.

8. **Paint the cast shadow.**

 Paint the mixed dark color (half red and half blue) for the shadow at the farthest point from the circle. Add some white and the color from Step 2 near the circle. Make a smooth blend in the cast shadow.

9. **Paint the dark at the base of the circle.**

 Where the circle meets the cast shadow you need a dark line crevice. Using a #00 rigger brush, paint this small line with some of the dark purple mix. Your circle has now become a ball or sphere. Continue to blend paint till your figure looks three-dimensional.

See Figure 6-7 for an example of this technique.

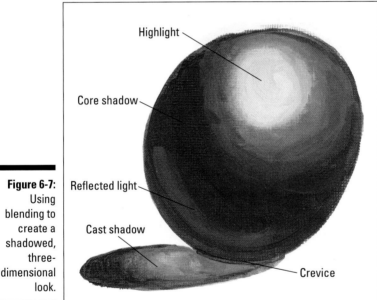

Figure 6-7: Using blending to create a shadowed, three-dimensional look.

Project: Create a Still Life

The earlier sections of this chapter give you all the art tools to paint an apple. If you feel this subject is too easy or you want an additional challenge, stay tuned for the extra credit at the end of this section. *Note:* This project requires making base coats and color bridges on your palette, as well as glazing. If you don't know what those techniques are (or just need a refresher), check out Chapter 4 before beginning this project.

For this chapter's project, I have chosen a thumbnail and made a cartoon. You may use my cartoon to do this project. See Figure 6-8 for the cartoon and

prepare your canvas as described in this chapter. Trace the cartoon, enlarge it, and transfer it to your painting surface. When you're finished, you may want to do the exercise again and make your own decisions for another still life, using another type of fruit or vegetable. Make thumbnail plans. Choose one to enlarge and transfer it to your painting surface. Add paint to make the objects look round. Blend different colors. You can make a whole series of edibles and decorate your kitchen.

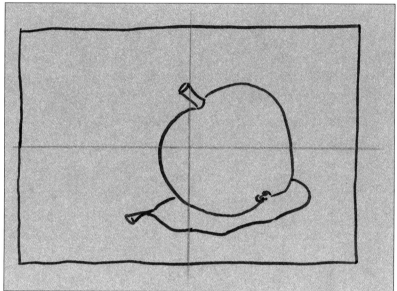

Figure 6-8:
Cartoon for the apple still life.

1. **Prepare your palette with red, green, brown, yellow, blue, and white.**

 Make a dime-sized puddle of each color by following the project instructions in "Making a smooth transition" earlier in the chapter. Any color pigments are fine; my pigments in Figure 6-9 are Napthol Crimson (red), Cadmium Yellow, Titanium White, Ultramarine Blue, Permanent Green, and Burnt Umber (brown).

2. **Make some color bridges on your palette.**

 The bridges (described in Chapter 4) you need are red to blue, red to white, and red to yellow.

3. **Get a piece of acrylic paper measuring 5 x 7 inches and a #6 round brush.**

 You use this brush throughout the project.

4. **Using the #6 round brush, draw the outline of the apple.**

 Dip the brush into the red paint so the hairs are covered halfway. Notice that the apple isn't a perfect circle; you can draw (with your brush) an apple that's out of round or a bit bumpy and your apple will still look fine.

5. **Base coat the apple red.**

 Base coating is described in Chapter 4. Fill in the shape of the apple with red paint. You don't have to worry about shading yet. See Figure 6-9a.

6. **Rinse.**

 Don't forget to rinse your brush between colors so that your colors stay clean.

7. **On your red-blue bridge of paint, choose a purple to put on the edges of the apple.**

 Blend the purple into the red. Try not to make a complete outline — leave some areas around the top edge unshaded. See Figure 6-9b.

8. **Add white on the upper-right portion of the apple to create a highlight.**

 Pull the white away from the light spot to blend it into the red. Rinse your brush as needed to control the color. Use a clean damp brush to manipulate color and make a smooth transition of white into red. See Figure 6-9c.

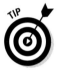

9. **Add some details to the apple.**

 It's easier to do all the blending first before you add the details.

 When the shape of the apple looks round, you're ready to add details. The apple has a stem end and a bottom end, which has the little center leftover from where it was formed after it was a springtime blossom. Use Burnt Umber to paint the stem and bottom. Notice that the stem gets larger toward the top; the bottom of the apple is just a little dot of brown. Add a little white to make half the stem lighter on the sunlit side. If you want to make more details, you may want to look at a real apple for reference. Figure 6-9d shows these added details.

10. **Paint a cast shadow.**

 Use the purple (close to Step 7 purple) from your red-blue bridge of paint to form a shadow resembling the shape of the apple. Figure 6-9e adds this shadow.

11. **Put reflected light in the shadow and the apple.**

 Shadows are transparent — you're sort of painting air. To help with this illusion, put a little red in the cast shadow. Rinse your brush and put a little yellow (selected from the yellow-red bridge of paint) on the bottom of the apple where it touches the cast shadow. Add a little water and glaze the yellow over the dry red apple. (More on glazing in Chapter 4.) The apple separates from the cast shadow with the addition of this reflected light. Blend the colors till they're smooth transitions; add water to the paint if necessary. Figure 6-9f shows the results of adding reflected light.

12. **Finish up the details.**

 Put little dots like pores on the apple in a diluted yellow and pull little lines across the body of the apple in the same color. Put a little light brown (brown tinted with white) on the bottom brown blossom end. All done! See Figure 6-9g.

Extra credit: Want more apple fun? Paint more apples. Arrange a still life to paint: cut open an apple, peel an apple, take a bite out, or leave a core. Get different colors of apples. Put the apples on different surfaces, or change or add a background (backgrounds for still life are covered in Chapter 11). In

Figure 6-10, the same apple I painted in this project is surrounded by a diverse group of others. Notice the reflected light from one apple to the other. The green apple reflects a little of itself into its neighbor, as do the yellow and red apples. Artists have enjoyed recreating this bounced light and reflection throughout art history.

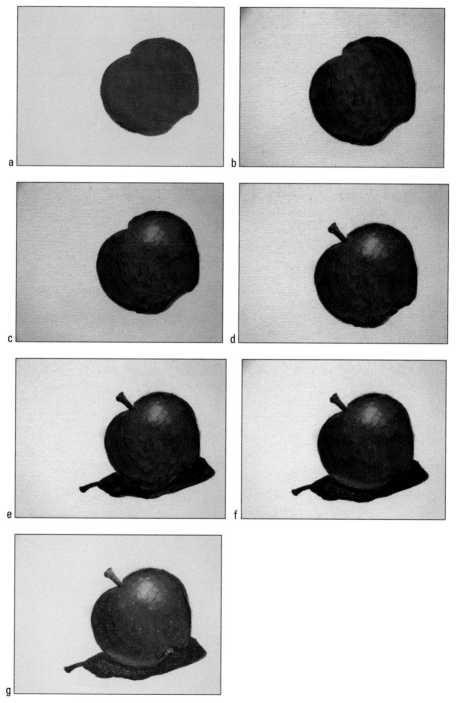

Figure 6-9:
The apple
project from
start to
finish.

Figure 6-10:
More fun with apples.

If you want to try my example, use the cartoon in Figure 6-11.

TIP

Cut fruit like apples turns brown quickly when exposed to air. Squirting lemon juice over the exposed flesh helps prevent browning. Or take a photograph and work from that. Actual models are better because they give you more information to look at, but photos last longer.

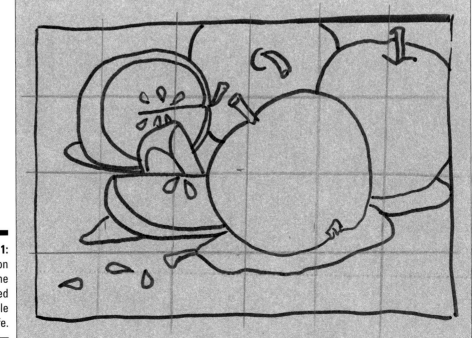

Figure 6-11:
Cartoon for the advanced apple still life.

Part III
Finding the Fun in Fundamentals

In this part . . .

You have to know the rules before you can break them successfully, and that's what this part is all about. The first chapter in this part explores color. The second chapter helps you decide how to arrange your painting subjects using the elements and principles of design. The last chapter in this part shows you how to put it all together for a proper composition.

Chapter 7

Taking a Quick Color Tour

In This Chapter

▶ Recognizing pigment and chemical color names

▶ Creating primary, secondary, and tertiary colors (and mud)

▶ Navigating the color wheel

▶ Exploring value, color temperature, and color mixing

▶ Experimenting with different color painting plans

This chapter is all about color. Here I talk about popular acrylic colors, color charts, give some interesting color histories, and provide a brief refresher in chemistry — all of which can help familiarize you with the gorgeous colors available to the acrylic artist.

Looking at Popular Colors

Certain colors are more popular, and many artists gravitate to them again and again. Familiarize yourself with the colors in this section, and you'll have a reliable base of paints from which to build your palette.

Red

A bright, fiery, attention-getting color, red ranges from a yellowy orange to a deep maroon. Some reds have white added to them, making them pinks and magentas. Reds are perfect for fruits and flowers.

You can divide pure reds into two categories: *red-yellows* (orangey red seen on pomegranates) and *red-blues* (deep, bluish red seen on plums). Some popular paints in these groups include

▶ **Red-yellows:** Cadmium Red, Pyrrole, and Napthol Red

▶ **Red-blues:** Crimson, Magenta, Alizarin Crimson, and Quinacridone Red

Figure 7-1 shows some popular reds.

Red is often a *fugitive* color (not *lightfast*), meaning it can fade. Look for the word *permanent* before buying your Alizarin Crimson, or it will fade.

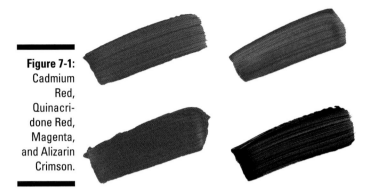

Orange

As you learned in school, orange is produced by mixing red and yellow. A warm and happy color, orange is great in evening skies, desert rocks, and makes a nice flesh tone if you dilute it. *Fruit-like oranges* are the colors you see on tangerines and, you know, oranges. *Dark oranges* are more common in sunsets and Southwest landscapes. The following list names some orange paints:

- ✔ **Fruit-like oranges:** Pyrrole Orange and Cadmium Orange
- ✔ **Dark orange:** Quinacridone Burnt Orange

Figure 7-2 gives some orange samples.

Figure 7-2:
Pyrrole
Orange,
Cadmium
Orange, and
Quinacri-
done Burnt
Orange.

Brown

Deep down, brown is really a dark orange. Earthy browns are good for painting tree trunks and rocks and are essential in landscapes. Browns fit into three general categories: *yellow browns* (coyote fur), *orange/red browns* (sunflower centers), *dark browns* (box of chocolates), and the Cleveland Browns (okay, that last one doesn't count). Common paints in these colors are

- ✔ **Yellow browns:** Mars Yellow and Raw Umber
- ✔ **Orange/red browns:** Red Oxide and Burnt Sienna
- ✔ **Dark browns:** Violet Oxide, Burnt Umber, and Vandyke Brown

Figure 7-3 gives you the lowdown on brown.

Figure 7-3:
Raw Umber,
Burnt
Sienna,
Burnt
Umber, and
Violet Oxide.

TIP

To make your brown even darker, add a touch of Ultramarine Blue. Equal mixes of Ultramarine Blue and Burnt Sienna make a great black. Add water or white to this mix for a gray very close to Payne's Gray.

Yellow

Bright and happy, yellow is another attention-grabber. (Perhaps that's why you chose this book?) Look around next time you're at the grocery store — yellow is the most common color on packaging. You can also find it in nature: Use it for your painted flowers, birds, butterflies, and sunshine. Because yellow is such a light color, the differences in paint are less noticeable than some other colors. Yellows range from lemony to orangey and typically fall into three categories: *yellow-blues* (spring daffodils), *yellow-reds* (ripe yellow peppers), and *earthy yellows* (bobcat fur). The following list gives you some popular paints associated with these categories:

- **Yellow-blues:** Hansa Yellow, Aureolin, and Nickel Azo
- **Yellow-reds:** Diarylide, Cadmium, and Bismuth
- **Earthy yellows:** Yellow Iron Oxide, Yellow Ochre, Naples Yellow Hue, and Raw Sienna

Figure 7-4 illustrates some yellows.

Figure 7-4:
Aureolin,
Hansa
Yellow,
Diarylide,
Yellow
Ochre, and
Naples
Yellow.

Green

The dominant color of nature, green is a soothing, calming, cool color great for painting grass and leaves. You can easily mix up your own green by using blue and yellow or black and yellow. Categories of green include *yellow greens* (spring leaves), *bright greens* (summer grass), *blue greens* (deep ocean), and *earthy greens* (army camouflage). The following list gives you some paint colors in each of these categories:

- ✔ **Yellow greens:** Green Gold
- ✔ **Bright greens:** Hooker's Green, Sap Green, and Jenkins
- ✔ **Blue greens:** Phthalo Green, Viridian, and Cobalt Titanate Green
- ✔ **Earthy greens:** Terre Verte and Chromium Oxide

See Figure 7-5 for some green examples.

Figure 7-5: Green Gold, Permanent Green, Phthalo Green, Terra Verte, and Jenkins.

Greens that come straight out of the tube are often too bright and need a little help from another color to make them look more natural. I like to add a bit of green's complement, red, to neutralize the color into a more natural green.

Blue

Blue is cool and soothing. As the color of water, it's ideal for painting lakes and such (as well as the skies those lakes reflect). You can find two categories of blue: *blue-reds* (distant mountains) and *blue-yellows* (deep water). This list provides common paint colors in these families:

- ✔ **Blue-reds:** Ultramarine Blue, Azurite, Anthraquinone Blue, Cobalt Blue, and Cyan
- ✔ **Blue-yellows:** Manganese Blue, Prussian, Cobalt Teal, Cobalt Turquoise, and Ccrulean Blue

Figure 7-6 is sure to give you the blues.

Figure 7-6:
Cerulean,
Anthraqui-
none Blue,
Cobalt Blue,
and
Ultramarine
Blue.

Cerulean is a great sky color, whereas Ultramarine Blue is a perfect shadow glaze. Be careful with the Phthalo Blue colors — they're very potent and can take over your painting quickly.

Violet

Violet (sometimes called purple) is the color of royalty, spirituality, mysticism, and fun. It's a good shadow color and is especially dramatic coupled with Phthalo Green. Violets fall into three groups: *light violets* (pale amethyst), *purple* (columbine petals), and *dark purple* (ripe plums). Here are some popular violet paints:

- **Light violets:** Cobalt Violet and Smalt
- **Purple:** Quinacridone Violet
- **Dark purple:** Ultramarine Violet and Dioxazine Purple

Figure 7-7 displays the most common violets.

Figure 7-7:
Smalt,
Cobalt Violet,
Quinacridone
Magenta,
and
Dioxazine
Purple.

Cobalt Violet is one of the most expensive colors, but you can mix your own beautiful violets: Try combining Magenta and Cobalt Blue.

White

Technically, white isn't a color. It's the simultaneous stimulation of all three kinds of color receptors in the eye — essentially, it's the sum of all colors.

Because you use white to lighten colors, you'll use a lot of white paint. Sometimes you use as much white as all the other colors combined. Here are the two most popular whites:

✔ Titanium White

✔ Zinc White

Find six white items from the kitchen — something like an egg, a cream pitcher, a glass salt-filled shaker, a cloth, and whatever else. Arrange them in a still life so that some light can fall onto the subjects. Are they all the same white? More than likely, very subtle differences in the items show up as slight colors. Do you see a pale blue white? A yellow white? By painting this still life, you train your eye to see much more in white.

You can also use the canvas primer acrylic gesso (described in Chapter 2) as white in your painting.

Figure 7-8 shows you the two main whites.

Figure 7-8:
Titanium
White and
Zinc White.

Black

Black is the absence of color. When something doesn't reflect light in any part of the visible spectrum, it's black. Use black paint sparingly, because it can be harsh and look like you punched a hole in the canvas. I only use black to darken other colors. But if you need a really dark hole, or a dark shadow under a pot in a still life, black just may be the solution.

Black pigment is created from burning something to get the ash — for example, Ivory Black. (That sounds oxymoronic, because ivory is white, right? The name came from its origin: burning elephant tusks.) Ivory is expensive and rare these days, so bone is a common substitute.

Here are black colors you're likely to encounter:

✔ Mars Black

✔ Carbon

✔ Ivory/Bone

✔ Payne's Gray

Figure 7-9 shows examples of black paints.

Figure 7-9:
Mars Black,
Bone Black,
and Payne's
Gray.

a b c

Because tube blacks are so intense, a better choice is to mix your own black to make a *colorful dark.* Dark opposite colors sometimes mix to make black. A couple favorite mixes of mine are Burnt Sienna and Ultramarine Blue or Alizarin Crimson and Phthalo Green. You can add dark purple to either of these to make a deep black.

Deciphering Paint Descriptions

If you've read other parts of this book, you may have noticed that I often name-drop different paint colors. I admit that sometimes they sound more like something from a chemistry lab than colors. But that's not really a bad thing. When the name includes the chemical or mineral used to create it, the artist has a better idea about what is contained in that color. This section helps you figure out certain terms you may see in paint names or paint descriptions so that you can have a better idea of what you're getting to work with.

Some paints do have normal, recognizable names, such as Daffodil Yellow. The problem with that is that a *daffodil* evokes different colors among different people. More importantly, cutesy names may also indicate a lower grade of paint.

Common chemicals

If you weren't a chemistry major in college, some names of paint colors can be baffling. You'll get used to them with time and use, but to help you speed up that process, I provide a few facts and pronunciations to get you through the supply store. Here's a list of some popular chemical names shared by a number of paint colors:

- **Quinacridone (kwin-*ah*-cre-doan):** This chemical can be yellow, red, magenta, orange, blue, violet, gold, or crimson, and it produces transparent, intensely bright colors that are some of my favorites. The Liquitex brand has registered the name ACRA for its Quinacridone colors.

- **Cadmium:** Cadmium can be yellow, red, or orange.

- **Phthalocyanine:** This chemical can be green or blue and usually appears in paint names as *Phthalo.* The Winsor & Newton brand uses the term *Winsor* to indicate Phthalo colors.

- **Mars:** Mars is made from an artificial iron oxide. It can be orange, red, brown, yellow, violet, or black.

Common descriptors

You often see a qualifier placed after a paint name, like *Light, Medium,* or *Dark.* These adjectives indicate the *value* (lightness or darkness) of the paint. Sometimes tubes of paint rate value on a scale of 1 to 9 from light to dark. The word *deep* can also indicate a dark version of a color. You may also see the term *shade,* which indicates a tendency toward another color. Usually it's a blue with a green shade or a green with a blue shade.

As with many art terms, *shade* has different meanings in different contexts. Along with the definition here, *shade* also describes darkening a color by adding black to it.

Hues

Hues are used as replacements when certain chemicals or colors are unavailable, too expensive, fugitive, or pose possible health hazards. These colors have *Hue* after their names, such as Cadmium Medium Deep Hue.

Don't confuse this definition of *hue* with the word's more general use as a synonym for color (as in, "The hue is red.")

Working the Color Wheel

Colors are arranged in the order in which they appear in the spectrum of visible light. When pure white light (which contains all colors) passes through a prism, it splits into a rainbow of colors.

The acronym ROYGBIV (pronounced Roy G. Biv, like a man's name) helps you remember the order of the colors: red, orange, yellow, green, blue, indigo, violet.

If you bend the spectrum into a circle, it becomes the *color wheel.* The color wheel is a tool that helps you quickly determine the following:

- ✔ **Which colors mix to make other colors:** To make a color, simply mix the colors that appear on either side of it on the wheel. ***Note:*** This mixing formula doesn't apply to primary colors, which can't be created. See the following section for more on primary colors.

- ✔ **Which colors are complementary:** No, these colors don't tell you how nice your hair looks today. *Complementary colors* appear directly across the wheel from each other, like red and green do.

- ✔ **Which colors are analogous:** *Analogous colors* are a set of three neighboring colors on the wheel. Blue, blue-green, and green are analogous colors.

By understanding the color wheel, you can mix any color you want, whenever you need it for your painting.

Making your own color wheel is a great exercise in exploring color, mixing color, and creating a tool that you can use throughout your painting career.

The following sections discuss the components of a color wheel and how to create your own.

Primary, secondary, and tertiary colors

The *primary colors* are the three colors from which all other colors can be made:

- Red
- Yellow
- Blue

In Figure 7-10, I place primary colors at the peaks of a triangle within a circle.

You mix *secondary colors* by combining two primary colors. The secondary falls between the primaries on the wheel. These colors include

- Orange (a mix of red and yellow)
- Violet (a mix of blue and red)
- Green (a mix of yellow and blue)

Tertiary colors are made by mixing a secondary color and one of the primaries adjacent to it on the color wheel. Tertiary colors are

- Yellow-orange (mixed from yellow and orange)
- Red-orange (mixed from red and orange)
- Red-violet (mixed from red and violet)
- Blue-violet (mixed from blue and violet)
- Blue-green (mixed from blue and green)
- Yellow-green (mixed from yellow and green)

Figure 7-10 shows some recommendations for primary colors that blend well together. You can make your own versions of these color wheels if you have the same colors. If you don't, just experiment with the colors you have. You may discover a secret supercolor!

Clear as mud: Using color bias to mix colors (or mud)

Sometimes primary colors don't mix very well to make a pure secondary color — they make mud instead. Why? Well, to get a pure secondary, you need pure primaries. In a perfect world, artists would have perfect primary colors, but in the real world, a primary color often has a bit of another primary color hidden inside it. This other color gives the primary a *bias* toward the hidden color. To create a perfect color wheel in spite of this, use two versions of each primary color, one that biases toward each of the other primaries. For

example, use two reds: a yellow-red and a blue-red. Figure 7-11 shows this wheel setup.

Figure 7-10:
Primary
color combi-
nations.

To mix a clear, bright secondary color, use the two primaries that have each other in them. For example, to make orange, mix the yellow-red and the red-yellow. If you mix in the third primary (or even the primary that has the third primary in it), the mix is muddier — that sneaky third primary creates the *mud,* or mix not as pure as a properly biased combination. For example, mixing the yellow-red and the yellow-blue creates a muddy orange. In the "Looking at Popular Colors" section earlier in this chapter, I divide the primary colors into these bias groups.

Even though mud is typically an unwanted result, it can also make a rich black or a nice gray that's useful in many situations. By mixing complementary colors, you neutralize the colors to a brown or gray — mud. It all depends on your intention. If you understand this theory of mixing color and choosing the proper bias colors to mix, you are in control and can choose to make clean color mixes or muddy neutrals.

Try some different combinations to make different grays. And keep your successful formulas handy so you can re-create them when needed.

Re-create the chart in Figure 7-11 on a piece of canvas paper. First, trace around a saucer or glass to make a quick, accurate circle. Choose colors to fit each primary area and then mix your own secondary colors by using the adjacent primary colors. Place a swatch of secondary color between the two primaries that were used to mix it. Mix a tertiary color by mixing a primary and secondary color and placing the tertiary color between them. Make more than one color wheel to try different versions of the primary colors.

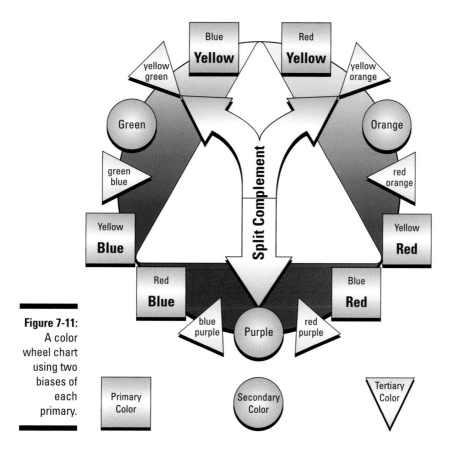

Figure 7-11:
A color wheel chart using two biases of each primary.

Three Color Exercises

The three exercises in this section are great, basic ways to make a painting that concentrates on one, two, and three colors, respectively. The first two exercises are designed to demonstrate that color has value and temperature, and the last one lets you mix primary basic colors.

Each exercise uses the same painting but focuses on a different area or color plan. Doing all three of the exercises makes it easy for you to compare your work and figure out your preferences. You can even hang them in your work area to remind you of the importance of working with value, temperature, and color mixing.

Exploring value with monochrome: The one-color exercise

What's the easiest way to eat an elephant? One bite at a time. Likewise, this exercise lets you dip your toes into the water by painting an entire work in one color (plus black and white).

Black and white aren't really colors — they're *neutrals*. Neutrals don't normally lean toward any color, though some blacks and whites can subtly lean toward a color such as a bluish white or purpley black.

This project focuses on *value,* which is the range of light and dark versions of a color. And that's where black and white come in — they help artists make paint colors lighter and darker. Add black, and you have a *shade* or darker value of a color. Add white, and you get a *tint* or lighter value of a color.

The old masters used this one-color painting technique a lot, often *under painting* (covering the canvas with a preliminary paint layer) the entire work in black and white. (See Chapter 4 for more on under painting.) This technique is a good way to force the artist to deal with value because colors can trick the eye into looking at exciting color and forgetting values. The French term for this technique is *grisaille* (pronounced grizz-*all,* meaning "grayness"), but you probably know it as *monochrome,* which often under paints in *earth tones* (such as browns and ochres) or grays.

The following steps guide you through the one-color exercise in value.

1. **Trace the drawing in Figure 7-12 and transfer it onto a 5-x-7-inch piece of canvas paper.**

 If you plan to do the two- and three-color exercises in the following sections, create three of these sketches now so you can skip that step later.

 You can find instructions for transferring a drawing in Chapter 6.

2. **Gather your supplies: a container of water, a sponge, a pointed #8 round brush, a ¼-inch flat brush, a hole punch, and paint in white, black, and a dark color.**

 The round brush is for painting; make sure you rinse it thoroughly between colors. You can also use three separate brushes (one for each color) if you prefer. Use the flat brush to mix the paint; I use Burnt Sienna (an earthy red-brown) as my dark in this example. The hole punch is somewhat optional; basically, you need to be able to make a decently neat hole in Step 4.

3. **Put dime-sized globs of each color on your palette and blend color bridges between the dark color and each of the neutrals.**

 Chapter 4 has instructions on making color bridges. These bridges provide a full range of values for you for this project. Keep the paint wet by occasionally misting it with a water-filled squirt bottle.

 If you plan to do the one-, two-, and three-color exercises in one sitting, think about setting up your palette in a color wheel-style triangle. Taking this step now will make it easier for you to blend color bridges in those later exercises.

4. **Make a quick value-matching gauge by painting ten increasingly dark values from your bridge on a 1-x-10-inch strip of canvas paper and then punching a hole in each segment when dry.**

 Each value step should be a 1-inch square. Step 1 is pure white, step 5 is pure dark color (in my case, Burnt Sienna), and step 10 is pure black. The holes will allow you to compare your values with those in an already-painted painting.

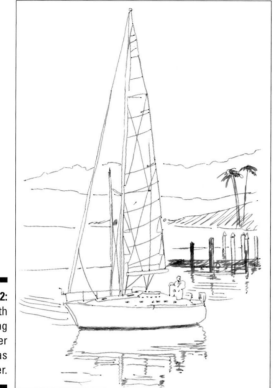

Figure 7-12:
Start with
a drawing
and transfer
it to canvas
paper.

5. **Using your value-matching gauge, identify the color values in Figure 7-13 and paint in the areas on your outlined canvas paper.**

 You can add water if you like to make the paint flow more easily, but be careful not to change the value if the paint is too thin. If the value isn't right after it dries, you can go over it again in another layer to lighten or darken as needed.

 "But wait!" you say. "I'm using dark green, and Figure 7-13 is Burnt Sienna. How will I ever match up the right values?" Never fear; focus on the values by squinting your eyes to reduce the color to just lights and darks. Seriously, try it — it's surprisingly effective. Move along the gauge till you find the closest value match.

Taking your painting's temperature: The two-color exercise

In this exercise, you use two colors to demonstrate *color temperature,* which is a blanket term denoting that colors can be warm or cool. *Warm colors* are the colors of fire: yellow, orange, and red. *Cool colors* are the colors of water: blue, green, and violet. Color temperature is an important concept because it influences the illusion of space. Warm colors look like they advance toward the viewer — red cars typically get tickets faster than blue ones because that advancing quality makes them appear to be going faster. Cool colors look like they recede into space, like the way a blue sky seems to extend farther than a (warm) orangey sunset even though they're the same sky.

Figure 7-13:
A one-color painting uses lights and darks to define areas.

With color temperature in mind, paint a picture by using only a warm color (in this exercise, Burnt Sienna) and a cool color (Ultramarine Blue). The added color gives you plenty of value choices to choose from; you can also mix the two to make a near black.

1. **Trace the drawing in Figure 7-12 and transfer it onto a 5-x-7-inch piece of canvas paper.**

 If you created extras as part of the project in "Exploring value with monochrome: The one-color exercise," you can skip this step. You can find instructions for transferring a drawing in Chapter 6.

2. **Gather your supplies: a container of water, a sponge, a round brush, a ¼-inch flat brush, and paint in white, black, and one warm and one cool color.**

 The round brush is for painting; be sure to rinse it well between colors. You can also use four separate ones (one for each color) if you prefer. Use the flat brush to mix the paint.

3. **Put dime-sized globs of each color on your palette and blend color bridges between the warm color and each of the neutrals, the cool color and each of the neutrals, and between the warm and cool colors.**

 If you tried out the one-color exercise in the previous section, you may already have white, black, and one color on your palette, which means you just need to add a warm or cool color (depending on what you already have). When you mix the two colors in equal parts, you get a near black. Though you use the tube black for making your bridges, use this mixed black for painting your darks — it will harmonize more with the other colors because it was created by the blending of the two. For more on harmony, check out the next section and Chapter 8. Be sure to mist your paint on the palette so it doesn't dry prematurely.

4. **Paint the areas in your drawing outline to match the colors used in Figure 7-14, or experiment with different coloring.**

 This exercise is just to get you familiar with mixing colors, so any result is fine. You may even make it better!

Figure 7-14: A two-color painting uses warm and cool color temperature.

Harmonizing with primaries: The three-color exercise

You may not be able to mix your own primary colors, but if you have those three colors, you can mix everything else. (See "Primary, secondary, and tertiary colors" earlier in this chapter for more on the primary colors.)

If you completed the two-color exercise in the previous section, you may already have two of these colors on your palette. Burnt Sienna is a red-brown. Ultramarine Blue is definitely blue. In this exercise you add Yellow Ochre. These colors aren't required here — use whatever you have on hand — but keep in mind that your final painting will look a little different if you substitute. For help picking colors that work well together, refer to "Clear as mud: Using color bias to mix colors (or mud)" earlier in this chapter.

This project is great because it forces you into a painting that's *harmonious* (all the parts work well together). More on harmony in Chapter 8.

1. **Trace the drawing in Figure 7-12 and transfer it onto a 5-x-7-inch piece of canvas paper.**

 If you created extras as part of the project in "Exploring value with monochrome: The one-color exercise," you can skip this step. You can find instructions for transferring a drawing in Chapter 6.

2. **Gather your supplies: a container of water, a sponge, a round brush, a ¼-inch flat brush, a spray bottle for misting, and paint in white, black, Burnt Sienna, Ultramarine Blue, and Yellow Ochre.**

 The round brush is for painting; be sure to rinse it well between colors. You can also use five separate ones (one for each color) if you prefer. Mix the paint with the flat brush.

3. **Put dime-sized globs of all five paints on your palette and blend color bridges between each pair of Yellow Ochre, Burnt Sienna, and Ultramarine Blue.**

 You don't need to make any bridges for the white and black; they're just for tinting and shading.

 Chapter 4 gives you instructions on creating color bridges. These bridges will create secondary colors: an orange between Yellow Ochre and Burnt Sienna, a green between Ultramarine Blue and Yellow Ochre, and a purple between Burnt Sienna and Ultramarine Blue. Because these particular primary colors are earthy, the mixes will not be very bright. Mist your paint on the palette with water so that it doesn't dry prematurely.

4. **Using the color mixes on your palette, paint the areas within your drawing by using Figure 7-15 as a guide.**

 Don't worry if your painting is a little different than the one in Figure 7-15. This exercise is about mixing paints, so whatever you come up with is fine.

Figure 7-15: A three-color painting mixes all the colors to produce color harmony.

A Few More Color Plans

Having a *color plan* (a limited color palette) is a sure-fire way to improve your paintings. You can use the full spectrum of colors, but it may be more difficult

to organize everything into the design without ending up with chaos. Another, better option, especially if you're just beginning, is to use a limited color plan to create a more unified whole picture. With a few limited colors (plus black and white), you solve design problems like having too many unrelated colors before you even get into the painting.

Three good limited-palette color plans to start with are complementary, split complementary, and analogous (covered in the following sections). These aren't the only color plans by any means — any group you think of can be a color plan, even if it looks terrible. Because everyone has different likes and dislikes, "good" and "bad" plans are largely a matter of taste anyway. Color taste is also very trendy. The "avocado" scheme that people like to mock from the '70s is basically the same as the newer "wasabi" scheme.

The one-, two-, and three-color exercises in the previous section present monochrome, color temperature, and mixed primary limited color plans. The following sections give you three more limited color and one unlimited plan (full wheel) to choose from. In each section, I painted the boat scene from Figure 7-12 in that section's color plan so that you can compare the results. You can choose any of the color plans that you like to make any painting.

Complementary

A *complementary color plan* is a two-color palette that uses any complementary color (opposites on the color wheel) combination. Popular primary-secondary complementary combinations are red and green, yellow and violet, and blue and orange, but you can use any opposite colors you like. Figure 7-16 illustrates this plan using orange and blue and all their mixes.

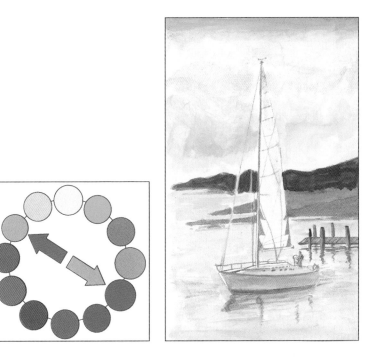

Figure 7-16: A complementary color plan.

Split complementary

In a *split complementary color plan,* you use one color and the adjacent colors on both sides of its opposite color. In Figure 7-17, I used a secondary color (violet), and its split complement tertiary colors (yellow-orange and yellow-green).

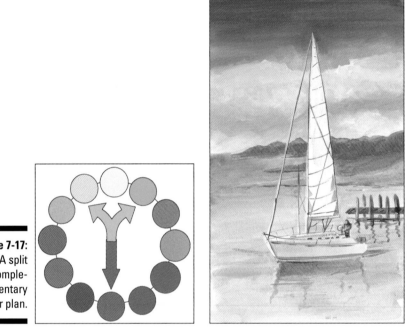

Figure 7-17:
A split comple-
mentary
color plan.

Analogous

An *analogous color plan* uses three colors that are adjacent to each other on the color wheel. A variation on this plan is to use an analogous paint combination and just a bit of the complementary color. Figure 7-18 uses green, blue-green, and blue. The tiny bit of orange (Burnt Sienna) is the complement for a bit of zing (better known as *contrast,* discussed in Chapter 8).

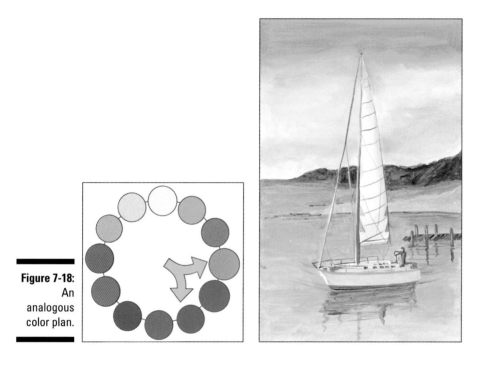

Figure 7-18:
An analogous color plan.

Full wheel

A *full wheel color plan* is exactly what it sounds like: a plan that puts the whole color wheel at your disposal. Sometimes you just need all the colors. Figure 7-19 utilizes the full wheel plan.

If you have trouble getting a feeling of harmony with this plan, try one of the plans in the previous sections to create more color balance. Check out "Harmonizing with primaries: The three-color exercise" earlier in this chapter for more on harmony, and Chapter 9 for info on balance and composition.

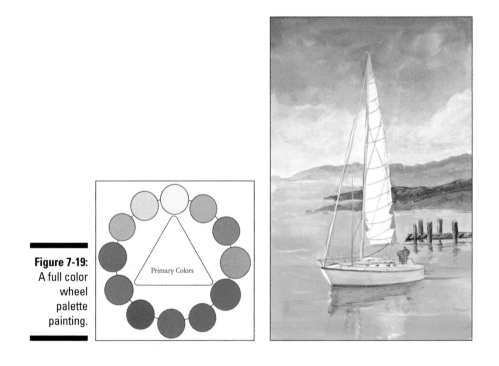

Figure 7-19:
A full color wheel palette painting.

Chapter 8

Design of the Times: Design Elements and Principles

In This Chapter

▶ Describing the elements of design

▶ Exploring the principles of design

Design refers to the particular way an artist puts together paintings. Two things help artists execute design: elements and principles. *Elements* simply mean the building blocks — such as color, value, dots, texture, line, shape, volume, and size — that artists use. *Principles* are rules and guidelines used in producing art.

In this chapter, I define the elements of design and then discuss the most important principles in detail. My hope is you can use these design elements and principles to improve your own work.

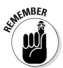

Keep in mind that all the elements and principles presented in this chapter are just words or vocabulary to help people discuss art. By using the same terminology, artists can talk about art together and use the same words. Two people can both be correct even if they see different things. For example, perhaps I say a particular painting illustrates dominance of value, but you think it's balance of direction. We can both be right and discuss why. It's art after all, not math, so there isn't just one right answer.

Elements of Design

Every good visual arts program starts with some basics: the elements of design. The following elements are just some of the things you can use in making art:

✔ **Color:** *Color* is the rainbow of hues: red, orange, yellow, green, blue, and violet. It's such a huge topic that I give it its own chapter — Chapter 7. But very simply, color can be reduced to one word, which you may remember from school: ROYGBIV (pronounced "Roy G. Biv"). Good old Roy is composed of red, orange, yellow, green, blue, indigo, and violet. You can make every other color from a combination of these.

✔ **Value:** *Value* is simply light and dark. Did you notice that black and white are missing from Roy's name in the previous bullet? That's because they aren't colors; white is the reflection of all color, whereas black is the absorption of all color.

In paint, you change a color's value by adding white or black paint to it (creating *tints* and *shades,* respectively). With a little practice, you can make tons of minute, identifiable variations before the color turns essentially white or black. The Cheat Sheet at the front of this book has a handy tint and shade chart.

✔ **Dots:** *Dots* of every size are kind of like the atoms of art — they're the individual points that add up to what you see. When dots become large, they border on becoming shape (which is another element). When you consciously and deliberately use dots to make a picture, it's called *pointillism* or *stippling* (shown in Chapter 4).

✔ **Texture:** *Texture* is the tactile quality of a painting; after all, not all paint dries completely flat on the canvas. Check out Chapter 11 for more on painting with texture. Texture can be real, as in thick chunky paint, or implied, as in having the appearance of a tactile quality yet is smooth when touched.

✔ **Line:** *Line* is a series of connected points. You can paint lines with a brush or scrape them into the paint with a tool (a technique called *scraffito*). Lines can be straight, curved, wavy, or can outline a shape as in a contour line. Lines can be implied, as in objects that line up, or they can be actual, as in a drawn pen line.

✔ **Shape:** *Shape* in art is a container that defines a space or object or the space around the object. Shape splits into two categories: *geometric* (such as circles, triangles, and squares) and *organic* (wriggly and free form). *Negative shape* is the area surrounding the positive shape and is just as important as the positive shape. In painting, shape is mostly two-dimensional — length and width. The depth is an illusion unless the paint is really thick or you're doing a layered collage.

✔ **Volume:** *Volume* (also known as *depth*) is the illusion that a painted object has three dimensions. If working in sculpture, it would be actual three-dimensional space. Chapter 11 lets you practice giving flat shapes the illusion of volume. Similar concepts to volume you may encounter are *mass* and *form.*

✔ **Size:** *Size* represents the amount of space an object takes up within a painting. But size is relative — you have to compare and judge the size of one object in a painting against the sizes of other objects in the work. A marble is large when placed among peas, but small when compared to oranges.

You can use each element of design with each principle of design (discussed in the following section). Figure 8-1 connects each element with each principle so you get a visual image of just how complicated design can become. The good news is that this complexity is the reason you can always find a solution to your design problems. You may think that someone has surely found all the solutions given all the artists and works that have come before you, but rest assured that the solutions are almost infinite. You, too, can find your own solutions to artistic challenges with nothing but simple elements and principles.

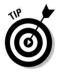

Try using one principle and one element at a time — don't feel obligated to throw everything into one painting from the get-go. Each time you paint, focus on improving one thing. Pretty soon, you'll be ready for a famous gallery (or at least the art show at the state fair).

Figure 8-1:
A list of elements and principles and the tangled web they weave.

The Principle of Balance

Balance is the arrangement of elements so as not to overpower an area with a heavy feeling. It comes in two varieties: symmetrical/formal and asymmetrical/informal. *Symmetrical* or *formal balance* means that each half of a painting is the same; if you drew an imaginary line down the center, each side would have the same parts. *Asymmetrical* or *informal balance* isn't so strict, which is why it's often more attractive in art. With asymmetrical balance, one big thing on one side can balance several little things on the other side. Most paintings utilize informal or asymmetrical balance because it's less obvious and predictable and, therefore, more visually pleasing.

When you're dealing with balance, in art or otherwise, you have to keep weight in mind. In an art context, *weight* refers to how much attention an element commands. Just as several smaller kids balance one bigger kid on a teeter-totter, "weightier" objects in a painting require more, "less weighty" objects to balance them out. The following sections detail how to balance weighty and less-weighty versions of each element.

Balancing color

Some colors weigh more than others. In general, darker colors weigh more than lighter colors, so you want to offset smaller amounts of dark color with larger amounts of light color. For example, red is a huge attention-grabber — it weighs more than a light color like yellow does. You'd want to balance a small bit of red with a bigger area of yellow. Also keep in mind that an isolated color stands out, so weave the colors throughout the entire artwork. I play with color balance in Figure 8-2.

Figure 8-2:
Colors
can be
distributed
to provide a
balanced
composition.

Balancing value

In Figure 8-3, I use black, white, and gray to show the effects of balancing value. Dark values weigh more than light values, so here I use more white than black. See Chapter 7 for more on value.

Figure 8-3:
Larger light
areas
balance
against gray
and dark
areas.

Balancing dots

Dots are weightier than empty space, so work to balance dots with empty space. Figure 8-4 balances dot patterns.

Balancing texture

Rough texture is weightier than smooth texture; you want to be sure to balance out any added texture with smooth areas. In Figure 8-5, I created texture by applying the paint with a palette knife and using scraping and scraffito.

Figure 8-4:
Dots are placed to provide balance.

Figure 8-5:
Texture balances against smooth surfaces.

Balancing line

Lines that move (squiggle, curve, wave, and so on) weigh more than straight lines, so you need more straight lines to balance with wavy ones. Check out line balance in Figure 8-6.

Figure 8-6:
Different types of lines balance each other in this composition.

Balancing shape

Positive shape and negative shape can be balanced. Positive shapes are heavier, but the surrounding area (negative shape) has weight too. Don't neglect negative shape; it's just as important as positive shape. In Figure 8-7, I balance negative shape (the black area surrounding the bottles) with positive shape (the white bottles). I leave all these shapes flat and graphic because adding dimension would introduce another element (volume).

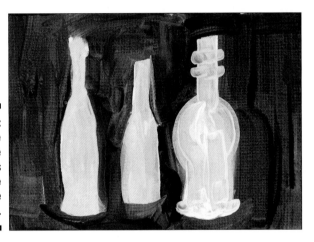

Figure 8-7:
The positive shape balances with the negative shape.

Balancing size

As is typically true in life, large size weighs more than small size visually. You can achieve this balance by offsetting one big item with several small items. Figure 8-8 shows an example of size balance.

Figure 8-8:
The large round circle balances many angular small squares.

Balancing volume

Objects with dimension weigh more than flat objects. In Figure 8-9, some of the circles appear to have volume because I give them shadows to make them look like spheres. However, I leave more circles flat to help balance that effect.

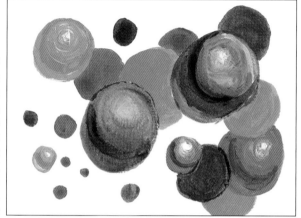

Figure 8-9: Many flat circles balance against a few spheres exhibiting mass and volume.

Play with elements and balance on your own. Pick an element and create a painting that focuses on balancing that element. After you've mastered balancing all the single elements, challenge yourself by trying to balance multiple elements in one painting. It's even possible that you may disagree with one of my examples. Try to improve upon it — you have my blessing. You can even make paintings that don't balance. Then you're working with "discord." Nothing wrong with that either; it's just a way of sending another message.

The Principle of Contrast

Contrast is abrupt, significant change like jumping from black to white. Contrast is best used sparingly — it demands attention, so save it for the most important area in your painting. The following figures show the eight elements by using the principle of contrast.

Contrasting color

One way to show contrast is through color. For example, red is often a great attention-getter in paintings (which may be why most painted cowboys wear red bandannas around their necks). Artistically, red is a great tool for drawing attention to an area. Figure 8-10 uses red to contrast the white, black, and gray background.

Figure 8-10:
A bit of bright red provides contrast to the black, white, and gray composition.

Contrasting value

Value contrast is one of the most popular combinations for a painting. Imagine a bright window letting sun into a dark room. That's value contrast. The background in Figure 8-11 is pretty dark, so the one light spot immediately draws your attention, creating a center of interest.

Figure 8-11:
A bright light makes contrast against a dark background.

A general rule says that a painting's center of interest is almost always the lightest item placed next to the darkest item — in other words, the area of greatest contrast. If you place this pinnacle of contrast somewhere other than your intended center of interest, you may create two areas of attention. If that's what you're going for, great. Generally speaking, however, your works turn out better if you don't divide attention too much, so change the location of your most contrasted values to the center of interest as necessary so you have one star of the show.

Contrasting shape

Figure 8-12 shows contrast on a couple of levels. First, the roundness of the dots stands out against the straight background. Also, because some of the dots are big enough to become circles, you see a contrast in shape.

Figure 8-12: Round shapes contrast against an angular background and straight edges.

Contrasting texture

Figure 8-13 has texture that jumps out as contrast to the soft, graduated background. It also has a bit of color contrast, too, with the hint of turquoise in the texture contrast area.

Figure 8-13: Texture is contrasted against a soft, smooth background.

Contrasting lines

Figure 8-14 is similar to Figure 8-12. Straight lines contrast against soft, undulating clouds. Bonus points if you noticed the value contrast as well.

Figure 8-14:
A stiff hard
edge line
contrasts
against the
soft texture
background.

Contrasting size

Figure 8-15 shows how size can create contrast. The one big square jumps out against the sea of small rectangles.

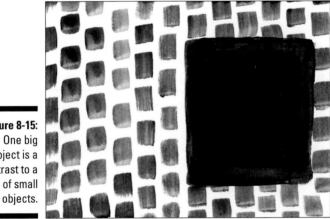

Figure 8-15:
One big
object is a
contrast to a
sea of small
objects.

Contrasting volume

Figure 8-16 contrasts volume. When all the shapes are flat, the one with mass and volume stands out in contrast.

Make a series of thumbnail (small) sketches exploring contrasting the elements. Follow the abstract examples I provide, only apply the principles and elements to real objects in landscapes or still lifes. Choose your favorite thumbnail sketch and make a painting.

Figure 8-16:
One three-dimensional volume is a contrast to a group of flat circles.

The Principles of Repetition, Alternation, and Variation

Repetition itself is pretty self-explanatory — you take an element and repeat it. Here I focus on the offshoots of repetition: alternation and variation.

In alternation, the element is repeated but takes turns *(alternates)* with something else. For example, a pattern in fabric may be flower, leaf, flower, leaf, and so on. In fine art, a great way to make interesting paintings is to alternate value. That means using dark, light, dark, light — like a chessboard, except with shapes. Look for interesting juxtapositions to put alternating values of dark and light.

For example, look at Figure 8-17. Instead of the tree having one solid value, as it may be in real life, the trunk is dark against the light foreground and then light against the dark barn. When the branches hit the light sky, they're dark. This tree illustrates alternation of value.

Fences, ducks, telephone poles, houses, and wires can use the same alternation of value for interest. Save the lightest light and the darkest dark for the center of interest. In this case, the duck presents a double whammy as the center of interest. First, it's the lightest object in the painting. Second, one living thing in a painting — whether an animal, person, or just a face — attracts attention. People like to see other things that look back at them. Adding the darker value for eyes and shadow guarantees that the duck is the center of interest.

Try painting a scene like Figure 8-17, using color but retaining the values.

Variation or variety is the spice of life, and that goes for art, too. In fact, variety is everything. So shake up your elements and principles when you repeat them to avoid monotony. If you use blue, change it to dark blue and then to light blue. If you have a row of trees, make some thick and some thin. Vary their spacing. And for Pete's sake, make them different heights.

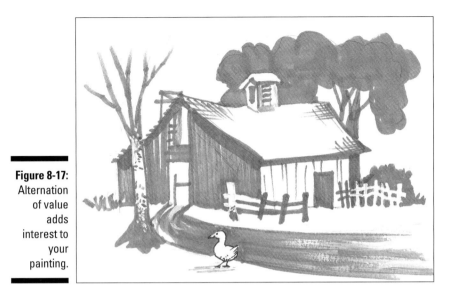

Figure 8-17:
Alternation
of value
adds
interest to
your
painting.

The Principle of Direction

Direction can also be called *movement*. It is the way that the eye moves through the painting. You can use direction in a single line or in the entire artwork. For example, the whole background may have a diagonal direction, giving the entire painting an exciting thrust. The direction of the painting is the perceived feeling of action.

The general direction of a painting comes down to three choices:

✔ **Horizontal:** The overall effect of horizontal paintings is a calm feeling. I suspect it reminds people of lying down and taking a nap. The word horizontal comes from, of course, *horizon* — so landscapes are often horizontal. Figure 8-18 shows a simple horizontal-direction painting. All the colors and lines go in the horizontal direction.

Figure 8-18:
A horizontal
direction.

✔ **Vertical:** Dare I say vertical paintings are uplifting? Portraits and still lifes are often vertical formats. Vertical paintings, such as the one in Figure 8-19, do create a feeling of formality, substance, and rigidity. Of course, that all depends on how the elements within the painting are delivered.

Figure 8-19:
A vertical direction.

✔ **Diagonal:** Slanted paintings are supposed to evoke excitement and throw the viewer a little off balance (in a good way). Of course, the success of this goal is partly determined by the execution of the style, too. Diagonal is my personal favorite painting direction; Figure 8-20 has all diagonal direction lines. Any painting can have a diagonal direction by the way you place the elements. I like to place colors in the background to create a diagonal movement for a little more interest.

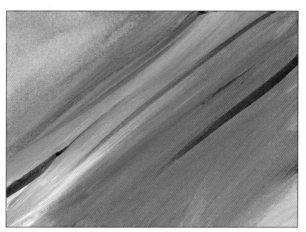

Figure 8-20:
A diagonal direction.

Direction of texture

Figure 8-21 combines texture and direction and pulls diagonally. While the paint was wet, I took a paper towel and quickly pulled the corners through the paint in a fanning motion to produce the texture. Fanning in the way you want the paint to go creates the directional line.

Figure 8-21: Manipulating the paint when wet creates direction.

Try this technique for yourself:

1. **Get a paper towel and fold it in quarters.**

2. **Twist the center to make a handle allowing the corners and edges to be free.**

3. **Use a flat brush to quickly place three colors of acrylic paint in stripes to cover the entire surface.**

4. **Rinse the brush or leave in water to clean at the end of your painting session.**

5. **Before the paint dries, hold the paper towel by the twisted handle and pull the ends of the paper towel through the paint in a flicking, fanning motion, like you were dusting furniture.**

 You will pull the paint in the direction that you pull the paper towel.

 Stop and let the paint dry when you are satisfied with the amount of spontaneous movement.

You can do this technique to realistic subjects too. It looks like glints of light bouncing around.

Direction using lines

Figure 8-22 uses wavy and straight lines in a horizontal direction with a sunny yellow color — and seems not to follow the calm horizontal feeling. It gives a very different feeling than Figure 8-18, which is also horizontal line and shape. The wavy lines and sunny color add excitement, which goes to show that any rule can be broken in art (but always know a rule before you break it).

Figure 8-22:
Direction
of line.

Direction using shapes

Figure 8-23 uses shapes to create a diagonal direction by placing the shapes in that slanted space from corner to corner. A viewer naturally wants to organize like objects and "sees" a line and direction.

Figure 8-23:
Creating
direction by
using
shapes.

The Principles of Emphasis and Subordination

Dominance, or emphasis, and subordination are opposites describing what you choose to focus and not focus on in your painting; you put *emphasis* on whatever feature you want to be dominant, and you *subordinate* the stuff you want to give less attention. Any work of art should have at least one dominant object — a center of interest. If all the elements have the exact same emphasis, you have something like wallpaper, gift wrap, or patterned fabric, which is probably not what you were shooting for. Everything else in the painting should point the viewer toward that emphasized area. Think of a movie: The focus is on the main character, and all of the supporting characters help move her story forward.

Dominance of color temperature

Figure 8-24 uses warm color emphasis, with bits of subordinate cool blue. More information on color temperature in Chapter 7.

Figure 8-24:
Warm
dominance
composition.

Dominance of value

In Figure 8-25, light value is emphasized while dark is subordinate.

Figure 8-25:
Light is
dominant
in this
composition.

Dominance of dots

Figure 8-26 has an emphasis on dots as they grow into circle shapes, moving in a dominant diagonal direction. The eye-catching red colored dots command even more attention.

Figure 8-26: Dots are dominant in this composition.

Dominance of texture

I emphasize implied texture in Figure 8-27 by using a dry brush to paint a rough pattern around the circles. Texture is the dominant element because there's more texture than shape.

Figure 8-27: Texture dominates and shape is subordinate.

Dominance of line

Figure 8-28 uses line as the dominant element by repeating the lines in different directions. The lines also exhibit variety because of their different thicknesses.

Figure 8-28:
Lines
dominate
this
composition.

Dominance of shape

In Figure 8-29, rectangular shapes are the dominant element because no other shapes compete here. The light blue squares are subordinate because the rectangles overlap the squares, which makes them seem like they are in front or dominant. The small dark square is perhaps the most dominant feature because its dark value contrasts the nearby light value. Check out "The Principle of Contrast" earlier in this chapter for more on contrast.

Figure 8-29:
Rectangle
shapes are
dominant
in this
composition.

Dominance using size

In Figure 8-30 the size of the undulating red shape is dominant. As with the dots in Figure 8-26, the red coloring here contributes to the dominance.

Figure 8-30:
Yes, size
matters:
Here bigger
is dominant.

Dominance using volume

In Figure 8-31 the mass of the cube is dominant against a flat orange
background.

Figure 8-31:
The cube,
which
exhibits
form, mass,
and volume,
is dominant.

Paint a miniature set of dominance examples like those shown in this section.
Change something to make them different while still demonstrating the con-
cept. Choose your favorite to make a larger painting.

Chapter 9

Putting the Pieces Together: Composition

In This Chapter

▶ Choosing and placing your focal point

▶ Tailoring design elements to improve composition

▶ Keeping an eye on composition even after you're done planning

*C*omposition is the act of taking all the parts and pieces of design and putting them together to form a whole artwork. (See Chapter 8 for more on design). The goal is to group and organize the elements of art to create unified paintings that communicate what you want to say.

When it comes to composition, there are some rules you should generally adhere to, and this chapter is where I discuss those guidelines to help you make the best paintings you can. If you follow my advice here and work through the suggestions in this chapter, you'll definitely create better paintings compositionally.

Way too often, artists only use composition as a way to critique a painting when it's finished (and yes, that works well), but the best time to use composition is in the planning stages to create a well-designed product.

First Things First: Intention and Placement

Before you begin to paint, you need an idea. What is the main point of your painting? It can be something intangible, psychological, and deep, or, say, a simple exploration of nature through a landscape. You're free to choose to be as simple or complex as you like. Whatever you envision for your painting, you can rely on the effectiveness of certain composition aspects that the history of art has proven over and over again to be very helpful.

If you feel overwhelmed by trying to create something that's never been done before — how can you possibly do it when everything has been done many times? — just remember that it hasn't been done by *you*. You bring something unique to the subject — yes, YOU! Every person approaches the same subject differently, which is why art can never be exhausted.

Determining and placing the focal point

After you decide on your subject matter, narrow it down to the one main object that you want as the *focal point,* or center of interest — an unfortunate term because you should *not* put your focal point in the physical center of the painting. The focal point should go somewhere besides the center, because it's just more interesting to the human eye that way. Art likes the unequal in everything, which is why one of its principles is variation. (Check out Chapter 8 for more on variation and other art principles.)

Following the Rule of Thirds

Renaissance painters used what they called the *Golden Ratio* for proper placement of the center of interest. Precise use of the Golden Ratio involves more math than you probably signed up for, so I don't get into that here. The modern approximation of it — the *Rule of Thirds* — is likely more useful. In short, here's how it works:

1. **Decide first on the outside shape of the painting: rectangular *landscape* (horizontal), rectangular *portrait* (vertical), or some other shape.**

 This landscape and portrait terminology doesn't reflect any sort of requirement about how you paint those kinds of paintings. In this context, the words refer to the direction and not the painting type. You can paint landscapes and portraits in any orientation you want.

2. **Draw lines equally dividing the surface into thirds horizontally and vertically (like a tick-tack-toe board).**

 You end up with nine equally sized blocks.

3. **Pick one of the four intersections of the lines; these are the four perfect spots visually to place your focal point.**

Figure 9-1 shows a landscape-oriented picture divided into thirds, and the circles show the possibilities for focal point placement.

Figure 9-1:
The rule of thirds gives you four choices of placement for your focal point.

Putting your focal point to work

You're not quite done yet — your focal point needs to do a few more things besides just be in the right place. You should orchestrate the picture so that the focal point or center of interest possesses one or more of the following properties:

- ✔ It puts the lightest light value right next to the darkest dark value.
- ✔ It has the most detail — the cleanest, strongest, sharpest edges.
- ✔ It has the brightest, most intense color.
- ✔ It contains the largest shape.
- ✔ It has the most contrast.

The items in the picture other than the focal point should all support it. Everything should point somehow to this area, using such tricks as directional lines, gradation changes, increasing detail, and increasing contrast (these are all elements of design found in Chapter 8). Why only one focal point? Including more than one area of contrast, for example, sets up conflict for the viewer regarding which is more important. You want the composition to make a smooth, satisfying path for the eye to travel. The focal point is the eye's destination and payoff.

In Figure 9-2, the focal point is the closest horse to the viewer. How can you tell? It's located in the bottom third (not the center) in this vertical format, and it's larger than the other two horses. Plus, the land masses and reflections point directional lines to that particular horse.

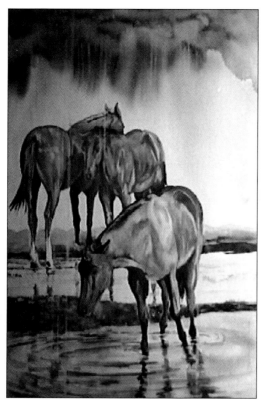

Figure 9-2:
The biggest horse is the focal point.

Give 'em room

Sometimes blank space is just as important as space filled with lines, shapes, and colors. If the focal point is very busy, the eye needs a resting place in the picture. Leave some blank areas (in interesting shapes, of course) for a resting place.

Another space consideration: If you have living things like people, animals, and birds in your painting, don't place them close to the edge of the picture, especially if they're facing that edge — they look like they're ready to leave. Compositionally, your eye follows where the live subject is going, and you may just keep on going to the next picture in the gallery. Arrange your composition so that you keep the viewer looking at your picture.

In Figure 9-3a the profile (side view) of the face is placed too close to the edge of the picture. It feels as if the person doesn't have enough room to breathe. Figure 9-3b shifts the face, giving it more room.

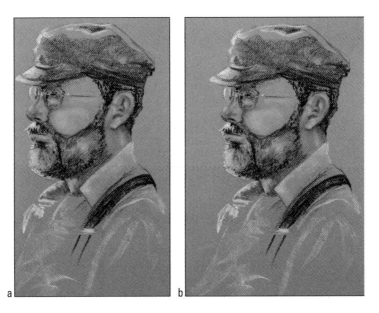

Figure 9-3:
Don't put your focal point too close to the painting's edge.

a b

Off-setting the horizon

Similar to the placement of the focal point, don't put the horizon line in the center of the picture. Putting a horizon in the middle cuts the picture in half and sets up two equal areas of space, which is less visually interesting. Figure 9-4a shows a landscape with the sky and land approximately the same size because the horizon is in the center. By moving the horizon as shown in Figure 9-4b, the areas are different sizes and therefore less monotonous and more interesting.

Setting the mood

Another important part of the composition plan is choosing and executing the *mood* of the painting. Look at other paintings. Go to a gallery or museum

or look through an art book. Which artworks make you feel something? How did the artists evoke that emotion? Creating a mood properly can take a plain painting and elevate it to a higher level.

Figure 9-4: Horizon in the center: bad (a). Better variety in division of space: good (b).

a b

You can set mood through subject and color temperature and/or value. Warm colors and light values are happy, exciting, and uplifting; cool colors and dark values are somber, thought-provoking, and calm. If you're painting a rain storm, you choose darks and grays, with maybe a little contrast in the form of something like a yellow raincoat at the focal point. (I discuss color in Chapter 7 and value in Chapter 8.)

Figure 9-5 uses somber, dark, less-intense colors to create a calm mood. The contrast of the bright sun peeking through the trees is an immediate attention grabber for the focal point.

Figure 9-5: Subject, color, horizontal composition, and dark values combine to evoke a quiet, calm mood.

Create some mood paintings. Make a happy, positive mood painting; a sad, somber painting; and an angry, aggressive painting. Use whatever elements, shapes, colors, size, lines, or values you think will achieve your goal. When you finish, show them to someone else to see if they can guess what mood you were trying to communicate.

Less is more

When creating a painting, look at all the bits you're putting in. Does everything have a purpose? Does everything support the focal point? Or are certain things pretty much clutter? If clutter is the answer, fix it. Leave some things out. Make sure the supporting cast in the picture isn't upstaging the star (the focal point). See Figure 9-6 for an example of a cluttered picture that was simplified.

You're not bound to reality or to some reference photograph — if something doesn't enhance the main idea of your painting, you can leave it out, even if it "should" be there.

Figure 9-6:
The irises are too complex here (a). Simplifying the composition helps the eye to focus (b).

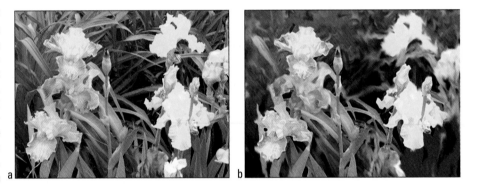

More Composition Guidelines

Aside from the fundamental rules of composition (discussed in the previous section), artists, critics, and art teachers have formulated a bunch of other composition rules based on what they've discovered works best. In this section I share some of these rules.

Throughout this book, I stress that you don't have to be bound by the so-called rules of art, and that's true here as well. *However,* getting away with breaking composition rules takes really strong composition skills — the art police aren't going to put you in cuffs if you don't follow these suggestions, but I've included them here to help you make better paintings, so don't cast them off without knowing them. Just because you don't have to wear a parachute when you jump out of a plane doesn't mean you shouldn't go ahead and strap on that pack.

Going with odd numbers

When choosing how many items to put in your painting, choose odd numbers rather than even numbers. Even numbers can confuse the viewer, giving them an equal choice as to which one to look at. Make one item the star and the others costars. Think of a still life, for example — your best bet is to include three or five items. One item is probably a little sparse, two or four divide the attention, and many more than five become busy.

Of course, every rule has its exceptions. Sometimes objects can group together to form one shape, making them seem like one object. Overlapping shapes is a good way to form a new shape — they look more like one thing, so you can count it as an odd number.

Figure 9-7a shows two gulls as the subjects. The composition would be improved by adding a third gull (Figure 9-7b).

Figure 9-7:
A composition with two similar subjects competes for the viewer's center of attention (a). Three birds, with one being larger with greater contrast, improves composition by providing a focal point (b).

Avoiding tangents

Avoid lining up two items exactly so that they're *tangent* to each other (their shapes touch). Allowing outlines of two different shapes in a painting to touch like that makes it difficult to interpret what is going on. A better composition is to have the items overlap (especially good for creating depth) or to put a space between them. Look carefully at the spaces between items; you want to have spaces of varying widths. If you want items to relate to one another, have them face each other as if they're having a conversation (even if they're inanimate objects — what, you never played with sock puppets?) To improve the composition of Figure 9-7a (in the previous section), which shows two touching pylons, I separated the pylons in Figure 9-7b.

Varying your edges to create depth and to help the focal point stand out

Shapes are contained by three basic types of edges:

- ✔ Hard, crisp edges
- ✔ Soft, slightly blurred edges
- ✔ Lost edges

Use these three kinds of edges to your advantage. Hard edges are good for detail and focal point areas. Soft edges are good for creating depth and space, because they make the object seem a little farther away. Lost edges create mystery. You know the edge exists, but it's not defined at all in the painting and is therefore lost, usually in an adjacent shape. You shouldn't spoon feed all the details of everything to the viewer; they should have to get more involved to know where edges are. (Check out Chapter 10 for more on edges.)

Figure 9-8 shows a portrait that uses all three types of edges to make the focal point — the face — stand out. The sharpest edges and most details are therefore in the face. I used soft edges in the hat and dress, and lost edges above the hands where the body meets the background.

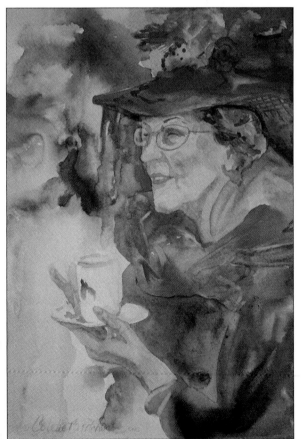

Figure 9-8:
Three kinds
of edges:
hard, soft,
and lost.

Keeping light and shadows consistent

Determine one main light source in your painting and know where it's coming from. All shadows should be headed in approximately the same direction, away from that one light source, as shown in Figure 9-9. Obviously the light source is the sun (or moon) for a landscape, but it may be a light bulb for a still life.

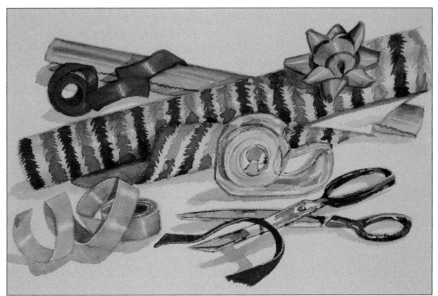

Figure 9-9:
Consistent shadows from one light source.

If you're working from multiple reference photographs, check to see where the shadows fall in each one. If they're different, be sure to adjust them accordingly so your shadows are consistent.

Check Yourself: Analyzing and Revamping Your Composition

Here are some ideas to examine your composition to see whether it's right in the planning stage of your painting.

Thinking, planning, sketching, and then painting, in that order, yield better compositions and much better paintings. Taking the time upfront before applying any paint is always worth it.

Keying the painting

A *key* is a general tendency or emphasis toward something, usually value or color. A light-value painting is a *high-key* painting (see Figure 9-10a), whereas a predominantly dark-value painting is a *low-key* painting (see Figure 9-10b). A few keys you want to be sure to establish are as follows:

✔ **A dominant value key** will give the painting an eye path and interest.

✔ **A dominant color key** will give the painting focus.

✔ **A dominant temperature key** will help set the mood. Choose either warm or cool to be the overall temperature and then have a little of the opposite in the center of interest area. (I discuss color temperature in detail in Chapter 7.)

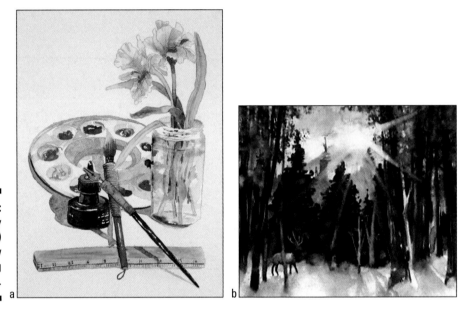

Figure 9-10:
A high key painting (a) and a low key painting (b).

a · b

Thinking in threes

Think in threes (and note that three is an odd number). For example, three areas of importance: big, medium, and small. Dividing your composition into three sizes can provide the variety that makes the picture sing. You can divide any of the elements into these three sizes: color, texture, and especially value work well in three different proportions. Divide the areas of values into three: light, medium, and dark. Make sure that the area each one fills is also different. Make one two-thirds of the picture, one one-third, and the last one just a little bit (in the center of interest). That bit of variety does wonders for making a composition interesting.

Figure 9-11a is an outline of the color photograph in Figure 9-11c. In Figure 9-11b, I use three values (light, medium, and dark) in three sizes (small, medium, and large). As always, variety of value and sizes of shapes makes a more interesting composition.

Try breaking up areas of value into three proportional sizes: large area of light, middle size of medium value, and a small amount of dark for punch.

1. **Make an outline drawing.**

 You may copy Figure 9-11a or make your own drawing.

I even use my computer to make thumbnail duplicates so I can experiment with different value choices. The press of a button on my printer reproduces reduced thumbnail outlines, from four to twelve to a page. If you don't have such technology, just copy the outline with tracing paper.

Figure 9-11:
Outline (a), value study (b), and color study (c).

2. **Take three markers with three different values, and color in areas till you like the plan.**

 The three-value system of sketching is a great way to practice and plan paintings. It also trains your eye to see values. Each value should be divided into different proportions: In Figure 9-11b, the light area is the largest, followed by middle value and a small amount of dark. You can follow my lead or change the order.

3. **Make another study in color.**

 See if you can follow your value study, using colors that have the same values. Squint a lot to check your values (see the nearby sidebar "Tricks for reducing color to values").

TIP

Tricks for reducing color to values

In a world awash with color, you may have trouble reducing those colors to values. Here's a trick to help you see values: Squint. Squint your eyes till you tune out the color and see only darks and lights. Look at your paintings and squint to see whether you have enough values and whether the values make a pattern. The pattern should lead your eye around the composition.

Another trick to isolate values is to use red acetate, a kind of film. You look through red film to see values in your paintings because red filters out the other colors and allows you to see only dark and light. Then you can simplify the areas of value into interesting shapes. Print shops often sell *rubylith,* a red film that blocks light for making printing plates. Photographers also use red lights and film. A graphic arts supplier may have such film, or you can try a transparent red folder from an office supply store.

Cropping

Cropping is the process of removing unnecessary elements from a picture. You can crop in the planning stage or the finished product stage. L-shaped cropping tools help plan a drawing. Hold up your hands, make letter Ls with your index fingers and thumbs (your right hand makes it backwards), and put them together to make a square. In this way you can crop elements out of a scene or a painting with your hands. Moving the square closer to your eyes enlarges the view. When shopping for a painting subject, use these Ls to isolate the subject from the clutter.

You can also use cropping on a final painting. If the painting yielded something you don't like, crop it out. Sometimes a painting has too many things going on in it — improve it by cropping it down into just the good elements that work. One big unsuccessful painting may become three little successful paintings.

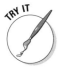

Find an interesting photograph in a magazine. Use your hands as a cropping tool to find several abstract compositions within the photograph. You may like one well enough to use it as a painting inspiration.

Implosion and other shapes

A painting's overall composition should take on a general shape, usually created by your placement of the elements, values, and color patterns.

Imagine an explosion. All the lines radiate away from the center. That would not be a good composition shape for a painting because all the lines lead the eye out of the picture. A better plan is an *implosion:* a swirl directing the eye inward till it reaches the focal point. Other general shapes that work well for composition patterns: the *cruciform* or *T,* the *S* or *Z* shape (depending on which way it's facing), *C, O, X* (without something directly in the center), *U,* and *L* shapes. A triangle is also a great compositional pattern. As if those options weren't enough, you can reverse and flip the shapes for even more possibilities. Figure 9-12 illustrates some composition patterns.

Take the composition examples in Figure 9-12 and apply them to some of your painting ideas. Sketch the compositions on paper. Try using light, medium, and dark values in the proper proportions (small, medium, and large shapes) to plan interesting compositions. Think about which elements capture specific feelings. Make value and color patterns to direct the eye's path. Figure 9-13 shows some of my paintings that use the compositional letter patterns *C, S, L,* and an upside-down *U.*

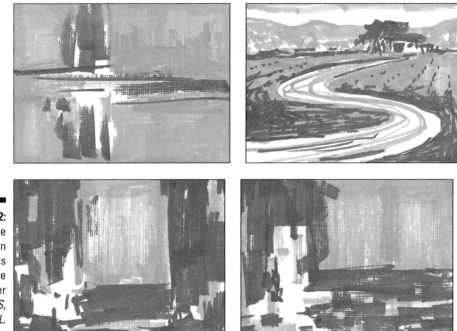

Figure 9-12:
Some composition patterns that use letter shapes: *T, S, U,* and *L.*

Unity: A final checklist

The ultimate question: Does the painting hold together? Do the four quarters of the painting look like they belong together? If not, what is missing? Can it be added? Look at the principles and elements as individual criteria. For example, is everything in balance? Does something feel out of place? You have looked at millions of images throughout your life, so you can't help but have a great intuition when you look at images now. You know when something is wrong. Go through some of the elements and principles and suggestions in this chapter and Chapter 8 to critique and analyze your painting and its composition.

Here's a quick critique checklist:

- Does the painting have a center of interest?
- Is anything too centered?
- Does the painting have odd or even subject numbers?
- Is there an interesting eye path? Value pattern? Colors?
- Is there enough variety? Of edges? Values?
- Does the painting communicate? Ideas? Mood?
- Are the shadows consistent with the light source?
- Are there any "eye traps" created by tangents?
- Do you like it? I hope the answer is "YES"!

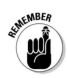

REMEMBER

You have a lot of things to think about when designing a successful composition, and you may feel like you have to juggle all the parts at the same time without dropping any. Don't worry — many correct decisions happen intuitively.

Figure 9-13: Paintings with the composition letter patterns *C, S, L,* and upside-down *U.*

Part IV
Acrylic's Versatile Styles

"I painted still lifes for a long time, but I'm slowly getting into figure drawing."

In this part . . .

This part's chapters show you how to manipulate acrylic paints to look and act like watercolors and oil paints. You also discover the ins and outs of creating an abstract painting. Finally, this part gives you tips on creating edges and shadows when painting a still life, a landscape, and an abstract.

Chapter 10

Letting It Flow: Creating a Watercolor-like Landscape

In This Chapter

▶ Thinning acrylic paint to a watercolor consistency

▶ Painting beautiful all-weather skies

▶ Creating hard, soft, and lost edges

▶ Planting realistic-looking trees in your landscapes

▶ Using layers to create perspective and distance

▶ Putting the techniques together to paint a landscape

*A*crylic paint, when thinned enough, can look and act like *watercolor paint,* a water-soluble paint that rehydrates when you get it wet. Because it's so thin, it lies absolutely flat on paper. Watercolor is identifiable by its transparent glow from the white surface, juicy washes, and mingling colors.

So why not just use watercolor paint if you want a watercolor look? Well, even though acrylic and watercolor can look alike, acrylic offers some advantages that go beyond what watercolor is capable of doing:

✔ **Acrylic paint allows you to use white paint.** Transparent watercolor doesn't use white paint — you leave empty space on the white paper when you want that color, which means you have to carefully plan which areas of white space to save. Acrylics offer white paint, which gives you more planning options

✔ **Acrylic additives can give you more time to work with the paint.** Both watercolor and acrylic dry quickly. Acrylics, though, have products that extend the *open time* (window in which you can work the paint), such as retarder and acrylic glazing liquid. Check out Chapter 3 for more on additives.

✔ **Acrylic mistakes are easier to correct.** When watercolor is dry, you may be able to *lift* (erase) or move the paint by applying water to make corrections, though that may cause running and lead to additional mistakes if you're not careful. With acrylic, you can just paint over the top.

✔ **Acrylic paint is more reliable for painting layers.** Painting layers in watercolor may make layers beneath blur or run. After acrylic dries, however, it doesn't move. You can paint on top of a dry layer of acrylic paint and if you don't like the result, simply wipe it off before it dries.

Allowing your acrylic paint to run and flow where it wants can be fun, challenging, and rewarding. In this chapter, I give you several techniques to help you achieve a watercolor look with acrylic paint, plus a landscape project that puts them all together. This chapter focuses on landscape painting, but you can use many of the techniques I discuss in other types of paintings as well. (**Note:** Throughout this chapter, I'm talking about *fluid* acrylic paint, the kind that comes in bottles. You can use acrylic paint that comes in tubes or jars and thin the paint with water or acrylic medium. I provide a complete description of mediums in Chapter 3.) I like the paint to be the consistency of cream for these techniques.

Born to Run: Thinning Acrylic to be Like Watercolor

Before you can paint acrylics like watercolors, you have to thin your acrylic paints to a watercolor consistency. It's a pretty easy process:

1. **Squirt a nickel-sized puddle of fluid acrylic paint (in the color of your choice) on your palette.**

2. **Squirt a nickel-sized dollop of acrylic medium near the paint on your palette.**

 Acrylic medium is colorless paint (with the same molecular structure as regular paint) used to thin paint. You can also use water; just have a cup of it handy.

3. **Using a brush, mix the paint and the medium (or water) together till the mixture is a creamy consistency.**

 Add water or medium by dipping the brush into the liquid and adding it to the paint. Swirl the paint and liquid together till the paint becomes the consistency of cream. If you dilute thick paint it may take several brush loads of water/medium. Fluid acrylic may be thin enough so as to need no water/medium.

The following exercise gets the paint flowing. You can let the paint dry between colors or let the colors flow together by applying them all when wet. In fact, try both wet and dry techniques to see what happens. The surface (canvas paper) can be wet or dry. To make it wet, simply use a flat brush to apply clear water to it, making a damp (no puddles) surface. When you apply paint to a wet surface, it escapes into the water. It travels into the wet area and leaves exciting edges and unexpected textures. It may feel out of control, but that's part of the fun. Let the water do the work and see what happens. When you apply paint on a dry surface, it will stay where you place it. This is a good way to do details.

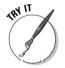

Here's how to play around with thinning acrylic paint to see how it works for you:

1. **Get a 6-inch square piece of acrylic paper.**

2. **Prepare your palette by thinning paint as described earlier in this section.**

 I chose four different colors for this exercise.

3. Use a ¼-inch flat brush to apply some paint to the top edge of the paper. Dip the brush in the thin paint so that the hairs are covered halfway and paint a stripe from edge to edge at the top.

4. Tip the paper vertically and let the paint run down, misting it with water as necessary (see Figure 10-1a), and let dry when you're satisfied.

5. Rinse the brush in clear water.

6. Rotate the paper one quarter of a turn and repeat Steps 3 through 5 with another color of paint (see Figure 10-1b).

7. Keep rotating and repeating Steps 3 through 5 until you've done all four sides (see Figure 10-1c).

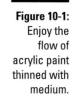

Figure 10-1:
Enjoy the flow of acrylic paint thinned with medium.

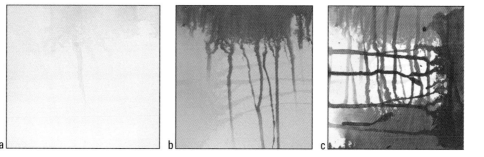

a b c

Feel free to play around with this exercise until you have a good feel for how much water or medium you need to thin the paint to achieve the kind of results you want.

The Sky's the Limit: Painting Translucent Skies

Clouds, rain, and sky are perfect painting subjects for a watercolor technique. Less is more when painting sky. A background of blue with a sweep of white paint into the damp blue background produces the look of clouds and sky with little effort. You can paint a rainy sky quickly by applying a stripe of gray paint on a predampened surface and allowing the paint to "rain" by tipping the surface to allow gravity to pull the paint down into the water.

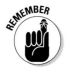

Watercolor technique lets the water do the work. Let it flow, and don't be afraid to lose a bit of control.

The logical way to paint a landscape is to work from back to front: You paint the things that are farthest away first — that way you can paint over the top of that layer instead of having to be careful and paint around things. Using watercolor forces planning to save the white space on the paper for clouds, but acrylic can achieve the look by painting over the blue sky with white paint, saving you time.

With that in mind, the first place to start, naturally, is the background, because it's farthest away. In a landscape, that is usually the sky. Almost anything else

in your landscape (mountains, trees, fields, buildings, water, and so on) is bound to be closer than the outer atmosphere. So if you want a background of one plain color, such as a blue sky, paint it first and then paint clouds on top of it.

Riding off into the sunset

Thin layers of paint can simulate the real layers of color and air in a sunset. Because the paint is transparent, the white surface peeks through from underneath the paint and helps create the illusion of the glow.

In the following exercise, you can experiment with painting a multicolored sky, such as a sunset.

Note: Even though you'd usually paint a sunset with your paper in horizontal *(landscape)* orientation, do this project with the paper in vertical *(portrait)* orientation, with the paper propped up off the table so the colors can flow down easily. (Check out the preceding section for more on tilting the paper to promote running.) After it's dry, you turn the paper back horizontally, and the flow becomes the layers of color in the sunset.

The following instructions show you how to use thinned acrylic paint to make a watercolor-esque sky.

1. **Arrange a 5-x-7-inch piece of canvas paper at a slight incline on your table (propped against something about as thick as a deck of cards) so that gravity does the blending work for you (see Chapter 6 for more on blending).**

 If the paper sags, support it with a board, drawing pad, or piece of plexiglass.

2. **Squeeze a few (separate) nickel-sized dollops of paint and medium onto your palette, choosing colors to make a vibrant sunset.**

 Use your *color wheel* (see Chapter 7) to choose colors that are neighbors (analogous). Say, for example, that you have a blue sky but you want a yellow sunset on the horizon. If you allow the yellow and blue to mix directly, you end up with a green sky, which you probably hadn't planned on painting. To avoid a green sky, separate the yellow and blue with red. The blue mixes with the red to make purple, and the yellow and red blend to orange. You get a rainbow of colors that look like a proper sunset — without green.

3. **Using a ¼-inch flat brush, pull about one quarter of the medium toward each paint dollop and mix them slowly, rinsing the brush between colors and making sure to leave some pure color and pure medium to add later.**

4. **Rinse the brush and use it to dampen the paper with clear water where the sky will be.**

5. **While the paper is damp, apply paint along one side in a strip about half an inch wide, starting at the top and pulling the color down the page.**

 Use the flat brush to dip into a color halfway up the hairs. Go back and forth till you cover the amount of paper you want, letting the color fade

toward the edges of the strip, which will come in contact with the other colors to allow a blend with other colors.

6. **Rinse the brush, change colors, and repeat Step 5 until your sky is finished, blending the colors into smooth transitions where they meet.**

 If your paint is too streaky, let the paint dry and then add another layer by repeating Steps 4, 5, and 6 again over the top to achieve a smoother transition between colors.

7. **After your paper dries, turn it horizontally.**

 Your sky is ready for you to paint scenery on top of it (see Figure 10-2).

Figure 10-2:
Paint fluid acrylics vertically to create flowing sky colors and then turn the paper horizontal when dry.

Raindrops keep falling on my head

You can also use the flowing paint to make a rain storm. Follow the steps in the "Riding off into the sunset" section, but orient the paper horizontally and use a blue-gray color along the entire top of the damp paper. Tilt the paper and let the water move the color down like rain; you can even tilt at an angle if you like. Figures 10-3a and b show a photograph of a rainy sky and an acrylic painted rainy sky.

Figure 10-3:
A real rainstorm and a painted sky with flowing acrylic.

a

b

Hard edges

Hard edges are distinct, crisp, and defined — you know exactly where the object starts and ends. Notice the hard edges in Figure 10-5. Painting a clean, hard edge can be as simple as using your brush and letting the paint do the work. To paint a crisp, hard edge, paint on a dry surface so the paint doesn't leach into a wet space. If you're painting a hard edge, such as a building side, there's no shame in using a ruler to define a straight line.

You can also create a hard edge placing a bit of masking tape along your desired edge and painting right up to the tape. Use tape that doesn't pull off paint, such as a low-tack tape found in the paint department of hardware stores. I especially like white artist's tape because it's acid free and comes in a variety of widths. (More on the importance of acid-free products in Chapter 2.)

Figure 10-5:
This cloud has a hard edge; you can definitely see where it ends and the sky begins.

Soft and lost edges

Soft edges are less defined. Think of a camera shot that is a little out of focus — the edge exists, but you have to really look at it to decide where it is exactly. Soft edges often indicate that items are farther away in space in your painting, like looking out your window and seeing fuzzy edges on a tree 100 feet away.

To make a soft edge, blend the paint into another color using a soft brush. You can also fade the paint away by adding medium or water to the wet paint to make it gradually disappear. Another little trick to soften edges is to *gently* sweep a big, soft mop brush back and forth across the cloud. If the background color is still wet, this blends the colors together subtly

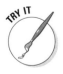

Here's an exercise to help you practice creating soft edges:

1. **Get out a piece of canvas paper, a paint color of your choice, and a ¼-inch flat brush.**

2. **Dip the brush into the paint and make a half circle stroke (see Figure 10-6a).**

3. **Rinse the brush clean in water, blotting excess water on a sponge.**

4. **Apply a stroke of clear water repeating the same half circle stroke below — but not touching — the inner side of the painted circle (see Figure 10-6b).**

5. **Do another brush stroke of clear water between the two strokes, so that the brush touches both.**

 This stroke brings the paint to the damp area and makes a soft edge, as shown in Figure 10-6c.

6. **Continue to stroke using clean water, working the paint out gradually, to make a soft edge using dark to light values.**

 You've now made the outer edge of the circle as a hard edge, and the water-softened other side as a soft edge. Figure 10-6d shows the final result.

Lost edges are edges that have completely disappeared. The edge fades away and becomes lost in another item. Lost edges ask viewers to get involved by having them make their own decisions as to what is going on in the scene. In Figure 10-7 you see some of the soft edges of the cloud vanishing into the sky color.

Figure 10-6:
Creating a
soft edge.

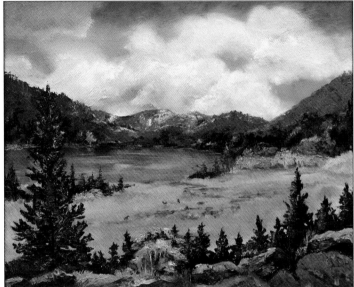

Figure 10-7:
Soft and lost
edges on
clouds.

To make lost edges, allow the shape with the edge to fade into whatever is beside it. Perhaps the values (light and dark) become very close, and the viewer can't tell where the object stops and the background starts. (More on value in Chapter 8.)

You can use any comfortable method to hold your brush, but I like to have a more random way of placing paint, and the following position gives me more flexibility: At the farthest point from the tip, the back of the handle, grip the end of the brush as you would a stair railing (see Figure 10-8a). Loosen your grip a little. Teeter the brush by wriggling your pinky, ring finger, and middle finger. Your index finger and thumb, then, are really all that are holding the brush. Practice twisting the brush in your hand. Roll the handle using your index finger and thumb. Artists often hold their brushes in this fashion to give the brush more freedom to make expressive marks. Another way to hold the brush is like a pencil, as in Figure 10-8b, which gives you control for small detail work. All edges can be created with any way of gripping the brush. It is applying the paint and what goes beside it that defines the edge.

Figure 10-8:
A couple of
ways to
hold your
paintbrush.

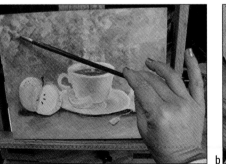
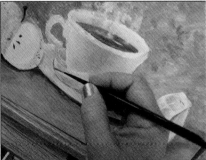

a b

Try painting some clouds using the brush grips described in the preceding paragraph. Roll the brush when applying paint. Try pushing paint toward you and pulling the paint away from you. Every so often, rinse the brush and apply a little water to soften an edge. Concentrate on making a variety of edges. You may even add other colors. Often clouds reflect pinks, oranges, and yellows from the sun.

Seeing the Forest for the Trees

Trees are an important part of many landscapes — I spent a fall afternoon looking at the fabulous foliage of Colorado. Check out the variety of trees in the photo shown in Figure 10-9.

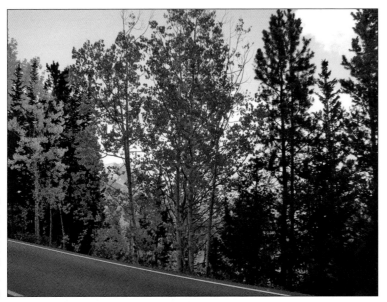

Figure 10-9: Fall trees are defined by many edges.

Nature is inspiring, of course, but trying to paint it can be a bit daunting. However, with some fairly easy tricks you can simulate the edges of complex leaf patterns. In this section, I show two different techniques for painting trees using thinned acrylic paint. Be sure to notice the variety in edges: hard, soft, and lost; for more on these kinds of edges, see the preceding section.

Defining tree edges by painting and spattering

Painting every leaf on a tree can be too much visually, not to mention a lot of work. I like to simplify a tree by *not* putting in all the details. The edge is what

defines the tree. The center of the tree in Figure 10-10a, for example, is simply colors that have mixed and mingled on damp paper.

In Figure 10-10b I spattered the leaves on with a toothbrush loaded with paint (more on spattering in Chapter 5). Spritz water with a spray bottle to make the spatter move. This technique works really well for creating random texture with thin acrylic. The paint can mingle and create new colors by running together.

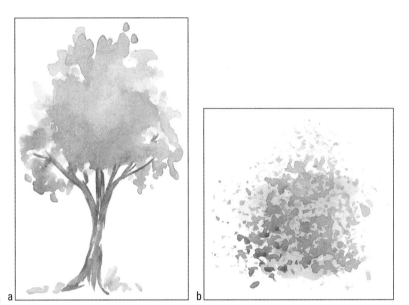

Figure 10-10:
Two techniques for creating interesting trees.

a b

If you're in the mood for some fun, try spattering a tree:

1. **Cover any areas where you don't want paint with a rag or towel.**

 Spattering is messy, and the paint can and does go more places than you want. I always have some paint-covered terry cloth towels dedicated for this purpose.

2. **Dip an old toothbrush in water-diluted paint.**

3. **Grab the handle of the toothbrush so your thumb can pull the bristles back and let the paint fly.**

4. **Rinse your brush, change colors, and spatter some more.**

5. **Spritz the painting with water and let the colors flow together.**

 Note: Too much water can mix the colors too much, giving you a muddy result. Less is more.

6. **Pick up a brush and gently move the color together to fill in the center of the foliage.**

To contain the mess, put the painting in a box — the sides help trap the paint. To save your manicure, dip your fingers in dishwashing liquid before you paint. The undercoat of soap should help the paint wash right off your skin. Don't let the paint dry anywhere you don't want paint permanently.

Making a tree brush out of rubber bands

You've probably seen all those specialty brushes available in art stores. Whenever you need a new gimmick, by all means go buy one and try it. But you can also make your own.

Here's a fun homemade brush handy for painting leaves on trees. I know several artists who paint their leaves by using this method and get unbelievable details. The project at the end of this chapter uses this brush to make the aspen tree leaves and wildflower-like colors in the grass.

1. **Gather up a bunch of rubber bands.**

 They can be different sizes and colors. The example in Figure 10-11a uses about a dozen bands.

2. **Tie them together tightly with cord near the center of the bundle.**

 Almost any cord, twist tie, or even wire works. Secure it firmly with a square knot or wire twist (as shown in Figure 10-11b).

3. **Wrap the excess cord several times around one half of the bundle and secure it with a slip knot as shown in Figure 10-11c.**

4. **Trim the ends of the rubber band evenly (see Figure 10-11d).**

 A dab of white glue on the tied cord allowed to dry overnight really secures the brush. See Figure 10-11e for the final product.

You can make different brushes for a variety of textures by choosing wider or narrower bands, or by tying more or fewer rubber bands together. You may like this brush so much that you want to make a more sophisticated handle — as it is, you just grab it by the tight, corded end.

Try out the brush by dipping it in some paint and pouncing it on some paper. It produces exactly the type of detail that can indicate leaves on a tree. Change colors to make it interesting. Mist the painted dots with water sprayed from a squirt bottle to soften the dots.

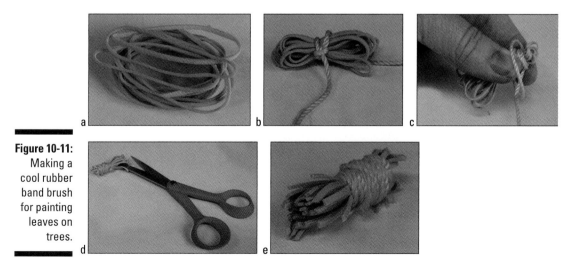

Figure 10-11: Making a cool rubber band brush for painting leaves on trees.

Layering Paint for Endless Possibilities

When you first conceive a painting, it seems like a lot to paint. But remember, you don't paint it all at once. Usually, you work up a painting in layers. A *layer* is one coating of paint that you apply and then leave to dry. You can then paint another layer on top of the first, followed by another and another and . . . well, you get the idea.

Look for the farthest distant object or area to start with in your painting. In a landscape (the focus of this chapter), that is usually the sky. (In other kinds of paintings, it's something else — in Chapter 11, for example, the background of a still life is the cloth on a table.) Then you add whatever is next closest. In a landscape that may be a distant hill, mountain, or group of trees. You continue moving forward, painting closer and closer objects.

Getting a little perspective

To create the illusion of distance, artists use the concept of aerial perspective. *Aerial perspective* uses the following tricks to make two-dimensional objects, such as forms in a painting, appear as though they exist in three-dimensional space. As objects get farther away from the viewer, they

- Get smaller
- Become grayer or cooler (bluer — more on color temperature in Chapter 7)
- Have less discernible detail and softer edges

As they come closer, they

- Get bigger
- Become warmer (redder)
- Have more details and sharper, harder, more defined edges

Backgrounds, middle grounds, and foregrounds

In a landscape, imagine that you're dressing a stage like the director of a play does. She has to account for the back curtain or set, the middle area where some of the action takes place, and the front of the stage that is closest to the audience. Your painting should have the same three areas — the *background, middle ground*, and *foreground*. By putting all three areas in a painting, you emphasize the depth and create the illusion of three-dimensional space.

Figure 10-12 shows the basic layering strategy, using a patch of visually close land with some grass on it to illustrate. Just follow these steps, being sure to let each step dry before moving on to the next to keep your edges crisp.

1. **Paint some color onto canvas paper and then texturize it by dabbing with a crumpled paper towel.**

 This swatch serves as your foreground practice area (shown in Figure 10-12a).

2. **Paint around the area where the grass will be.**

 This technique is called *negative painting*. The grass is the positive shape, so when you paint what surrounds it, you're painting the negative shape (Figure 10-12b). More on negative shapes in Chapter 8.

3. **Use a liner brush to add lines that represent blades of grass.**

 Vary your colors to make the grass more natural. You may have some dried brown grass, some new tender green shoots, and some mature grasses with seed pods. (See Figure 10-12c.)

4. **Dab paint on the foreground using a rubber band brush.**

 In this case, the results look like seed pods, wildflowers, and whatever else may be in the grass (Figure 10-12d). (You can find instructions for creating a rubber band brush in the section "Making a tree brush out of rubber bands" earlier in this chapter.)

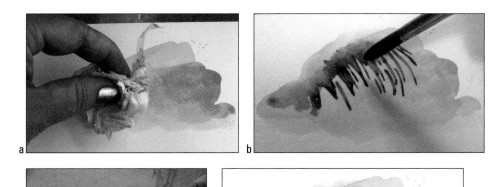

Figure 10-12:
Building a typical foreground.

Project: Putting Together a Watercolor-like Landscape

This project combines all of the techniques covered in this chapter to paint a real landscape, complete with background, middle ground, and foreground. As you may expect, it involves layers and using color temperature to create depth of space (check out Chapter 7 for info on color tricks). Let each new layer overlap at the top edge of the previous layer's bottom edge. Remember, layers get warmer as they come toward the viewer.

I didn't sketch this project first — you can just paint over areas if you want to change something you've done. You don't have to make an exact copy of my project if you don't want to; just look at the example as a guideline.

1. **Choose your canvas paper size.**

 I did the example here on a piece of 5-x-7-inch canvas paper.

2. **Squirt out dime-sized blobs of white, yellow, orange, green, blue, black, and purple onto your palette, replacing them as necessary as you work.**

3. **Get water, some paper towel, a sponge, and the following brushes: #10 round, #000 liner, #4 round, and #1 round.**

 I describe brushes in Chapter 2 and more setup details in Chapter 4.

4. **Paint the sky layer.**

 A. Mix a sky blue (cobalt blue) color. Choose and adjust your color so it looks like the sky you want. A quarter size of blue got a dime of white added.

 My cobalt blue was too dark, so I added some white till it looked like a Colorado sky. My blue leans toward purple (to get more of a purple blue, add a touch of red, such as Alizarin Crimson).

 B. Use the #10 round brush to apply an even coat of blue, painting around the shape of what will be your cloud (leaving the cloud area white).

 Be sure to paint underneath the cloud as well.

 C. Before the blue is dry, rinse the brush and paint a cloud by swirling on white paint with the brush lying nearly parallel to the paper.

 Create soft edges between the cloud and the blue sky for visual interest. See Figure 10-13.

5. **Use the dry #4 brush to gently swirl around the sky, cloud, and the cloud's edges to soften it till it looks natural, blending paint where necessary. Let it dry when you're happy with it.**

 You may need to go back to add more color and soften edges till you like the sky.

6. **Paint on a distant mountain layer.**

 Use the round #10 brush to apply a greener blue (such as Phthalocyanine Blue). Add a touch of orange to neutralize the blue on your palette (see Chapter 7 for more on neutralizing color). See Figure 10-14.

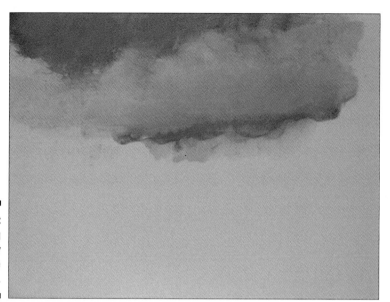

Figure 10-13:
Painting your sky in the background.

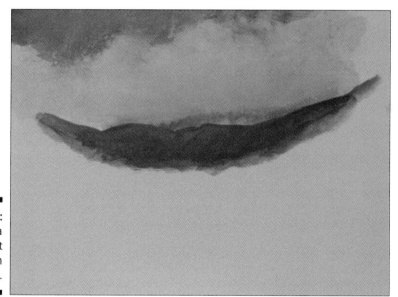

Figure 10-14:
Painting a distant mountain range.

7. **Paint the edge of a far layer of trees.**

 A. Make a color bridge of green paint by mixing yellow to blue.

 You can choose many different greens along this blend of paint. Head to Chapter 7 for more on creating color bridges.

 B. Alternate painting yellow-greens and blue-greens to make a jagged tree line that defines the next green mountain layer.

 Use the point of the round brush to make little triangles along the tree line that defines the top of the mountain. Vary the height and width of the triangle shapes as well as the spaces between them. See Figure 10-15.

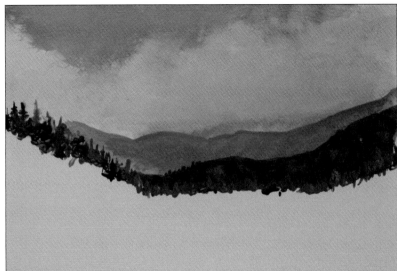

Figure 10-15:
Adding a far tree line along a mountain ridge.

8. **Fill in a closer, green mountain layer beneath the trees with more greens.**

 Use the point of the round brush to apply a variety of the green paint colors created in Step 7A. By dabbing the paint using the tip of the brush, you can quickly produce the look of the triangular shapes of many trees on the mountains. See Figure 10-16.

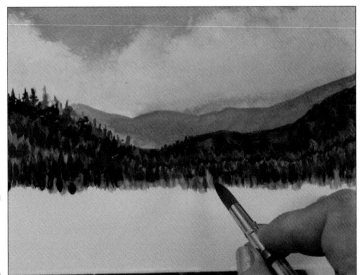

Figure 10-16:
Adding in green mountains.

9. **Paint the foreground with warm colors such as yellow, Yellow Ochre, and orange.**

 Add some grass areas using negative painting, rubber band brush dots, and liner brush-painted blades of grass. Follow the foreground example from the project in "Backgrounds, middle grounds, and foregrounds" earlier in this chapter for guidance. See Figure 10-17.

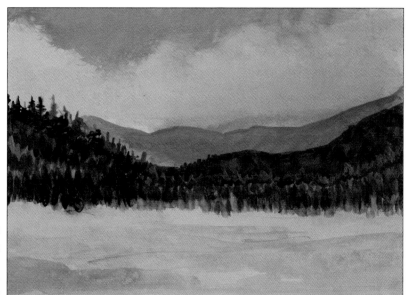

Figure 10-17:
Creating a
foreground.

10. **Add as many details as you like.**

This step lets you personalize your painting and try the techniques discussed in this chapter and elsewhere in the book. Use a rubber band brush to add more details in the foreground and trees. Glaze on warm yellows to bring trees forward or separate more layers, or glaze on cool blues to push other areas back into space. (See Chapter 4 for more on glazing.) See Figure 10-18. You're done! You have a beautiful watercolor-like landscape.

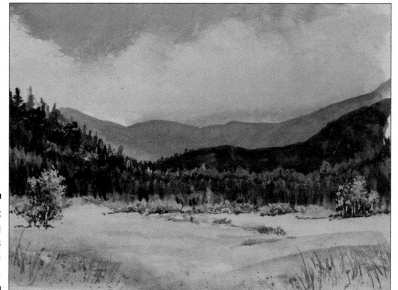

Figure 10-18:
Adding
details
to the
foreground.

Extra credit: You can add even more layers. In Figure 10-19, I added a wildlife layer: the elk in the foreground and the birds in the sky. You can add whatever you like. Notice how the elk's dark-value legs stand out against the light yellow meadow foreground. (Check out Chapter 9 for more information on values.) The elk gives the painting a center of interest, and the birds direct the eye back up into the painting.

Now, some landscape purists like only land, trees, and sky in their landscapes — in other words, no buildings or wildlife. Humbug. You add whatever you want.

Figure 10-19:
Adding a
layer of
wildlife.

Chapter 11

Laying It On Thick: Painting Like the Oil Masters

In This Chapter

▶ Preparing to paint oil-esque acrylic works

▶ Using oil-like techniques to create acrylic masterpieces

▶ Painting oil-textured dogs and corn (but not corn dogs)

Many new artists choose oil because they think it's what's best — after all, oil painting has been the queen of painting for centuries. However, if the old masters had possessed the technology of acrylics, I think they would have preferred those. Using some of the techniques and tips I discuss in this chapter, you can make acrylic paint achieve the look of oil without the risk (many of the old masters suffered from lead and cadmium poisoning) and with many more advantages. Acrylic paint is entirely capable of producing thick, rich paintings like the museum oil masterpieces.

This chapter aims to acquaint you with the pros and cons of oils versus acrylics and provide lots of ideas on making your acrylic paintings as good-looking as any oil-based one — leading up to three projects that can help you bring it all together at the end of the chapter.

Getting Ready to Create an "Oil" Masterpiece

Acrylic paint's versatility allows it to easily mimic the look of oil paint (as well as watercolor and other types of paint) without a lot of the hassle. In order to produce your own oil-like masterpiece with the ease that acrylic paint affords, you just need to do a little prep work. Your first orders of business are to amend your acrylic paints to extend their drying time and to choose and prep an appropriate surface on which to paint.

Extending your acrylic's drying time to mimic oil

Oil paint takes a long time to dry — up to six months. Who has time for that? On the other hand, the long drying time allows for more painting time to

blend colors while the paint is still wet. Acrylic paint typically dries very quickly, but you can extend drying time to give yourself a bit of the time luxury available to the oil painter. You have a few options:

- ✔ **Slow-drying acrylic paint:** Some recently developed acrylic paints have a slower drying time than normal acrylics. For example, Golden Paints (a manufacturer in New York) makes a line of paint called Open that stays wet ten times longer than regular acrylic paint. As with all acrylic paint, slow-drying paint's drying time depends on air temperature, humidity, and thickness of the paint. However, you still notice a significant increase in the amount of time your paint stays wet. For instance, in a humid environment like New York, the slow-drying paint can take several days to dry, where as the same application of these paints in a hot, dry environment like Arizona may dry overnight.

- ✔ **Retarder additive:** Several manufacturers make *retarder,* a clear additive that you can mix with any acrylic product (including paint, of course) to slow its drying time. It comes in a few choices for length of drying time.

 Be careful with retarder. If you use more than 15 to 20 percent retarder to 85 to 80 percent paint, the paint stays tacky and never fully dries!

- ✔ **Acrylic glazing liquid:** Several manufacturers make a glazing liquid designed to extend the open time of acrylics to allow time for blending and glazing effects. These products act like a retarder yet fully dry without a tacky feel. They contain binder (retarders don't), and you can use them in any ratio.

All acrylics, mediums, slow-drying acrylics, and retarders are compatible. If you use the slow-drying acrylics, wait 30 days before applying a final varnish. An oil painter needs to wait six months to varnish (see the sidebar near the end of the chapter for more on varnishing).

Sometimes I want to paint the background of a painting and have it dry quickly so I can start working in more layers. For this purpose, plain old regular acrylics are a good choice. Sometimes I want to blend clouds and sky and take my time — that is a good time for some slower drying acrylic.

Choosing and prepping a surface

Of course, you can't paint without a surface to paint on. Prepared canvas is the go-to surface for oil paintings because the oil will leach and spread across a more absorbent surface like paper. Plus, oil also needs to breathe (because it continues to oxidize forever), and the open back of canvas allows air to get to the canvas. Acrylic paints won't leach and don't require the extra air as long, but using them on canvas helps you achieve the look of oil tradition with less hassle. If you want to use canvas, head to Chapter 2 for instructions on prepping the surface with gesso.

Many artists like the feel of canvas fabric because it gives a little when they push it with their brushes. However, canvas is easily punctured, and the flexibility of canvas increases the risk of cracking or loosening paint from your painting (acrylic paint is less likely to crack than oil, but it's still possible). For acrylics, I like to use *cradled boards,* which are made from wood (usually maple) and available in many sizes. They're a bit more expensive, but also

save money because they don't require framing. If they're raw wood, prime with acrylic gesso for better results. Preprimed boards are ready to paint.

Trying Oil-Inspired Techniques

Oil painting is still popular because it's rich in techniques that help painters make beautiful art. An old masterwork has so much depth because the painter used many layers of thinned paint to build up a surface quality. The shadows and forms look so real you may think you can reach into the painting and pick up a piece of fruit from the still life.

By learning a few oil-inspired techniques, you can produce virtually the same results with acrylic paint. This section shows you how.

Painting backgrounds with aerial perspective

The first step in making a painting, whether oil or acrylic, can be a bit daunting; looking at that fresh, empty white canvas can inhibit the creative juices. But just getting some color over the white can help overcome your inhibition, so be bold, get some paint out, and start blocking in a background.

With backgrounds, whether you're painting a landscape, portrait, still life, or an abstract, start at the farthest point away and paint items in order as they get closer to the viewer. That makes it easier to overlap things in the painting and create the illusion of space.

A fun way to start is to put several colors on the canvas and blend them with a big brush. If you get it too blended and wish you had stopped earlier, add more paint and try again. See Chapters 6 and 10 for more on blending.

Backgrounds should support the subject matter. The subject is a gourmet meal, and the background is the good china.

Backgrounds can also influence the final painting. In Figure 11-1, I painted concentric circles of warm colors radiating out from the sun. I didn't completely blend them, so you can see the separate colors and brush strokes. The background peeks through the overpainted layers, giving the final painting a unified feeling. (I discuss unity more in Chapters 8 and 9.)

Blurring the background focuses even more on the subject. Using *aerial perspective* is a technique to make the illusion of depth and focus even greater in your painting. The rules of aerial perspective are as follows:

- ✔ Things get smaller as they go back into space.
- ✔ Things get grayer and darker (less intense) as they recede.
- ✔ Less detail is visible the farther away something is.
- ✔ Things tend to get cooler (bluer) the farther away they are.

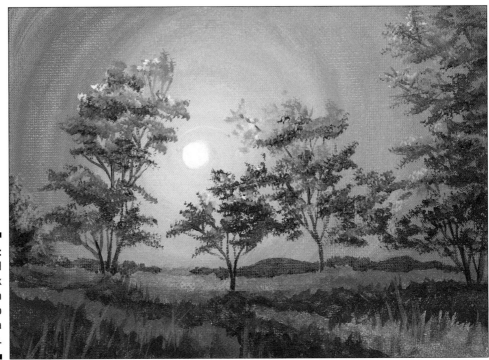

Figure 11-1:
Background
colors peek
through
layers to
unify a
landscape.

Figure 11-2 uses aerial perspective. See how the foreground signs are legible? You can even see the products in the front of the fish market. As the space recedes into the distance, objects get smaller and have fewer details, and you can't read the signs clearly.

Figure 11-2:
Aerial
perspective
uses size,
detail,
color, and
intensity
to create
depth.

Getting a sketch onto a dark background

You may just paint without drawing your subject first, but sometimes I think it's easier to paint if you have a sketch to go by — it's like making your own coloring book page. The *sketch*, or drawing, is an outline of the shapes that you fill with shadows and colors when you paint. In Chapter 6, I show how to resize and transfer a drawing to the painting surface with graphite paper. But what if you've painted the background a dark color?

Well, you can also transfer a drawing onto a dark surface. Here's the trick: Graphite paper comes in colors, including white. When you trace your drawing with a piece of white graphite paper underneath, the drawing is transferred onto the painting surface with white lines that show up beautifully on dark colors.

Overlapping

Overlapping (putting one thing in front of another) also helps create the illusion of depth that oil paintings often feature. When you place things side by side, their appearance has a flatter feeling (think of cookie cutter shapes lined up), but overlapped shapes create the illusion of distance. To create more depth and space in your painting, overlap shapes so that one is clearly in front of another. The more you overlap things, the deeper the space appears to be. Check out the illusion of space created by overlapping horses and riders in Figure 11-3. It would be a much different painting if the horses and riders were all in a row with no overlapping.

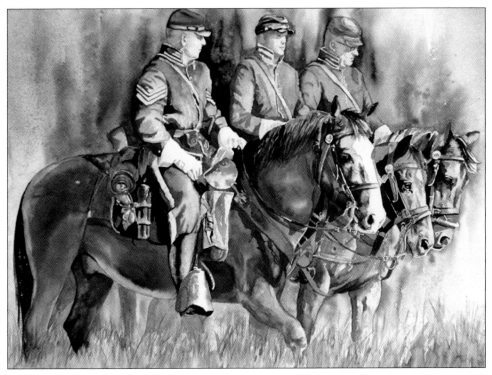

Figure 11-3: Overlapping horses and riders create the illusion of space and depth.

Creating texture

Look at a Van Gogh sometime — even a print. You can see the texture of the paint so clearly you almost want to run your fingers over it (but if you're reading this sentence at the Van Gogh Museum in Amsterdam, resist the urge). Texture can be real or implied. You can thicken paint and make physical peaks and valleys in it, or you can paint a texture that looks like bumps and rough spots yet when touched is smooth. Implied texture is an illusion. Incredibly precise painting that looks very real (textured) is called *trompe l'oeil* (pronounced tromp-*loy*), which means "fool the eye" in French. When you want to reach out and pick up an object on a painting, you know it's a trompe l'oeil painting. The following sections give you tips on creating these real and imaginary textures.

Using paste to create canvas texture

Oil paintings have incredible texture because the old masters used layer upon layer of paint to build the textures up. However, you can get the same look in acrylics with less paint by using paste to create texture. *Pastes* are basically thick goos formulated with various additives for different effects. In general, pastes are heavier than the gel mediums and aren't clear (because of their additives) — check out Chapter 3 for more on pastes.

To get the look of thick oil texture without wasting any paint, sculpt the modeling paste into whatever shapes you want by piling up the paste while wet. This paste requires an overnight drying time (though it dries more quickly the more thinly you apply it), so you have plenty of manipulation time. Make some indentations in the paste with a palette knife to create even more texture (such as indicating kernel lines in "Project: Fall Corn Still Life" later in this chapter). Figure 11-18 later in the chapter shows the paste process in the context of the Fall Corn Still Life project.

Using gesso to create canvas texture

Many oil masters used canvases textured with lead white — now considered quite toxic. However, modern science and acrylics have provided artists with improved products for their health and safety: *gesso* (a kind of primer). (Chapter 2 gives you more info on gesso.) By painting on gesso with a stiff brush, you can make swirls, crisscrosses, or other random patterns. If you want a stipple-effect texture, apply the gesso with a mini roller.

Using texture brushes

You can buy special *texture brushes* that can help you paint implied textures. These brushes have different shapes designed to make lines, fur, grass, waves, feathers, and other textures. Their stiff bristle hairs carry large paint loads for thicker paint distribution. (Check out Chapter 2 for more brush talk.)

Figure 11-4 shows three texture brushes and the textures they create. The top brush is a #10 *filbert comb,* a ratty, tapered brush. When I bought it, this filbert comb was packaged in a set designed specifically to paint fur and feathers.

The middle brush is a ¼-inch flat *rake*. The well-named rakes are similar to combs except they have a longer rattiness for even more pronounced lines great for grass and fur. The bottom brush is a *Wave* (made by Dynasty FM Brushes). Surprise — its end has a wave shape. It makes quick work of painting scales on a reptile, and you can surely come up with a hundred other uses. You can find many other brush shapes in an art supply store.

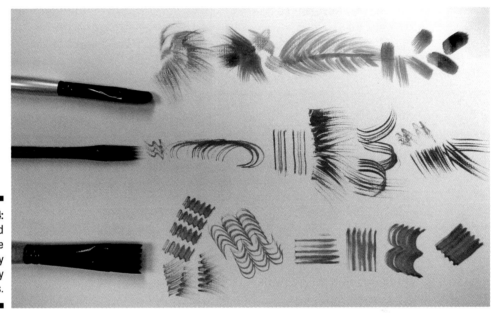

Figure 11-4:
Implied texture made by specialty brushes.

Using streaks and blends

Colors can be *blended* to make beautiful, gradual transitions between one color and another. You make a blend by stroking the brush over the paint many times until there's a subtle change from one color to the next such that you can't tell exactly where the change happened.

However, you don't have to blend paint completely all the time. Try a *streak,* a complicated-looking (but incredibly easy) stroke where you use multiple colors on one brush at the same time. Dip the end of the flat brush in one color and then dip just the tip of each corner in different colors. Stroke it on the surface and leave it alone — blending, though tempting, only loses the spontaneity. In Figure 11-5 I dipped a flat brush in three colors and stroked the paint onto the canvas paper in one pull. I made the thick and thin effect by twisting the brush to use the wide side and narrow edge.

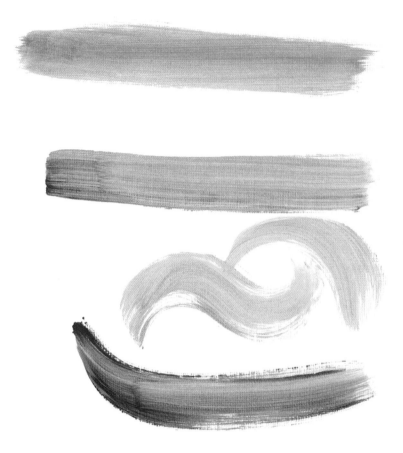

Figure 11-5:
Paint streaked — applied with one stroke but with several colors on the brush.

Using mediums, gels, and pastes to influence paint texture

Acrylic manufacturers offer a variety of ways to make your acrylic paint act like oil. Acrylic paint comes in two basic *viscosities* (thicknesses) of paint: regular, thick paint (an oil-like consistency often called *heavy-bodied* or *high-viscosity*) and a liquid version known as *fluid* or *soft-bodied*. You can make either of these paint types even thicker or stiffer by adding mediums, gels, or pastes into the paint. In general *mediums* are thin enough to be pourable, gels are *thicker* than mediums but thinner than pastes, and *pastes* are thick and usually look white or opaque. None of these products contains color; they're made out of exactly the same stuff as the paint but without the pigments. If you're looking for lots of texture, try adding extra heavy gel into heavy-bodied paint. See Chapter 3 for more on mediums, pastes, and gels. For *impasto* painting (a thick painting technique popular with oil painters), you can use acrylic paint and make it even more dimensional by adding heavy gel to simulate the look of chunky, deep oil paint that stands up and gets noticed. In Figure 11-6, I built up some impasto texture. This figure is a close-up of the Fall Corn Still Life at the end of the chapter.

Using scraffito

Oil painters use scraping or *scraffito* (more description in Chapter 4) to add dimension and detail, and you can do the same with acrylic. Scraffito allows you to draw texture (such as tree branches or grass) into the wet paint. Just use a palette knife (or credit card corner or chopstick — whatever works) to scrape lines before the paint dries.

Figure 11-6:
Impasto
painting.

Figure 11-7 shows a variety of scraffito textures. I incised lines in the paint by pulling the knife edge slowly through the paint in a scraping motion; by hurriedly scribbling through the paint; and by scraping in layers — first one way and then another.

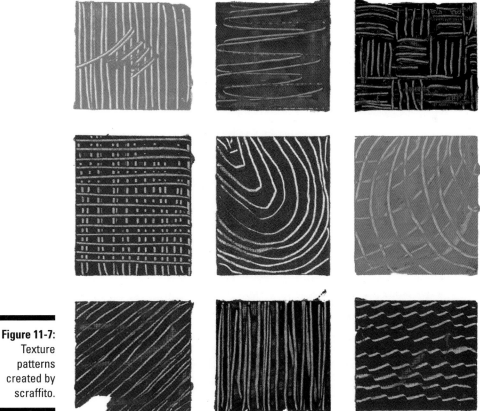

Figure 11-7:
Texture
patterns
created by
scraffito.

TRY IT

Create your own version of Figure 11-7. Use painter's (or masking) tape to mask off box areas and then apply various paint colors and scrape designs and lines while the paint is still wet. When you're finished, wait till the paint is dry and remove the tape by carefully and slowly pulling it away from the

surface, gripping the tape as close to the paint surface as possible to avoid tearing or peeling up paint with the tape.

Simulating depth with shadows

Shadows in a still life often guide your eye path through the entire painting. (More on eye path composition in Chapter 9.) In general, adding shadows to your acrylic paintings helps achieve the depth and lifelike look associated with oil.

Shadows are critical to realistic-looking paintings (oil-like and otherwise) and are another important way to show depth. To turn flat shapes into three-dimensional forms, employ some shadows. In Chapter 5, I show you how to turn a circle into a sphere by using shadows, but circles aren't the only shapes that benefit from shadows: A square can become a cube, a triangle becomes a pyramid — well, you get the idea. Even better, almost all objects can be created by using such basic shapes and forms. Master them, and you're a long way toward being able to paint anything. Figure 11-8 gives flat shapes *volume* (a more rounded look) by the addition of shadows.

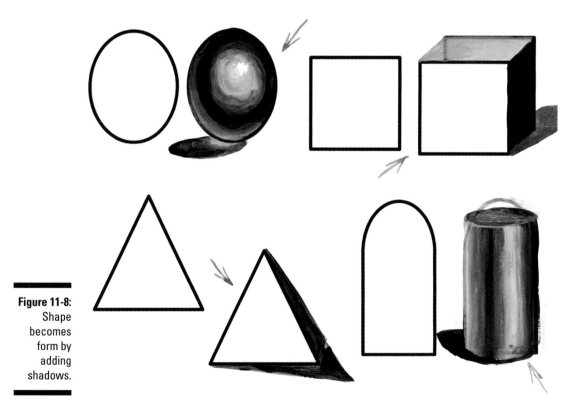

Figure 11-8:
Shape becomes form by adding shadows.

Creating shadows with glaze

How do you paint shadows on real things? Shadows are of course a bit darker than the surface upon which they lie. They're also transparent. You can see

through shadows to see details within the shadow. An easy way to paint shadows is by making a *glaze* — a very transparent paint color. You can easily make acrylic paint more transparent by adding medium, acrylic glazing liquid, or water to it. You then paint the glaze over an area to darken it without obliterating the details beneath the paint. (More on glazing in Chapter 4.)

I like to use Ultramarine Blue for shadows. Observe shadows in real life to see whether you can detect this or different colors. Figure 11-9 shows the blue shadows on a white iris.

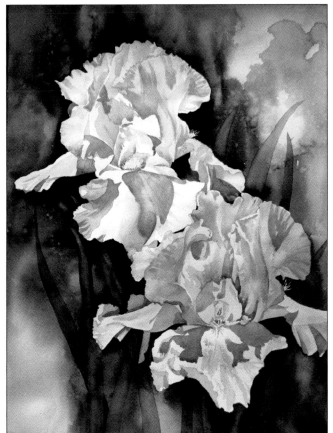

Figure 11-9:
Blue
shadows on
a white iris.

Shaping shadows

The shape of a shadow is important. Shadows should have an interesting shape that describes the surface, helps direct the eye around the picture plane, and defines the object casting the shadow. Think of a silhouette — a shadow shape.

The shapes of shadows are often more important than an object's interior details when it comes to making a drawing recognizable. The shadow shape in Figure 11-10, for example, lets you identify Abraham Lincoln without much detail at all.

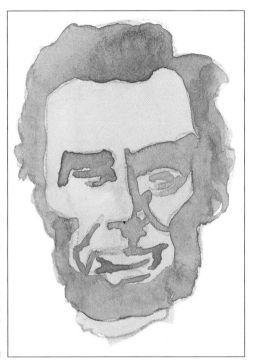

Figure 11-10:
A shadow shape quickly identifies the subject without details.

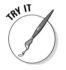

Want a cool oil painter trick to make still life come to life? Make shadows work for you by painting little highlighted areas of interest like dew drops and gemstones. This technique comes in handy in the "Project: Fall Corn Still Life" section later in the chapter, but it works for other things besides corn: beads, eyes, jelly beans, water drops, and about any other small, round item you can think of. Here's how to do it:

1. **Paint the shape in one color.**

 For the example in Figure 11-11a, I made a kidney-shaped dewdrop by using a #6 round brush and acrylic paint in Phthalo Blue and white.

Figure 11-11:
A kidney shape becomes a dewdrop.

a b c

2. **Paint one side dark and one side light and then blend, adding white to lighten as necessary.**

 In Figure 11-11b, light is at the bottom and dark is on top.

 If the result doesn't look quite right, let it dry and try again with a layer on top.

3. **Finish with a shadow and a highlight.**

> I painted the shadow in Figure 11-11c by using pure dark color beneath the drop. I made the highlight by painting a curved line of white paint over the dark top area.

Shadow shapes also work to describe landscapes, still lifes, and abstracts. *Values* (lights and darks) can be organized throughout the painting to make a pattern. Value patterns help direct the eye to look throughout the entire composition. But avoid isolated darks or lights. Give your values plenty of friends so they don't get lonely, and the painting should end up being well balanced with an interesting value pattern.

In Figure 11-12 you see a still life (a), its drawing with a value pattern (b), and the path the eye takes (c) to follow the value pattern. Planning a value pattern in this manner can improve your paintings.

a

b

Figure 11-12:
Shadows create a path or value pattern that guides the eye through the painting.

c

Project: Irresistible Husky Dog

Here's the first of three projects that provide great opportunities to paint with some of the oil techniques discussed earlier in this chapter. Wildlife has interested many oil painters over the years because the medium lends itself to making detailed fur, highlighted eyes, and beautiful blended backgrounds. Lucky for you, acrylic also works perfectly to paint these things. Spirit, the sweet dog in Figures 11-13 through 11-17, gives you a chance to work with shadows and fur textures, using high-contrast white and darks.

Practice on a test paper with your rake and combs before you go straight for the canvas. Dip the hairs into the white paint and work on creating wisps of hair on scrap paper. The paint should be a creamy consistency to create fine lines.

1. **Gather water, a spray bottle, a sponge, your brushes (#4 and #10 filbert comb, #6 round, and #10 flat rake), and several small pieces of plastic about 5 inches square.**

 The plastic can be a grocery bag or sandwich wrap — I used the cellophane wrap the canvas was sold in.

2. **Get a prepared surface of your choice about 8 x 10 inches.**

 I painted on a stretched, preprimed canvas.

3. **Prepare your palette with white, Phthalo Green, Forest Green, Payne's Gray, Phthalo Blue, Quinacridone Red, and Alizarin Crimson Hue.**

 I used craft paint in a bottle for the Forest Green; if you can't find it, add a little yellow to your Phthalo Green. Keep your palette paints misted.

 For more time before paints dry, use an acrylic paint that has a longer open drying time or add one drop of acrylic retarder to each of your regular acrylics.

4. **Paint the canvas background dark by squirting and then blending Payne's Gray, Phthalo Green, and Forest Green directly on the canvas before pressing crumpled plastic wrap all over the wet background.**

 Leave the plastic in the paint till it dries.

5. **While the background dries, prepare your drawing by enlarging Figure 11-13 to fit your canvas.**

 You can use a copy machine, or check out Chapter 6 for more on enlarging drawings.

Figure 11-13:
A drawing
suitable for
transfer.

6. **Remove the plastic wrap when the background is dry.**

 Don't be worried if the plastic left a little real texture. It adds interest.

7. **Transfer the drawing by using white graphite paper.**

 You can find instructions for transferring a drawing in Chapter 6. Figure 11-14 shows the transferred husky.

Figure 11-14:
Background
with
transferred
drawing.

8. **Paint the fur, using the comb brushes and rake (Figure 11-15).**

 Dip a filbert comb into white paint and then touch the canvas and pull until the hair is the proper length. (Use the #6 for larger areas and the #4 for the smaller hairs and the layered hairs on top.) Paint the hair strokes in the direction the hair grows — short, quick strokes with an upward movement at the end work well.

 Put the white on the brightest areas — the right side is where the light is hitting the dog's face. The dog's muzzle (nose) is a solid white, but you can build up the white by using the fur wisps. As the face turns to the shadow side, add some Phthalo Blue to the white mixture, continuing to make the white bluer as you progress across the shadow (left) side. When the paint drags too much because it's drying, rinse the brush and put a fresh dip of paint on it. If you make a mistake or get a glob rather than a wisp, simply wipe it off the dry background paint with a damp paper towel.

9. **Touch up dark areas if needed.**

 If you painted too much white, let it dry and then paint Payne's Gray with the same brushes to get the darks back where you want them.

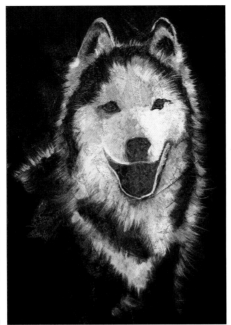

Figure 11-15:
Paint fur
with white
paint
applied with
a filbert
comb or
rake brush.

10. **Paint the eyes.**

 A. Mix some Phthalo Blue with white to make a pale blue and paint the eyes with the small round brush, leaving the pupil dark.

 You can touch the pupil up with Payne's Gray as necessary.

 B. Paint a slightly darker blue (by adding less white) around the edge and near the top where the eyelid casts a tiny shadow.

 You can see the eyes in Figure 11-16.

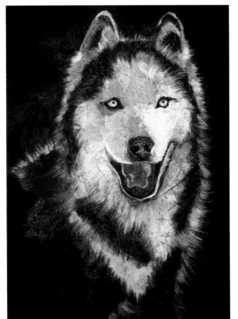

Figure 11-16:
Small bits of
color are
added to
the eyes,
tongue, and
muzzle.

11. **Using the round brush, paint the tongue to mimic Figure 11-16.**

 Mix three red/pink colors. Quinacridone Red and white make a light pink. Alizarin Crimson and white make a darker red. Add a little Phthalo Blue to the dark red for a purple shadow red.

12. **Paint the muzzle.**

 A. Mix Phthalo Blue with the Payne's Gray to make a black and then paint a bit of black to make nostrils.

 B. Lighten the black mixture with a little white for a gray to make the highlight shine on the muzzle.

 Keep the values dark. Figure 11-16 shows you the muzzle details.

13. **Continue the final details.**

 Touch up, fluff the fur, and layer where paint was too light. Figure 11-17 shows all the final details.

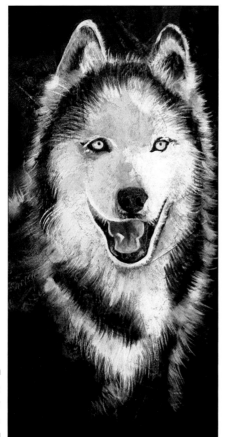

Figure 11-17:
Final husky portrait.

Project: Fall Corn Still Life

A still life is a popular oil painting topic. Oil painters like still lifes as topics because they don't move (unless to rot) for a long time, giving the painter

plenty of time to capture every detail. Acrylic does the same job, just more quickly (so you can still eat the food for dinner).

You can always find something around the house to set up as a still life. This fall I got some Indian corn — the color and shapes were just begging to be painted. Note that you have to let the paste dry overnight, so plan ahead accordingly.

1. **Get a painting surface ready.**

 I used an 8-x-10-inch hard board (masonite painted with gesso).

2. **Create three corn cob shapes by piling the paste on the painting surface and using a palette knife to make kernel-line indentations.**

 For Figure 11-18, I made the ears about ¼-inch thick.

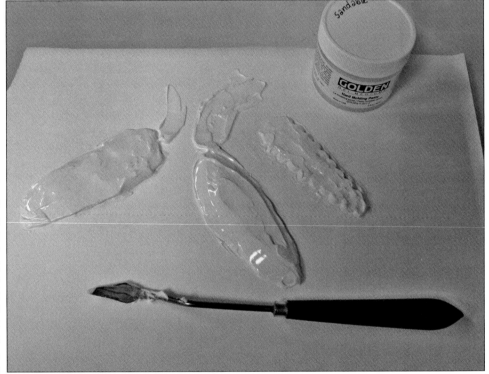

Figure 11-18: Sculpting heavy modeling paste into 3-dimensional corn ears with a palette knife.

3. **Allow to dry overnight.**

4. **Finalize the corn by sanding or carving if needed.**

 I sanded some of the pointed areas smooth. You can sand and carve paste into shape if you want a more accurate shape, but for this project I wanted it pretty loose.

5. **Prepare your palette with Naples Yellow Hue, Iridescent Copper, Diarylide Yellow, white, brown (ideally Burnt Sienna or Burnt Umber), and Phthalo Green.**

 Add a drop of acrylic retarder to each color if you want longer time before drying.

 Feel free to substitute colors as you need/want to.

6. **Base coat the corn with Naples Yellow Hue, Iridescent Copper, and Diarylide Yellow, using a ¼-inch flat brush.**

 Refer to Figure 11-19 for a rough guide. For more on base coating, head to Chapter 4.

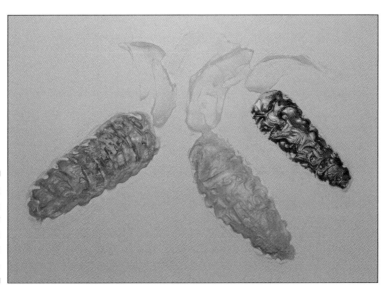

Figure 11-19: Paint corn ears by base coating with three colors.

7. **Using a ½-inch flat brush, dip into several colors and paint streaks for the corn husks.**

 In Figure 11-20, I used Naples Yellow Hue, white, Diarylide Yellow, brown, and Phthalo Green. See Figure 11-20. Turn the brush handle as you apply to make the thick and thin, turning husks. Notice the darker husks that go under other husks. You don't have to follow any drawing — just use your intuition, enjoy the paint, and put husks wherever you think you need them.

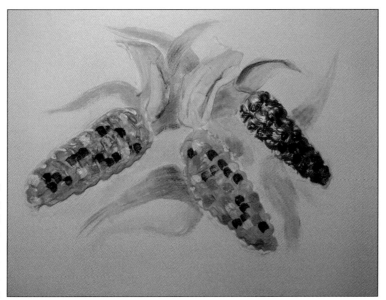

Figure 11-20: Paint streak strokes with a flat brush for corn husks.

8. **Create details and finish the painting.**

Put dark and colored kernels on corn ears, using one stroke of a ¼-inch filbert brush. When dry, add a shadow and highlight. (Check out "Simulating depth with shadows" earlier in this chapter for more on creating shadows and highlights.)

Paint more husks; you can add some darks between the husks, around the ears — wherever you think it's best. Figure 11-21 shows you my finished project.

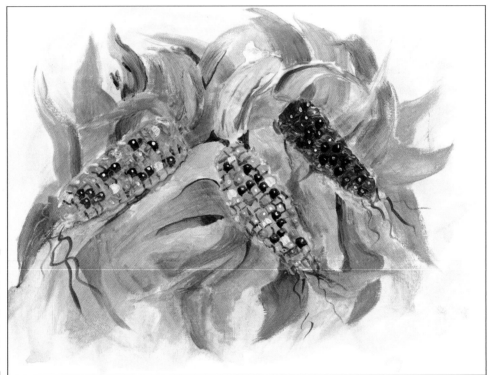

Figure 11-21:
Paint details
on kernels
and make
a value
pattern
throughout.

Project: Son of Corn Painting (A Sequel)

Many styles of oil paintings can inspire acrylic painters. This project is much like the one in the previous section; the difference is that the style here is tighter and a bit more time-consuming. If you do both projects, you can compare and decide which style to adopt in future paintings.

This still life project uses many of the oil-inspired techniques (including texturing canvas and streaking) in this chapter.

1. **Prepare a surface.**

I gessoed a texture on a cradled 11-x-14-inch hard board by applying gesso in different-direction strokes, using a ½-inch flat bristle brush. For general instructions on applying gesso, head to Chapter 2. See Figure 11-22.

Figure 11-22:
Gesso the surface with texture strokes.

2. **Prepare a palette of colors and painting area, including ¼- and ½-inch flat brushes, a #8 round brush, and a #000 liner brush.**

 Add a drop of acrylic retarder to each color if you want longer time before drying.

3. **When the gesso is dry, paint a background and blend to soften colors.**

 I painted on Yellow Ochre, white, Burnt Sienna, and Diarylide Yellow, using a ½-inch flat brush. Place strokes of each color all over the surface and a larger area of white in the upper right third (Figure 11-23a). Blend the colors in a big sweeping motion in all directions with the flat brush till they are soft with no hard edges (Figure 11-23b).

Figure 11-23:
Painting the background.

a

b

4. **Enlarge the drawing in Figure 11-24a to fit your surface and transfer it.**

 Place graphite paper between the drawing and the surface and trace the drawing to transfer (as shown in Figure 11-24b). The final drawing on the background appears in Figure 11-24c.

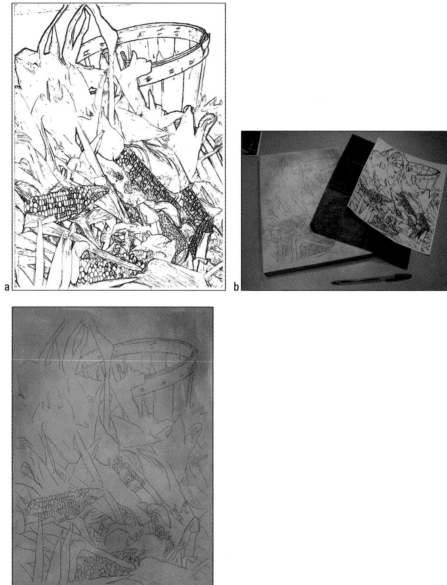

Figure 11-24:
Transfer the
drawing
onto the
background.

5. **Paint the dark areas to establish a value pattern.**

 Paint darks in the spots that you want to go backward into space. Figure 11-25 shows the value pattern I created.

6. **Paint the basket.**

 A. Use ½-inch and ¼-inch flat brushes, pulling streaks of paint to fill the slats in the bushel basket.

I used the following paint colors: Burnt Sienna, Yellow Ochre, Phthalo Blue, and Diarylide Yellow. To get the dark brown, mix Burnt Sienna with a bit of Phthalo Blue.

B. When the basket is dry, put a bit of the dark brown where you want the nail and use your index finger to pull the paint in the direction of the nail's dark rust stain.

Figure 11-25:
Painting the dark area establishes a value pattern.

C. When the rust stain is dry, add the nail head with a dark shadow outline and paint some dark lines around the rim to define the slats.

Figure 11-26 shows my finished basket. Don't worry about getting it exactly like this painting — use the figure to inspire your own basket.

7. **Paint the corn.**

A. Base coat the corn in transparent yellow.

I used a fluid acrylic Diarylide Yellow so that the drawing still showed through to guide details later. See Chapter 4 for more on base coating.

B. Use a round brush to paint colors to the kernels of corn.

Some kernels here are Yellow Ochre, and some are Naples Yellow Hue. For the red kernels, I used Alizarin Crimson Hue; to make the dark purple kernels, I added Phthalo Blue. I mixed the orange kernels from Alizarin Crimson and Diarylide Yellow, and the darker shadow is Burnt Sienna.

C. Add corn kernel highlights of white dots by using the very tip of the round brush.

Figure 11-26:
Painting the bushel basket with streaked paint.

D. For final detail, paint some Burnt Sienna lines around the crevices of the kernels of corn.

Choose one ear — the closest to the viewer — and make it the most detailed. The bottom ear got thicker paint and is quite 3-dimensional for this painting. You can see the finished corn in Figure 11-27.

Figure 11-27:
Corn ears painted using a variety of colors.

8. **Paint the corn husks.**

A. Make husks, using ½- and ¼-inch flat brushes to streak several colors.

B. Touch up the husks, using a round brush to get into tight areas.

I used white, Naples Yellow, Yellow Ochre, Burnt Sienna, and Diarylide Yellow. I mixed Yellow Ochre and Phthalo Blue to make a green.

C. Add shadow and depth to the husks.

To create shadow under the husks, glaze on Phthalo Blue thinned with water. To make a husk come forward, paint its edge with lightened yellow (add white to yellow) or white; glaze Phthalo Blue or Burnt Sienna to make a husk recede.

D. Mix Burnt Sienna and Phthalo Blue and use it to outline the husks, painting with the tip of a round brush.

Figure 11-28 shows the final painting.

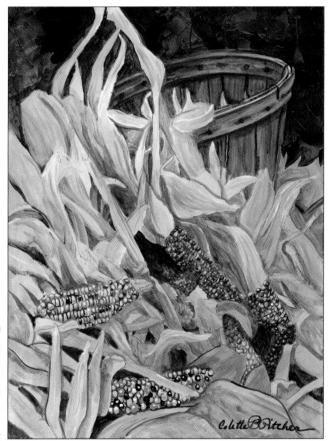

Figure 11-28:
The final pile of corn painting, celebrating fall.

Varnish: The final frontier

Oil paintings should always be varnished for protection. I love the gloss varnish on an oil painting that makes the colors really pop. Technically, you don't *have* to varnish if you're using acrylic paint in place of oil because acrylic is pretty durable. However, dried acrylic is porous, and dirt, grime, and pollution love to make their homes in such itty-bitty air holes. By varnishing, you protect the painting from these intruders.

Wait a week before varnishing your acrylic painting. If you're in a hurry, you can probably get away with waiting only three days (depending on your climate and other drying factors), but the full week allows the paint to fully *cure*. Chapter 4 gives you the full lowdown on varnish, but here are some of the qualities that varnish can provide:

- **Finish:** Varnish comes in three finishes: *gloss* (shiny), *matte* (not as shiny), and *semi-gloss* (middle-of-the-road shiny). You can use whatever varnish tickles your fancy for any particular painting, but semi-gloss is great for the oil-like still lifes in this chapter.

- **UV protection:** Ultraviolet light fades paint, and you can protect a painting with a special UV-protective varnish. However, non-UV varnish costs less, so it's worth considering if your paintings aren't going to be subjected to much UV radiation.

- **Spray or brush-on application:** Brush-on varnish is good for thicker coats and works well as long as you follow the manufacturer's instructions, although it does have a tendency to create bubbles. Spray-on varnish is easy for light coats and is bubble-free.

My choice is usually spray-on, removable gloss varnish with UV protection. Conservationists like removable varnish for cleaning hundreds of years from now. They can take varnish covered with grime, nicotine, and other pollutants off with a solvent and then revarnish the painting underneath for continued protection and vibrancy.

Chapter 12

Thinking and Painting Abstractly

. .

In This Chapter

▶ Following abstract art movements in the last century

▶ Getting abstract inspiration from everyday sources

▶ Conveying your message

▶ Playing with products that create abstract effects

▶ Ironing out a plan before you start your abstract painting

▶ Putting abstract techniques to work.

. .

Abstract painting doesn't look like anything — that is, it doesn't represent some worldly item like a landscape or still life does. *Representational art* describes art that looks like something recognizable. *Nonrepresentational art* may deal with just the elements of art (discussed in Chapter 8). Another term used to describe abstract art is *nonobjective* art — it doesn't present recognizable objects.

Before the turn of the 20th century, art imitated and illustrated real world contents or depicted stories (usually about religion or mythology). These highly realistic works portrayed heroic subjects, romantic ideals, and biblical figures and dealt with perspective and re-creating real scenes. Around 1900, the way artists thought about and produced art changed. Art became more about concepts, feelings, political thoughts, reactions to the times, everyday people and events, emotion, and poetry. After all, the canvas wasn't real but merely an illusion. How does an artist paint these things? Abstract thought can only be represented by abstract painting.

In this chapter, I give you a brief abstract art history so you understand where abstract art came from (and hopefully where you can go with it). You also explore styles, see how to find abstract subjects from everyday items, and think about putting more-significant content in a work of art. You get to paint along with 19 miniature symbolic abstract paintings, as well as some cool products to experiment with in new ways.

Cruising through Abstract Art Movements: An Overview

After artists began producing the nonrepresentational art, the critics and art historians were determined to categorize it. The following list runs down the styles that evolved and the label each movement got:

- **Impressionism:** Impressionism began in France around 1860. Though Impressionistic works don't appear abstract to today's audiences, they were a major departure from conventional art in their time. Some of Impressionism's hallmarks include using pure paint pigments to represent light and color; producing art *en plein air* ("on location"); painting everyday and natural settings rather than the religious and historical themes common in the day; and creating works that seemed rough and unfinished to audiences of the time. Impressionistic artists include Claude Monet, Georges Seurat, Camille Pissarro, and Pierre-Auguste Renoir. In fact, the name *Impressionism* came from a Monet painting called *Impression: Sunrise.*

- **Futurism:** Futurism began around 1909 in Italy. This movement portrayed machinery, transportation, the Industrial Revolution, and speed and used angular shapes and lines repeated in different positions to create movement. Futuristic artists include Giacomo Balla and Umberto Boccioni.

- **Vorticism:** Vorticism spun off from Futurism in England in 1914, largely as a reaction to World War I. As the first movement toward abstraction, its harsh, tortured, angular shapes depict movement. Wyndham Lewis and David Bomberg were both Vorticists. The name stems from Futurist Umberto Boccioni's comment that all creative art emanates from an emotional vortex.

- **Fauvism:** Fauvism was a short-lived movement based on a 1905 exhibition in Paris. The movement was marked by pure, bright colors; undulating line; and visible enthusiasm and passion. Fauvists include Henri Matisse, Maurice de Vlaminck, Andre Derain, and Kees van Dongen. The name was coined when one critique called the artists that produced the works *les fauves* ("wild beasts").

- **Cubism:** Cubism was centered in Europe from around 1900 to 1920. It let artists think differently about the world and how they depicted shapes, using angles to define form and space on flat canvas and showing the many sides of an object in the same picture. Famous Cubists include Pablo Picasso and Georges Braque.

- **Abstract Expressionism:** Abstract Expressionism was based in New York between the 1940s and 1960s. It used dripping, throwing, and free application of the paints to highlight the importance of the art materials. The spontaneous creativity these techniques encouraged supposedly released the subconscious into the art. Jackson Pollock, Franz Kline, Willem de Kooning, and Mark Rothko were Abstract Expressionists.

- **Constructivism:** Constructivism began in 1913 in Russia. It emphasized machines and technology in both sculpture and painting. Other hallmarks include flat tones without shadowing; more-graphic, less-real depictions; and an architectural, almost blueprintlike look. Constructivists include El Lissitzky, Ljubov Popova, and Vladimir Tatlin; many of this movement's artists were also involved with engineering, fabric design, costume, building, and set design.

- **Surrealism:** Surrealism was a 1920s French movement. It focused on real objects but with a dreamlike, fantastical spin; landscapes and everyday objects became illogical, nightmarish, alien, and distorted. Salvador Dali, Max Ernst, Frida Kahlo, Rene Magritte, and Joan Miro were all surrealists.

✔ **Minimalism:** Minimalism was popular in the United States in the 1960s and 1970s as a reaction to the emotional content of the Abstract Expressionism that dominated the art scene in the 1950s. Most works are monochromatic, use industrial components like fluorescent tube lighting or steel, and often have a mathematical base and little surface embellishment (as the name implies). These works typically occur in series, with more emphasis on the ideas and concepts than in the actual finished product. Minimalists include Robert Ryman, Donald Judd, and Robert Mangold.

Studying these movements can help inspire you to create your own piece that follows a particular movement or combines two or more of them into something entirely your own. Check out *Art For Dummies* by Thomas Hoving (Wiley) for more on these and other art movements.

Finding Abstract Ideas in the Real World

I like to look at something rather than just work strictly from my imagination. I suppose I'm grounded by nature and the world I live in too much, or perhaps I'm just a visual person and love to look. If the voices in your head are sending you images to make into paintings, go right ahead — you are blessed. But if you too need a visual reference, here are a couple of great tricks for finding an abstract design to paint.

Creating a cropping viewfinder

Sometimes you need to focus to find inspiration. *Cropping* (selecting a small piece within a larger piece) allows you to find that focus. You can use an *L*-shaped view window to isolate a small area you want to paint; this device is especially helpful for pulling small areas out of photos or magazine ads for abstract inspiration. You can also use your window tool to look within your painting for another painting. Perhaps you made a big painting that you don't like. Use your cropping window to pick out an abstract (or several) within the big painting.

Make a window-cropping tool to find your view. By making two *L*-shaped pieces of paper cardstock (something a little heavier than regular paper so you can use it without it ripping), you can crop images, scenes, photos, and even paintings. Here's how to make your own cropping tool:

1. **Get a piece of cardstock 8.5 x 11 inches.**

 You can make these bigger or smaller to meet your needs. I have a really big set cut out of mat board to help crop big paintings when choosing framing.

2. **Fold it in half short edge to short edge.**

3. **Beginning on the fold, cut out a rectangle, leaving a 2-inch border on all the open edges.**

 You can measure and trace out the rectangle first if you don't want to cut it freehand. Figure 12-1 shows this cut.

Figure 12-1:
Cut out the
window
on a fold.

4. **Open up the fold to reveal a window with a 2-inch border of cardstock.**

5. **Cut opposite corners diagonally so you have two *L*-shaped pieces of cardstock.**

 Figure 12-2 shows this cut.

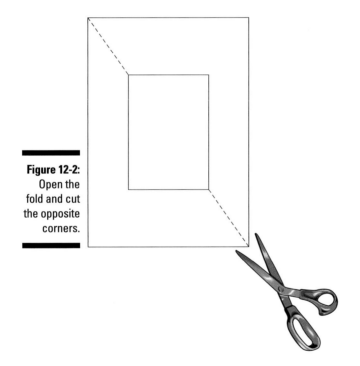

Figure 12-2:
Open the
fold and cut
the opposite
corners.

6. **Overlap the *L*s to make a viewfinder.**

 You can rearrange the *L*s to create vertical, horizontal, and square formats and adjust the size of the viewing window. You can also adjust the size of your view by bringing the viewing window closer to your eye (larger view) or moving it farther away (smaller view). Figure 12-3 shows how the final window isolates an area on a painting.

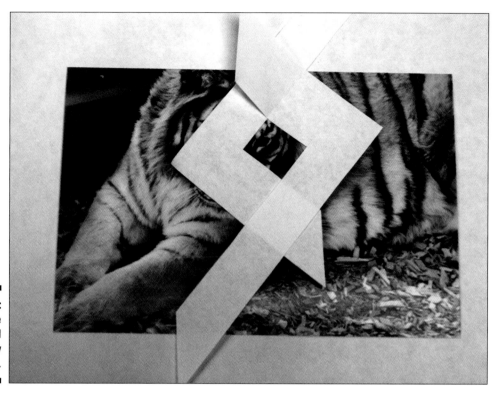

Figure 12-3:
Use the
L-shaped
window
to crop.

Pushing a shape out of shape

Most people look at abstract art and wonder how in the world the artist came up with that image. Sometimes the artist doesn't have a clue either, but sometimes he abstracts real objects into another look. The real object is pushed, pulled, twisted, colorized, sliced, diced, and julienne fried until it becomes nonrepresentational. The age of computer technology makes playing and experimenting with images and using them as a guide for abstract artwork even easier. You can do this with a pencil and paper too. You can push and pull the object into new shapes by drawing it and changing the dimensions. Try it by using a pencil and eraser or even paint the subject and move the parts around, push the edges out, use the colors in a new way, and so on.

Take a favorite subject. It's always more fun if you're working with something that really interests you. It also provides insight into who you are. I took a photograph of a tiger (shown in Figure 12-4a) and used my computer as a tool to help me abstract the image of my tiger.

Digitalism?

Many art shows don't allow digital art entries, but artists can (and do) still use digital technology as tools to plan, refine, and improve their art (not to mention inventory, save images, make prints, sell online, blog, and a gazillion other tasks). Perhaps this era will eventually be the Digitalism movement.

What I did on the computer to play around with my abstraction of the tiger took a fraction of the time that it would have taken to paint rough paintings of each possible option. In a few minutes, I have plenty of options for a painting (or series). I used Adobe Photoshop software for Figure 12-4b through f, but many other photo imaging programs are available to manipulate images.

In case you have Adobe Photoshop and want to know exactly how I got the images in Figure 12-4, here are the steps I took for each example:

Figure 12-4b: Filter→Ripple

Figure 12-4c: Filter→Pixelate→Mosaic

Figure 12-4d: Filter→Pixelate→Pointillize

Figure 12-4e: Filter→Distort→Swirl

Figure 12-4f: Filter→Distort→Polar coordinates

Figure 12-4: Planning an abstract from a photograph and digital enhancement.

Abstract Ways to Send a Message in Your Art

Many of the past abstract movements were based on thoughts and reactions to their environments. The artists were communicating these reactions through their art, and so can you. You may find that abstract art is an easier way to express these intangible ideas.

Abstract art is all about sending a message. So how do you go about doing that? You send messages with symbols, shapes, the direction you place lines, your color choices, and the way you apply the paint. Of course, you can use words, too. The method you choose to use may depend on how obvious you want your message to be. Sometimes you may use low-key line direction to convey your subtle message, and sometimes you may use a color sledgehammer to force your obvious message home. Sometimes, your message may be so subtle and subconscious that you don't realize you're conveying it until you look at the finished product. The real treat is when an observant viewer sees something that you were completely unaware you were putting in the painting — it means you've touched someone with your art.

Putting words in a painting

Carefully chosen words and letters can say a lot about your message, and so can the way you apply them. You can stamp letters, paint them, or glue on papers with words. A stamped letter may symbolize a feeling: "RUOK?" for an artsy text message. You can also scraffito (scrape) words, lines, and symbols in the paint. A scraped word can convey a hasty, energetic plea ("freedom") or a modern, trendy directive ("be green"). The Pop artists of the 1970s and 1980s used words very effectively — look at the works of Jasper Johns and Robert Rauschenberg to see how they communicated through letters and words.

Looking at what various symbols and elements can communicate

I discuss the *elements of art* (dot, line, shape, color, pattern, texture, size, direction, and value) in Chapter 8. But how you use these items can send messages and set moods for your art. Colors play a big part in communicating feelings; head to Chapter 7 for more on what feelings colors evoke. In Figures 12-5 through 12-24, I use these elements to demonstrate how symbols and art elements can convey messages in abstract art. You may have a different reaction to the piece than what I say it means. Everything is governed by personal experiences, so that's okay.

The great news about abstract painting: You can't do it wrong. Try different colors and mix up any of the techniques. Get crazy and don't forget to have a good time. It will show up in your work. In fact, you can work out any mood in an abstract painting. Purge. Angry? Use red with jagged line. Sad? Use blue and drip the paint. Frustrated? Put a bunch of paint on the surface and scratch energetic lines into the paint with the pointy end of the brush handle (just be careful not to rip the surface — unless that will make you feel better). Make several paintings at once. One can be drying while you work on another. Then you can switch so that you don't have to literally watch paint dry.

Paint along with me in the following figures to send some mini messages using the elements of art. You can certainly copy or change the elements to suit your own taste. You can do them in a miniature size (mine were 2.5 x 3.5 inches) if you want them to go quickly; you can even use them as *artist trading cards* (discussed in Chapter 4). Put your contact information on the back, and you have an original painted business card to give out as a very memorable sample of your work. I used one #8 pointed round brush for everything, except for Figures 12-22 and 12-23, where I used a palette knife to apply the paint (it leaves more jagged edges of paint). Bottom line: Make it fun. It isn't nearly as much fun if you just look and don't paint.

In Figure 12-5, an *explosion* of line and color bursts from the center in an outward direction. The warm colors of fire symbolize the idea of concentration or sudden outburst. By changing the colors or values, the explosion can become an *implosion,* focusing inward rather than exploding outward.

Figure 12-5:
Warm color
explosion.

Paint *zigzag lines* to create excitement. In Figure 12-6, the color red adds to the excitement as purple and blue balance the mood with a bit of calm.

Conflicting diagonal lines bring about feelings of conflict (big surprise) in Figure 12-7. They can symbolize war, confusion, and hate. Army green brings about even more strong feelings. Too much conflict can be harsh, so I added a bit of yellow hope.

In Figure 12-8, *balloons* or open-ended ovals suggest buoyancy, fantasy, and just general good feelings. The blue is a fantasy color to reinforce the floating feeling.

Figure 12-8:
Floating
shapes.

Spiral colors create generative forces that symbolize beginnings in Figure
12-9. Warm colors in the center cool off toward the edge. The beginning is a
warm energy like the core of the earth.

Figure 12-9:
Warm spiral
colors.

Rhythmic curves are graceful and youthful, and symbolize joy. In Figure 12-10,
I used blue because the curves can look like sky and clouds.

Figure 12-10:
Rhythmic
curves.

Pointed arches look like a gothic stained glass window in Figure 12-11 and suggest spirituality and hope. The warm yellow is also a color of hope and happiness.

Figure 12-11:
Pointed
arches.

The *mountain pyramid* symbolizes dignity, stability, and strength in Figure 12-12. The dark blue also is a stable, solid color.

Figure 12-12:
Mountian
pyramid
stability.

In Figure 12-13, the *diagonal* direction suggests motion, movement, and action and puts the viewer a bit on edge. Orange also is attention-getting and vibrant to reinforce the action.

Figure 12-13:
Active
direction
and colors.

Rounded arches can look heavy and severe but suggest strength and stability in Figure 12-14. The arches are warm colors, but their surrounding background is cool.

The *vertical lines* in Figure 12-15 make you look up, suggesting dignity and stability. Blue is a loyal color.

Horizontal lines are tranquil and calm, suggesting sleep, rest, or immobility. Compare the blue in Figure 12-16 with the blue in the vertical Figure 12-15; does it evoke a different feeling?

Figure 12-16:
Horizontal
line
direction.

Figure 12-17 has *rainbow arches* or concentric half circles, which suggest upward expansion, buoyancy, blossoming, and movement. The colors reinforce the rainbow, but you can get the same effect from a limited palette.

Figure 12-17:
Rainbow
arches.

A *waterfall* expresses fluid gravity and rhythmic descent. Blue reinforces the water theme in Figure 12-18.

Figure 12-18:
Rhythmic
waterfall.

A point-down triangle or *expanding perspective* suggests expansion, freedom, and growth in Figure 12-19. The triangle is an attention-getting yellow surrounded by contrasting darker cool colors that pop the yellow.

Figure 12-19:
Expanding
perspective.

A point-up triangle or *diminishing perspective* suggests distance, limited expanse, looking backward, or nostalgia. The triangle is red and gets dark in the front and brighter at its peak. It's surrounded by cool colors, which make the triangle pop even more in Figure 12-20.

Figure 12-20:
Diminishing
perspective.

An *upward spray* symbolizes growth, spontaneity, and idealism in Figure 12-21. Purple is a spiritual color.

Figure 12-21:
Upward
spray.

Rhythmic horizontal lines can suggest sleep, calm, or laziness. In Figure 12-22 the cool colors of green and blue reinforce the calm feeling.

Figure 12-22:
Rhythmic horizontal lines.

Upright flames vertically swirl to suggest aspirations, vigor, and spiritual intensity. The colors of fire — red, yellow, and orange — heat up the mood in Figure 12-23.

Figure 12-23:
Upright flames.

In Figure 12-24, a *bent vertical* can suggest sadness, weariness, and grief. What other color can suggest the blues better than blue?

Figure 12-24:
Bent
vertical.

Don't waste paint. Wipe brushes and palette knives on scraps of canvas paper or paper towel. When you're finished painting, take a paper and put it upside down in your palette to pick up leftover paint. Keep a paper under your small paintings so it catches paint when you paint to the edges. Don't throw these items away — let them dry and use them in a collage in Chapter 13. The abstract paintings in Figure 12-25 are my refuse papers from the previous examples.

Figure 12-25:
Scraps
and excess
paint make
abstract
paintings.

Handy Products and Techniques for Abstract Art

Sometimes, an abstract painting can be inspired by new art materials, and acrylic paints and all their mediums, gels, and pastes inspire much experimentation. In Chapter 3, I talk a lot about paints and their mediums. Here I show you how you can use some of the mediums, pastes, and grounds to further your abstract goals.

A *ground* is a substance applied to a *substrate* (painting surface) and painted on top of. Gesso is the most commonly used ground, usually to prime raw canvas or panels. *Pastes* are thick white substances that you can also use as a ground or to create texture. You can use these products on any substrate: wood panel, plexiglass, paper, canvas, and so on.

You can apply the grounds and pastes with a spackle knife, putty knife, palette knife, sponge, roller, or brush. Each applicator gives you a different texture. Think of icing a cake if you want a very thick application. The final texture can be smooth or wavy depending on your application. Some pastes make their own texture, and some products can be sanded and sculpted after they're dry.

You definitely want to finish these works with varnish.

Under it all: Starting with grounds and pastes

Abstract artists are always looking for something different and unusual. The products listed here are inspirations in themselves for creating, experimenting, and finding the unusual. Some pastes are absorbent and make great watercolor paper-like surfaces to paint on. These pastes accept paint for a soft blended background.

Crackle paste

Crackle paste does pretty much what its name implies: It leaves cracks in the finish (the thicker the paste, the larger the cracks). It works best on a rigid surface, because it may not adhere properly to a more flexible substrate like canvas; apply it in the thickness of a penny.

Crackle paste yellows with age; if you don't want quite that vintage of a look, add some Titanium White paint to the surface. You can tint this paste with acrylic paint — just don't use a mixture of more than 20 percent paint to 80 percent paste, or the paint acts as a binder and prevents the crackle effect. Be sure to seal it with varnish to prevent chipping and dirt buildup; I recommend acrylic medium to use as a varnish (it will do the same job).

In Figure 12-26, I applied crackle paste to a mat board; I applied a very thin layer on the left side and a thicker layer on the right — notice the smaller cracks on the thin left side. I let it dry, and then painted with diluted acrylic paints in Iridescent Copper and Iridescent Bright Gold. The paint accumulates in the cracks, highlighting them.

Figure 12-26:
Crackle
paste with a
wash of
paint.

Absorbent ground

This ground is used to prime mat boards, canvas, and other boards to produce the texture benefits of watercolor paper with the rigidity of a board. Your best bet is to prime the surface with gesso and then roll on three to six coats of absorbent ground after the gesso is dry. You can use brushes and squeegees, but these can create texture ridges, so be forewarned.

Fiber paste

Fiber paste was developed to resemble handmade paper. The texture gives an earthy unique look to the surface for something a little different. It also makes a nice background for a simple subject. In addition to acrylics, it works well with graphite pencil, pastels, watercolor, and oil paint. In Figure 12-27, I applied a smooth coat with a palette knife on a piece of mat board and let it dry. I then painted on fluid acrylics in Quindacridone Magenta, Cobalt Teal, Ultramarine Violet, and Iridescent Bright Gold. When the surface was almost dry, I took a black watercolor pencil and drew the curved lines from edge to edge. Because the paint was still damp, the lines bled a little as the piece dried.

Light molding paste

Like all pastes, light molding paste is very absorbent. It's 67 percent lighter weight than heavy molding paste (discussed in the next section) and makes a surface that allows blending colors on top of the dry paste easy. This paste works well for creating texture on surfaces like canvas, where heavier products can have so much weight as to rip or *fatigue* the fabric (make it sag in time).

In Figure 12-28, I applied the molding paste with a spatula that left ridges and let it dry. I then wet the surface with clear water and painted concentric circles of acrylic paint, using Titanium White in the center and moving outward with Naples Yellow Hue, Pyrrole Orange, Quinacridone Red, and finally Dioxazine Purple.

Figure 12-27:
Fiber paste
with acrylic
paint and
watercolor
pencil lines.

Heavy molding paste

This paste really holds its peaks and is therefore great for creating big, thick texture. You can play with it till it makes the shape you like. Sculpt it wet (you have 10 to 15 minutes before it starts to set up and becomes too rigid to manipulate) or wait and chisel it when dry. You can also sand the dry paste. In Figure 12-29, I mixed paint (Phthalo Blue) with the paste on my palette and then applied it to foam board with a palette knife, manipulating the paste into wave shapes.

Figure 12-28:
Light
molding
paste with a
wash of
paint.

Figure 12-29:
Heavy
molding
paste
waves.

Combinations

All acrylic paints, mediums, gels, and grounds are compatible. You can use one technique in one layer and then another technique in another layer to your abstract heart's content.

For example, Figure 12-30 uses several acrylic products. I applied absorbent ground to a mat board and let dry. Then I painted the surface with Quinacridone Magenta and Iridescent Copper in a swirling blur. Next I mixed two drops each of fluid acrylic paints in Quinacridone Magenta and Iridescent Gold into one tablespoon of heavy molding paste. I used a palette knife and a leaf stencil to apply the colored paste mixture and removed the stencil when dry. After letting the paste dry for at least a couple of hours (your time may vary depending on humidity and temperature conditions), I covered the entire surface with crackle paste about a penny's depth thick.

Over the top: Using products that go on top of grounds and substrates

Some mediums and gels are to be used on top of grounds, surfaces, and substrates. Most of these items are clear; you can use them by themselves or add acrylic paint to get your desired color.

Clear tar gel

Clear tar gel is a clear substance produced by Golden Acrylics to make long, continuous strings. The higher you hold the paint from the surface, the skinnier the string of goo. It makes acrylic pour in a continuous line so you can draw, squiggle, and drizzle out the paint. Scoop out clear tar gel with a palette knife and drizzle it on your surface. It's a bit difficult to control, but with some practice you can draw and even make words. It stays a bit thick, so it's raised when dry.

Figure 12-30:
Combination of ground, paint, molding paste, and crackle paint.

Color clear tar gel by mixing with acrylic paint in a container with a lid (you don't want it to dry out). You must let the paint sit for 24 hours after stirring or mixing to allow the string action to work. Likewise, don't shake up the gel. Air disrupts the string action, so you have to let it sit for 24 hours to get the viscosity back.

In Figure 12-31, I applied the clear tar gel over absorbent ground on mat board. I tried some controlled lines to make a music staff and treble clef. After it dried, I painted very diluted acrylic paints in Cobalt Turquoise, Quinacridone Magenta, and Phthalo Blue in a very watercolor-like style (see Chapter 10 for more on using acrylics like watercolors). When the first wash dried, I put another slightly darker set of color in the music staff lines. The clear tar gel separated the colors so they didn't blend when wet.

Figure 12-31:
Clear tar gel allows you to create your own Pollock-inspired creations with acrylic paint.

Hollywood imitates art

Golden Acrylics formulated clear tar gel at the request of the producers of the movie *Pollock* (2000), which told the story of Abstract Expressionist Jackson Pollock. The filmmakers were concerned about the flammability of the oil paints and solvents accurate to Pollock's era on the set with the hot lights. Golden created the clear tar gel to give the film the dripping quality of the oil paints without the fire hazard.

Faux encaustic

Encaustic is painting with beeswax. It sounds fragile, but encaustic paintings have been found from ancient times — after all, beekeeping and honey collection were figured out very early. Encaustic experienced a resurgence of popularity in the 1950s through the work of artist Jasper Johns. Encaustic is a bit difficult to work with because the wax must be heated to apply as paint, so you have a hot plate, hot wax, and lots of opportunity for mess. But it looks great: Layers of wax encapsulate layers of paint, and the thickness of the layers lets you look down into floating layers of paint.

Now for the faux (fake) part. You can fake this process with acrylic gel. Paint a layer of acrylic paint and let dry. Mix the amount of medium you need to cover your area with a few drops of paint (for an accurate wax color, use the formula later in this section) and apply a layer of this over the acrylic. Repeat for three layers; any more, and you just obscure the bottom layers.

Recreate the faux encaustic technique in Figure 12-32 with the following steps. It's a pretty good knock-off of an encaustic painting, and it won't melt!

1. **Paint squares in Azo Gold and Diarylide Yellow acrylic paint and let it dry.**

2. **Use a palette knife to thoroughly mix about an eighth of a cup of heavy matte gel with two drops of Iridescent Violet, two drops of Iridescent Gold, and two drops of Nickel Azo Gold.**

 Heavy matte gel is a thick, transparent, not-shiny gel. If you don't have a measuring cup handy, you can eyeball the gel measurement — you want a scoop about the size of a plum.

3. **Apply a layer of this mixture over the dry paint and let it dry overnight.**

 Figure 12-32a shows this first layer.

4. **After the thick layer (Step 3) is dry, you can paint a layer of acrylic paint.**

 This layer will look raised because of the "faux wax" depth in between.

5. **Repeat Step 3 twice more to get Figure 12-32b.**

Stamping

Rubber stamps are very popular. If you have one or two (or 10,328, like some artists), you can use them in your paintings. They're an easy way to create repetition (an element of design in Chapter 8) for added interest in your abstract work of art. You can also use stamps in layers or impress them in thick paint to remove paint. I carved my own using stamp carving knives and stamp materials found at the art store.

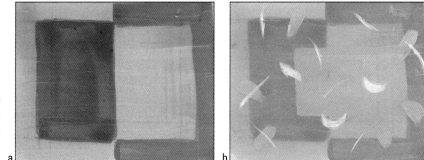

Figure 12-32:
Faux
encaustic.

a b

You can carve a stamp from a potato. Cut the potato in half so you have a flat surface to carve. Draw on your image in reverse (careful with letters and symbols — they must be backwards to stamp correctly) and then use a knife to remove the potato area around the area you want to make the stamp. Simple shapes are easier to cut out.

In Figure 12-33 I put acrylic paint on the stamp and stamped it on plain copy paper. I rinsed the color off and added another color to the stamp, rotating and placing the stamp in a different direction.

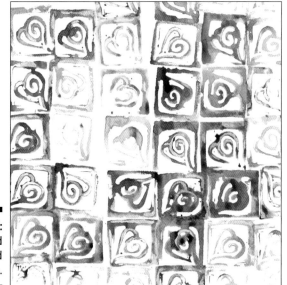

Figure 12-33:
Repeated
stamped
image.

Planning Your Own Abstract Painting: A Few Questions to Consider

Fail to plan and you plan to fail. Even if you want to do a subconscious, wing-it-as-you-go painting, doing at least a minimum amount of planning is helpful.

Having a few of these decisions made before you start frees you from stopping mid-painting to figure them out; the following list gives you a quick checklist of questions you may want to address pre-painting:

- ✔ **What size painting do I want to end up with? What shape?**

- ✔ **What kind of painting surface do I need?** Choose a canvas, board, hardwood, canvas paper, or something else.

- ✔ **What kind of texture do I want? Do I need a texture or surface treatment ground?** Check out "Handy Products and Techniques for Abstract Art" earlier in this chapter for the lowdown on achieving texture with grounds.

- ✔ **What do I want to say?** Sometimes choosing a project title before you paint can give you an edge — it may give you a mood or direction to work. For years, I painted without thinking about "why." I just wanted to celebrate beauty in nature. (I guess that answers "why.") Now, I like to give an artwork a story, even if it isn't obvious to the viewer.

- ✔ **How will I say it?** Here are some considerations to help you get your message across clearly:

 - **Colors:** Bright and happy, dark and moody — check out the color schemes in Chapter 7 to help convey your message with color choices.

 - **Shapes:** Round, square, angular, free-form — what shapes communicate your message?

 - **Abstract style:** Balanced, symmetrical, and geometric or asymmetrical, undulating, and curvilinear (or a combination thereof)?

 - **Composition:** How do I want to use the elements and principles of design in an abstract composition? Chapters 8 and 9 can give you ideas on design and composition, respectively.

 - **Words and symbols:** Do I want to include words and symbols to help convey my message? Which ones, and how do I want to put them on the surface? "Putting words in a painting" earlier in this chapter can give you some ideas about incorporating words and symbols.

Project: Abstract Extravaganza

Paint an abstract project. Like all the projects in this book, you can follow what I've done or change things to use the colors and canvas sizes you have. I used an 8-x-10-inch canvas, but you can paint as big or small as you like.

About halfway through this project I realized the symbolism. I put little dots in implied line paths following the other shapes left by the clear tar gel. The paths and choices individuals choose in their own lives take each person on a journey. Things that happen along the way make the colors and events in life. (Come to think of it, maybe that's not so abstract after all.)

1. **Gather a ½-inch flat brush, a brush with a small round handle end, water container and spray bottle, palette and palette knife, clear tar gel, and four analogous colors, plus any paint colors you want to use as accents.**

 I used Phthalo Blue, Cobalt Teal, Ultramarine Violet, and Quinacridone Magenta as my main colors and Interference Violet, Titanium White, Iridescent Bright Gold, and Dioxazine Purple as my accents. You may want to protect your painting area with newspaper. (See Chapter 7 for more on analogous colors.)

2. **Put colors out on your palette if you want to do any mixing.**

 Mist as needed to keep wet.

3. **In the order the colors fall on the color wheel, apply a line of approximately one teaspoon of each color to the canvas, starting with the first color at the bottom left corner and moving to the upper right corner.**

 I put Cobalt Teal near the bottom left corner, moved up and added Phthalo Blue, moved up and added Ultramarine Violet, and then added Quinacridone Magenta at the upper right corner.

4. **Start at the bottom left corner and spread the paint out using the flat brush to make crisscross brush strokes, blending the next new color when you get to it.**

 In Figure 12-34, I did not blend the colors completely, instead leaving brush strokes and color changes evident.

Figure 12-34: Paint the background.

5. **Let dry; you can speed up the process with a blow dryer or heat gun if desired.**

 I used a heat gun, which is very hot. When paint is thick, the heat gun boils the liquid trapped inside the dry skin on top of the paint, causing it to bubble up and even pop and leave a 3-dimensional glob. Bonus! I made a bunch of these because it was fun.

6. **Repeat Steps 4 and 5 if necessary until you like the result.**

 I wanted my first coat to look more gradual and blended, so I did a second coat to even out the colors.

7. **Use the palette knife to drip and squiggle lines of clear tar gel onto the painted surface; let it dry.**

 You can see this effect in Figure 12-35.

Figure 12-35: Add clear tar gel.

8. **Paint the entire surface with a water-diluted glaze of Iridescent Violet and a stripe of white in the center and then pick the canvas up, turning it so the paint runs in each direction until you're satisfied; let it dry.**

 Figure 12-36 shows my result.

9. **Paint dots of white using the round end of the brush (as shown in Figure 12-37).**

Figure 12-36:
Let the paint
run.

Figure 12-37:
Add white
dots.

10. Paint other colors of dots.

I painted gold dots and Dioxazine Purple dots. You can see the final result in Figure 12-38.

Notice some dots are painted on top of other dots; it makes shapes like eyes. Let the first dot dry before applying another dot unless you don't mind the colors mixing. Also, clean the brush end before changing colors unless you don't mind the colors mixing.

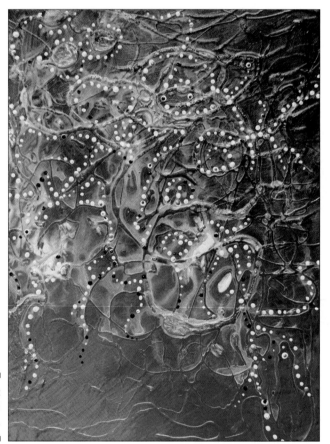

Figure 12-38:
The finished abstract.

Part V
Projects for Different Surfaces

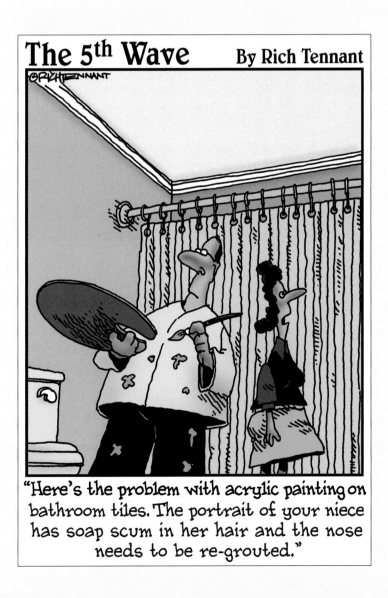

The 5th Wave By Rich Tennant

"Here's the problem with acrylic painting on bathroom tiles. The portrait of your niece has soap scum in her hair and the nose needs to be re-grouted."

In this part . . .

Acrylic paints have some unique properties; this part helps you exploit those properties with additives and mediums. You discover lots of unconventional painting surfaces (like metal, fabric, and candles) and the finer points of making a *collage* (a method of layering papers), which allows you to make decorative projects for home and gift.

Chapter 13

Creating Collages and Transfers

In This Chapter

▶ Thinking about collage supplies

▶ Choosing a collage theme

▶ Texturing and building layers on your collage surface

▶ Transferring images

▶ Crafting a collage masterpiece

*C*ollage is a term for art that uses papers and other items glued to a surface in layers, with images that often overlap. Many materials can be used, including acrylic paint, and there are some fancy tricks to make some magic transfers happen. This chapter contains many project ideas and one final project that you can customize to your own whim anytime.

What You Can Use in a Collage

Collage artwork has few rules and the opportunity for loads of experimental discoveries. Figure 13-1 shows an example of collage artwork that uses a copy of a pen and ink drawing, rice paper, glitter paper fibers, copper and gold leaf, acrylic paint, and interference paint — all in one project.

Following are some recommended traditional items to use in a collage:

✔ **Photographs:** Color, black and white, photo booth strips, and so on.

✔ **Printed materials:** Postcards, sewing patterns, magazine clippings, sheet music, maps, and so on.

✔ **Small items:** Beads, buttons, seashells, sand, charms, coins, jewelry, thread, and flower petals.

✔ **Sparkly stuff:** Glitter, mica flakes, foil, and gold leaf. Figure 13-2 shows gold and other colors of leaf (sold flat in sheets) and mica chunks that come in a vial. Both materials are available in many colors.

✔ **Specialty papers:** Japanese rice papers, lace papers, and various beautiful papers that have fibers, flower petals, textures, and threads embedded. You can find lots of these fun papers at the art supply store.

If you can attach it to a surface, you can use it. Like I said, there are few rules. You may have a great idea that I haven't listed here — go for it!

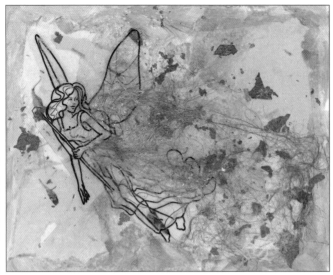

Figure 13-1:
Collage art
can mix and
match all
kinds of
materials.

Figure 13-2:
Collage
items that
add sparkle.

If you use papers and paint only, you can use canvas, paper, or boards as a collage surface (more on surfaces in Chapter 2). If you plan to use heavier items or a texture paste, you want a rigid surface that doesn't flex. Flexible surfaces may cause the paste to crack and flake off. Heavy things in your collage add weight to fabrics such as canvas; eventually, gravity wins — you can even end up with a torn canvas.

Deciding What You Want Your Collage to Say

Before you get too deep into making your collage, you may want to choose a theme to explore or decide on your reason for making your piece. Don't worry

about being too deep — just exploring the art materials can be a theme. But you may also want to communicate something. Do you have a message to convey to your audience? By *message,* I don't necessarily mean something expressed in words. Art, of course, can go beyond words. How you say that message can be as simple as choosing where to place items and what colors to use. Composition formats are listed in Chapter 9 and may inspire a collage pattern for placing your papers and paints. Choosing colors that go together will make a cohesive collage. Review Chapter 7 for color patterns to choose.

Deciding on a theme or topic can help you figure out what to gather for your collage. For example, Norma Erickson, an artist friend of mine, wanted to make a memory piece about her mother. She collected stuff that reminded her of her mother's hobbies and activities: sewing items, photographs, maps, and recipes. Her collage, shown in Figure 13-3, became a beautiful way to recall and memorialize.

Figure 13-3:
A collage can be a beautiful way to combine several memories of a person into one piece.

Here's a short list of ideas to communicate other themes. Add any other ideas you think of to the list:

- ✔ **People:** Family, friends, celebrities, gender, age, vanity, the human condition

- ✔ **Hobbies:** Bird watching, sports, travel, pets

- ✔ **Politics:** Pro or con, save the whales, stop the war

- ✔ **Spiritual:** Gratefulness, praising, good versus evil

- ✔ **Emotions:** Happy, sad, angry, satirical, cynical

- ✔ **Elements of art:** Color, shapes, lines

- ✔ **Worldviews:** Cultural varieties, nationalities, ethnicities

- ✔ **Nature:** Land, ocean, space

Preparing Your Background Surface

The following steps will get you started with a surface, texture, and color choice:

1. **Choose the type of surface you want to use.**

 I like foam core board because it's rigid and fairly inexpensive. Check out Chapter 2 for surface choice descriptions.

2. **Choose the colors you want.**

 What color do you want to begin with? You can use colored paper or mat board — or you can paint the surface with color(s). If you're using acrylic paints to add color, get them out in your palette ready to go.

3. **Create texture, if you want it.**

 Smooth surfaces work best if your collage involves transfers (which I cover later in the chapter). Rough surfaces are also fine for collages; they just may require a little more patience to get the glue to hold. Canvas, for example, has a linen texture, and papers have various textures.

 You can add texture by putting acrylic paint, gesso (primer), or paste on the surface. Brush on thick paste and use a palette knife to scrape texture into it. For Figure 13-4, I applied a variety of acrylic paint colors with my palette knife to the surface. Before the paint dried — which happens pretty quickly — I used the palette knife like a pencil and scraped lines into the thick paint. I continued scraping lines in different directions, overlapping other lines till the paint was dry and wouldn't allow any more lines. This piece is pretty nonrepresentational (see Chapter 12 for more on the abstract), but you can draw shapes or write words to make it more representational.

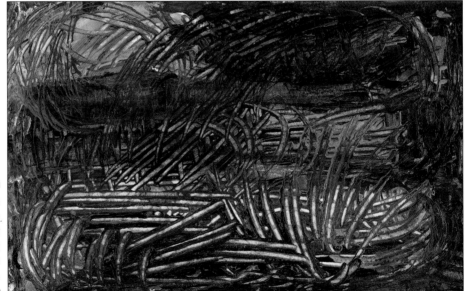

Figure 13-4:
Texture produced by scraping lines into thick paint.

Layering Your Collage

Collage implies that you work in layers. You can build up layers by adding paint or adhering papers. After any background work you do is dry, you can begin adding paint, paper, images cut from magazines, or other items to your heart's content. Another thing you can use is gesso. Gesso is what you typically use to prepare a surface for painting, but you can also use it as white paint substitute — when diluted and applied to art, it can look like wisps of transparent white. You can use gesso to tone down an area. Another way to tone down an area is to layer on a rice paper. You can do this to any painting. If you layer both paper and paint, your painting will be a "mixed media" category, which only matters if you enter a juried art show.

Layering with paper

Visit any art store and you'll find art papers from around the world. Some are textured, tissue, colored, patterned, plain, glittery, filmy, and shiny. One of my favorite papers is Japanese rice paper. It's usually white and nearly transparent with bits of string-like fibers randomly throughout. It looks fragile, but is amazingly tough.

You may even have some paper to use around the house: gift wrap, cards, recycled bits of candy wrappers, and envelope lining. Look for acid-free paper so the paper won't yellow and become brittle with time.

Figure 13-5 shows a sampling of papers that can be found at paper or art stores.

Figure 13-5: Specialty papers are perfect for collages.

Attaching and layering paper to your collage surface

Once you gather up some choices of papers, you are ready to do some gluing. Follow these easy steps to attach and layer paper to your surface:

1. **Choose an adhesive.**

 You may think you need glue to stick down paper and other items onto the surface. However, in the interest of keeping all products chemically compatible, an acrylic medium or gel is actually a better choice for

gluing items onto your collages. And because mediums and gels have different viscosities, you can choose among them to find the best one for what you're gluing. (You can find details on medium and gel products in Chapter 3.)

For example, a lightweight rice paper needs very little to glue it, and in that case a soft gel works well. A seashell, on the other hand, is quite heavy, so for that, you may want to apply a heavy gel with a palette knife and embed the shell into the gel. You can choose a matte (frosted) or glossy (shiny) finish. A gloss finish builds up the brilliance of colors and makes everything shine. But if the shine is too plastic-looking for you, you can lower the sheen level with matte medium or a matte gel. Both mediums and gels are available with a matting agent added if gloss isn't what you want. With medium, you're gluing, sealing, and finishing all with one product.

2. **To layer paper, paint acrylic medium or soft gel onto the area where the paper will be applied, press the paper firmly into the wet medium, and then paint another layer of medium or gel over the top of the paper.**

Because these products are plastic polymer, you have just laminated the paper. When dry, it's impervious to water, dirt, and fingerprints. Note that the medium or gel may change the color of the paper. And at first rice paper becomes transparent and practically disappears. Usually the paper reappears as it dries as a milky semi-transparent layer.

After you apply one paper, you can glue another over part of it or the entire thing. You don't need to let layers dry before applying another paper. You can wrinkle paper for even more texture.

Decorating your own papers

You can paint paper and use it in your collages (or anything else you may dream up). By painting plain paper with acrylic paint, you can make unique papers at a fraction of the cost of buying specialty papers. You can use regular copy paper or recycle other kinds of paper scraps. Here are some paper painting ideas to play with (you may come up with others):

✔ **Paint colors on paper and press bubble wrap into the wet paint.** Try different bubble wrap sizes for different effects. You can also paint the bubble wrap and stamp the dots onto paper.

✔ **Use a makeup sponge to dab paint over stencils and other fabric with holes, such as net and lace.** Dip the makeup sponge in two or three colors and stamp the paint or pull the sponge to make interesting shapes. I made the dots in Figure 13-6a with Punchinello, the material left behind when sequins are made. Figure 13-6b shows how I dragged the paint in swirls and arcs. I applied two colors of paint to the sponge — one at each corner. I started with black paper for these examples.

✔ **Use the techniques in Chapter 5 to make interesting papers.**

Tearing papers

Tearing paper leaves an interesting edge. To get a straight torn edge with heavy paper like watercolor paper, first fold the paper where you want the tear. Crease the fold with your fingernail or a credit card. Open the fold and fold in the opposite direction. Fold back and forth on the crease. Dip your

index finger in water and run a bead of water down the fold crease. Carefully tear along the fold. It should tear fairly easily because you have weakened the fibers by creasing the fold; lining the crease up along a table edge may also help to tear.

Figure 13-6:
Painting
your own
papers.

Tearing paper this way emphasizes higher quality rag cotton content paper (used for watercolor or printing) by showing what's called its *deckled* edge. Machine-made papers have straight cut edges. (More paper definitions in Chapter 2.) You can use scissors — even decorative cutting scissors — to cut paper, but a patterned cut edge tends to look "craftier," which may not be the look you're going for.

Printed paper tears differently if you tear toward you versus tearing away from you. When you tear toward you, the tear has a white edge. Figure 13-7 shows some paper edges: a deckled edge on colored-blue watercolor paper, and a printed paper. I tore the tiger-striped print toward me, making a white edge, and the zebra print away from me, leaving the print-only edge.

Figure 13-7:
Torn paper:
deckled,
torn edges.

Layering in paint

Because acrylic paint dries so quickly, making layers fast is easy. You can use paint in combination with paper to create layers. Paint allows you to add a shape or swirl or something more elaborate. Save paints with a sparkle for the top if you want the glitter to show, although starting with a metallic gold for example and layering over it simulates a gold leaf concept where bits and pieces can peek through. The following sections describe some of the paint options available to you.

Transparent paint

Transparent paint is, as its name suggests, see-through. It influences what it covers without obliterating it. You can make any paint more transparent by adding medium or water to the color. Because medium is colorless acrylic, it stretches the paint molecules out, making the paint more see-through.

Opaque paint

Opaque paint covers completely. You can get a color chart from the manufacturer that tells you which colors are transparent and which are opaque, or you can do a comparison test on your own. It's often worthwhile to do your own test for comparison. Paint a strip of black acrylic paint one inch wide along the length of your paper. After it dries, test your colors by painting a strip of a different paint color perpendicular to and over the black strip; if the second color covers the black, it's opaque. Figure 13-8 shows a sample comparison.

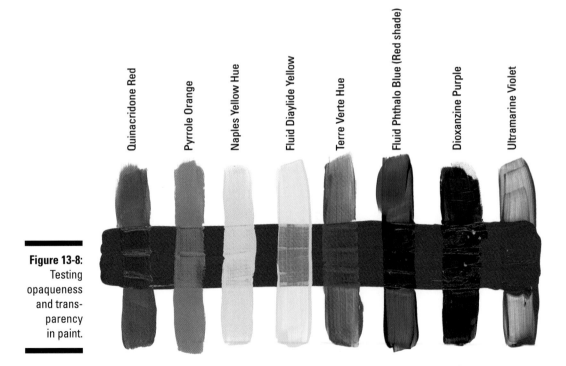

Figure 13-8:
Testing opaqueness and transparency in paint.

Metallic paint: Iridescent and interference

Metallic means metal colors: gold, silver, copper, and bronze. These paints all add a little sparkle and glitter to your project. Metallic paints come in two varieties: iridescent and interference.

- ✔ **Iridescent** paints incorporate mica flakes and powders to make the paints sparkle and give off a luminescent quality. These flakes make iridescents reflect the entire spectrum of colors, giving your collage a bit of eye-catching sparkle.

- ✔ **Interference** paints mess with the light waves and reflect only one color at a time. However, different light conditions change the reflected color. The paint shows up as different colors depending on what color surface it is painted on. For example, when the color reflects off a white surface, it may be an opalescent yellow, but when light is absorbed on a black surface it "flips" to its complement color purple. (I prefer to simply think of it as magic.) These colors show up better on black and dark surfaces. Check out Chapter 3 for more on how interference paints work.

Test these colors on black and white paper as shown in Figure 13-9. Because of the light in the photograph, you may not see the yellow color on white paper. I painted some wriggly black lines with acrylic paint on white paper and let them dry. Then I painted interference violet, which "flips" to a complementary yellow, in a pattern of dots and concentric circles. You can add these magic colors to other plain colors to give any paint an added sheen. Sealing interference paints with a gloss finish brings out their brilliance even more.

Figure 13-9:
Iridescent and interference metallic paint.

Working with Images and Direct Transfers

You can add *images* (photographs, magazine, photocopies, and so on) to your collage in three basic ways:

✔ **Draw or paint an image (picture) on the collage.** Of course, you can paint onto the collage in any number of layers, in one spot or over the entire area. (See "Layering paint" earlier in this chapter.)

✔ **Cut (or tear) and paste an image onto the collage.** Cutting and pasting is usually what people think about when making a collage.

✔ **Make a direct transfer of the image.** Want immediate gratification? Direct transfer is for you.

The following sections show you how to make a transfer and then provide some examples, variations, and a word about keeping everything legal.

Making a direct transfer

To do it, you need a photocopy or a magazine page. You will ruin the picture, so make a copy if you want to save the original. Any photo or printed image will work, but thicker paper makes it more difficult to remove. Cheap paper copies work best, but not ink-jet because the ink is water-soluble and will run.

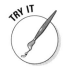

Follow this method to make a direct transfer:

1. **Make a good quality photocopy of an image you like.**

 The image on the photocopy transfers onto the surface, destroying the original copy.

 Photocopies from laser printers work better because the images are made with toner, making them waterproof. Ink-jet prints run when dampened — such as when you're gluing them down, for example.

2. **Get a piece of watercolor paper about a half inch larger all around than your photocopy.**

 Use any weight (such as 90#, 140#, or 300#) of hot press (smooth) paper. Use the tear method if you need to reduce the size of your watercolor paper (see "Tearing papers" earlier in this chapter). You get different results with other papers, so by all means feel free to experiment.

 A photocopy doesn't use white ink in white areas — it just leaves the white of the paper. Keep this consideration in mind when you're choosing a watercolor-paper color; when you transfer your photocopy, the paper color shows through the image's "white" areas.

3. **Using a ½-inch flat brush, paint a layer of acrylic matte medium on the paper.**

4. **While the medium is still wet, place the copy face down in the medium.**

 If the copy slides, it will distort the image, so don't wiggle it (unless distortion is what you want).

5. **Press down on the back of the copy to make sure it contacts the medium and squeeze out any air bubbles.**

 A credit card makes a good makeshift squeegee.

6. **Allow the paper to completely dry.**

 Half an hour may be long enough depending on your humidity and temperature conditions, but overnight is even better. If you're impatient, use a blow dryer or a heat gun to dry it faster.

7. **Saturate a cellulose sponge with water, place it on the back of the copy, and rub off the paper.**

 Let the copy paper get saturated as you rub away the copy paper with the sponge (or you can try using your finger). The wet paper peels up in little pieces. When it's gone, you should see the image that has transferred and embedded itself onto the watercolor paper.

8. **Let it all dry again.**

 If the image gets cloudy as it dries, you haven't gotten all the paper off. You can rub it off with water and your finger. To keep the wet look, paint a layer of glossy acrylic medium over the image.

The transfer technique gives you some surprises (hopefully pleasant ones). Sometimes, bits of the texture disappear (maybe because the copy didn't make enough contact with the medium), creating an interesting effect. A larger piece may look neat with some missing texture, whereas a small image may lose too much. If you get something you don't like, you can touch it up with paint. The transfer in Figure 13-10 was a photocopy of a painting I made. There are two transfers on different papers: one hot press watercolor paper (140# weight 100 percent cotton-content paper; see figure 13-10a) and one cold press (slightly rough texture; see Figure 13-10b). The cold press has more texture, and the transfer doesn't make contact as well as the hot press (which is smoother). You can see by the size of my hand in Figure 13-10c that this is a small transfer.

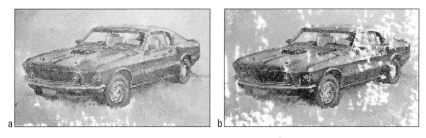

Figure 13-10: Smooth paper (a), cold press paper (b), and the transfer rubbing process (c).

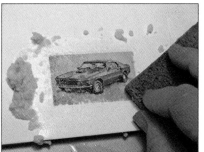

You can make transfers onto other papers besides watercolor paper. In Figure 13-11, I used a handmade tan-colored paper with a lot of flecks of stuff in it. But first, I copied the painting onto turquoise paper and then cut it out, leaving a turquoise frame — which is how I got the rectangle around the painting. This technique is a great way to collage a border around the outside of your piece. Next comes the transfer part where the copy will be influenced by the paper it is transferred onto. This painting copy had a lot of "white" in the sky, and the base paper showed through when the image transferred.

Figure 13-11:
A transfer of a painting onto handmade colored paper.

Another technique is to brush thick medium onto watercolor paper; the thick medium holds your brush strokes, which then texture the transfer. Figure 13-12 reveals this streaking, brush stroke texture.

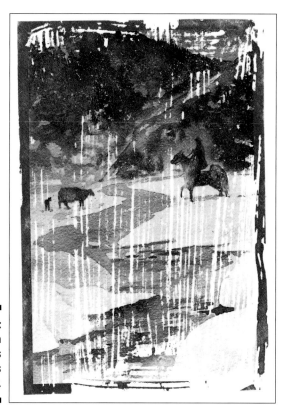

Figure 13-12:
Brush strokes show on this transfer.

You can also make transfers onto painted surfaces. In Figure 13-13 I painted some swirly stripes of Diarylide Yellow, Dioxazine Purple, and Iridescent Copper on foam core and let them dry. Then I transferred a copy of a charcoal figure drawing.

Figure 13-13:
A transfer of
a drawing
over paint.

Transferring drawings

You can also transfer original drawings (not copies) into acrylic pastes or mediums. The pastes give it more dimension and texture. Use the same process as the copy transfer method only use a drawing.

Figure 13-14 shows a drawing that I transferred into fiber paste. *Fiber paste* is white, so I added a Naples Yellow Hue acrylic to it first and mixed it thoroughly on my palette. I applied the colored fiber paste with a palette knife onto foam core board as smoothly as possible in a thin layer. While it was still wet, I put the drawing image side down into the paste and let it dry. Then I rubbed off the paper with water and a sponge. I like the way the fiber paste looks like an animal skin — it kind of looks like an old Western surface with the stagecoach drawing.

Figure 13-14:
Transferred
drawing into
fiber paste.

Because I was in a Western mood, I did another drawing transfer into paste on foam core in Figure 13-15a. After rubbing the transfer off, I painted over the top to create the final product shown in Figure 13-15b.

a

b

Figure 13-15: A transfer drawing in paste and then painted.

Making sure your collage doesn't infringe on copyrights

Use caution (and restraint) when using magazine pages and other people's images. Photographs in magazines, on the Internet, in newspapers and calendars, and so on are copyrighted, meaning they're the property of somebody else (usually the person who took the photograph). Using them as your own is stealing and can land you in court. Obviously, collaging your own photographs is no problem.

Copyright extends for 70 years past the life of the artist. At that time, it falls into *public domain* (meaning anybody can use it royalty-free) unless an estate renews the copyright. You can find plenty of public domain images on the Internet — search for "copyright-free images" or check out www. dotgovwatch.com/?/archives/8-The-Best-Copyright-Free-Photo-Libraries.html, which links to the public domain archives of several governmental agencies. Another site offering free stock photographs is www.fduniversity.wetpaint.com, the Free Digital University's Web site. Some sites want you to buy their services and ask for a subscription fee.

If you don't have access to the Internet, go to your local library. Many libraries offer Internet access, not to mention books. Check out books by Dover Publishing (also online at www.doverpublications.com) that have public domain images. Another option is the kind of services newspapers and graphic designers subscribe to that provide copyright-free images.

Did you know you can make a hologram — a photograph that looks extremely 3-dimensional? This fake hologram is a fun technique. Mix a couple drops of interference violet with a couple tablespoons of glass bead gel on your palette and use a palette knife to cover a photocopy with the mixture in a thin layer. Glass bead gel is white when wet, but it dries completely clear. This process leads to a result that resembles a hologram when dry, as seen in Figure 13-16.

Figure 13-16:
Faux hologram using glass bead gel and interference paint.

Project: Southwestern Cliffs Collage

This project pulls together a few of the techniques discussed throughout this chapter to make a collage project. You get to layer paint and paper. You could even add a transfer rather than painting on a subject like I did. You can duplicate this project exactly or use the steps with your own theme. My project uses earthy colors and is inspired by the cliff dwellings at Mesa Verde National Park in southern Colorado.

1. **Choose your surface.**

 I used stretched 140# cold press 11-x-14-inch watercolor paper. I wet the paper completely and stapled it (a staple per inch all around) to ½-inch gator foam and let it dry. I pulled the paper off the staples when finished and can reuse the gator foam to stretch other paper.

2. **Choose what you want to say and how to say it.**

 I chose a theme of ancient ruins in the Southwest. I chose a composition format (Chapter 9) and the colors that I thought worked best.

 I chose a forward cruciform shape (more on composition in Chapter 9). I painted Iridescent Gold, Ultramarine Purple, and Azo Gold (see Figure 13-17) as a background in this shape.

3. **While the paint dries, choose your paper and tear it into manageable sizes and shapes.**

 The paper is your palette of colors to glue or collage onto your painting. I chose papers that were similar in color to my paint choices. This was a small artwork, so I tore the paper into 1 to 2 inch pieces and a couple long skinny ones too. I placed the paper above the painting area where it was easier to reach, as shown in Figure 13-18.

Figure 13-17:
Paint the surface in a cruciform shape with acrylic colors.

4. **Use a ½-inch flat brush to paint a swatch of soft medium roughly the size of your paper, and then place the paper in the wet medium and paint another layer of medium over the top.**

You can glue the edges of the paper flat or leave them loose for texture and depth (see Figure 13-19).

Figure 13-18:
Paper "palette" choices to be glued to the painting.

Figure 13-19:
Glued
papers over
the paint.

5. **Put any final details in the collage.**

In Figure 13-20, I painted Micaceous Iron Oxide details that were inspired by a Mesa Verde Anasazi Indian ruin depicted in the photograph at the top. It's not an exact duplication but rather the essence of the ruin.

Figure 13-20:
A photo-
graph used
as refer-
ence to
paint some
Native
American
ruins for
the final
collage.

Knowing when you're finished

Especially with abstract and collage works, you may have a hard time deciding when your project is complete. Artists often feel like they need someone looking over their shoulders to let them know when to say, "Stop already! It's done!" Overworking a few paintings may be the only way to recognize this need on your own. After working on a painting for a long time, it can become hard to see it objectively; you may even want to set a timer to remember to take a break and analyze the painting's progress. Step back and look at the painting from a distance. Take a long walk to clear your head. Here are some tricks to see the painting with fresh eyes:

- **Look at the painting in the mirror.** By showing everything in reverse, the painting appears different enough that you can notice whether something is out of balance.

- **Turn it upside down and stand back.** Now all the colors, shapes, and values are in a new place. Do they feel right?

- **Start a critique group.** Find some like-minded individuals and meet for coffee and critique — having someone to answer to is quite helpful. Create your own deadlines to get paintings done and bounce ideas around. Someone else may see something you don't.

- **Check your art supply store for gadgets to help you view paintings unconventionally.** For example, you can get a reducing glass (sort of a reverse magnifying glass) that makes you feel like you're looking at the painting from far away without having to cross the room. Does the tiny painting have impact? Or do you need a stronger center of interest?

Chapter 14

Cool Projects for All Types of Surfaces

In This Chapter

▶ Discovering the wide variety of surfaces you can paint on

▶ Painting items you can display, wear, carry, and give away

▶ Manipulating the properties of paint to create cool projects

*P*ainting isn't just for flat canvas — acrylic paint is versatile enough to give life and color to almost any surface. For the projects in this chapter, you don't have to stick with the examples I choose — feel free to adapt them to whatever items you want: pillows, t-shirts, plaques, wall borders, tiles, notebooks, furniture, you name it. If it sits still long enough, you can paint it! Now that you can personalize, customize, and elevate the common to become art, you have no reason to keep ordinary, blah items in your home.

In this chapter I give you the exact colors I used, but as always you can use any color combination you like. I tend to use the craft acrylic paints — the ones that come in bottles — for these projects, but any acrylic paint works.

Wild About Wildcats: Painting on Wood and Clayboard

When artists paint things that are functional, the result is often called *decorative art*. Decorative art includes items that improve the decor of a home — for example, the wooden box of coasters shown in Figure 14-1, which sits on a coffee table.

You can always elevate objects of decorative art to fine art and hang them on the wall.

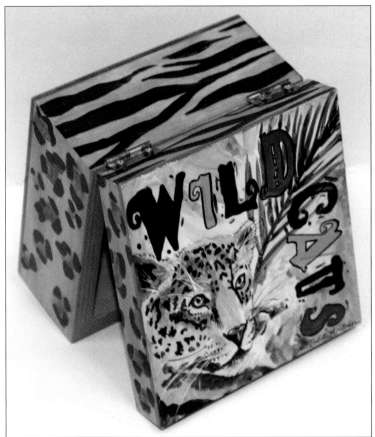

Figure 14-1:
Wildcat box
with four
coasters.

Wooden wildcat box

I found this nifty box with coasters inside first. Then I came up with the idea of what to paint on it. You may go at it a different way — for instance, you need something in a certain area to match your decor and go looking for the item to embellish to match. You may also see something painted here like these wildcats and adapt them to fit another shape or idea. You may think these coaster designs would be better on pillows for your zebra-striped couch. Go for it. The same painting steps will work on just about any surface.

1. **Start with an unfinished box.**

 I got a 5-inch-square stampboard box kit by Ampersand (www.amper sandart.com). The top of the box is prefinished with a smooth, white clay-coated surface. Inside the box are four 3½-inch-square sheets of stampbord, which become the coasters. (I show you how to paint the coasters in the following "Coasters" section.)

2. **Round up brushes (¼-inch flat, #4 round, and #000 liner), graphite paper, a ballpoint pen, a palette, a water container, a permanent black pen, wood sealer, and satin varnish.**

3. **Sand the all wood surfaces if needed, clean all wood surfaces, and then apply wood sealer and let dry.**

 Note: If it has a claybord top, it doesn't need sanding or sealer.

4. **Using graphite paper, transfer the drawing in Figure 14-2 to the top of your box.**

 Chapter 6 discusses transferring drawings with graphite paper.

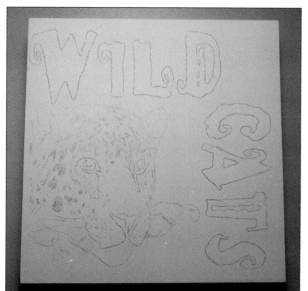

Figure 14-2:
Wildcat
transfer
drawing.

5. **Get your paints ready by pouring a quarter-sized puddle of each onto your palette.**

 I used acrylics by Plaid in the following colors: 918 Yellow Light, 917 Yellow Ochre, 943 Burnt Sienna, 479 Pure Black, 515 Vintage White, 518 Peony, 486 Prussian Blue, 471 Green Umber, 671 Metallic Green, and 526 Soft Apple.

6. **Paint the background.**

 A. Using the round brush, paint a palm tree in Green Umber and let it dry.

 You can speed up drying time by using a blow dryer. Notice in Figure 14-3 that I didn't paint over the lettering with the dark acrylic. Covering a dark color with a light color later is difficult (although you can do it if necessary).

 B. Paint just enough water to dampen the surface and give yourself time to work with the colors before they dry.

 C. Thin the Soft Apple, Metallic Green, and Prussian Blue with water and paint the background (everywhere except the cat's face) transparently, using the flat brush for larger spaces and the round brush for tight spaces, and let dry.

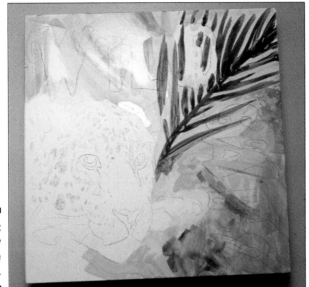

Figure 14-3:
Start by
painting the
background.

You can paint over the palm as long as you do so transparently so that the palm shows through the paint. Because the palm is dry, it won't move. Let the colors flow and don't worry about keeping it exactly like the example — you can't do this step wrong. Have fun watching the paint swirl around.

7. **Use the round brush to fill in lettering.**

In Figure 14-4, I alternated colors: Green Umber, Yellow Ochre, Burnt Sienna, and Prussian blue.

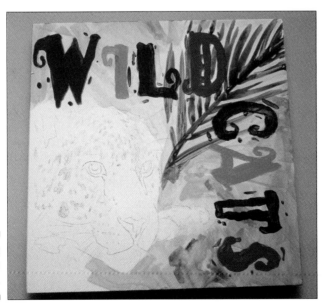

Figure 14-4:
Paint the
lettering.

8. **Base coat the leopard face with a transparent wash of Yellow Ochre (Figure 14-5); while that dries, outline the letters with a permanent black pen.**

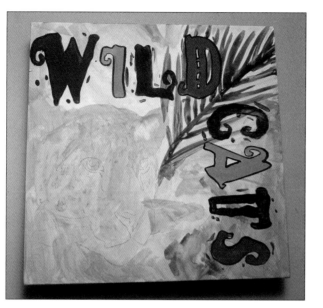

Figure 14-5:
Paint the
leopard.

9. **Model the face by using the round brush to apply Burnt Sienna to the edges and ears and around the nose.**

 Modeling the face (making it look rounded) gives it the appearance of depth. Figure 14-6 shows the modeled face.

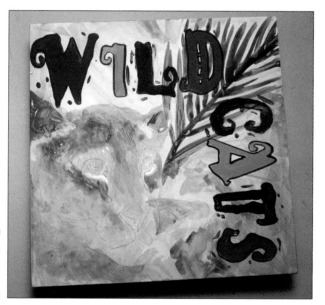

Figure 14-6:
Model the
face.

10. Paint the details.

A. Use the round brush to paint the nose with Peony. Paint the eyes Yellow Light with a little Yellow Ochre at the top to make them look round. Paint the spots black. Let these details dry.

B. Use the liner brush to apply black paint to outline the eyes and nose. Define the chin and ears with Burnt Sienna and black. Highlight the eyes, cheeks, and chin with white. Paint some white whiskers and hairs. Figure 14-7 shows the finished box.

I painted the sides of the box in faux fur patterns, with two sides of tiger stripes and the other two of leopard spots. I first base coated the sides with a transparent orange paint. I painted tiger stripes in black, using the flat ¼-inch brush. I added leopard spots by first making a thumbprint of Burnt Sienna and then adding three irregular blobs of black on the edges of the thumbprint.

After everything dries at least 24 hours, you can seal the painted surfaces with a coat of satin varnish, using a ½-inch flat brush. You can also varnish the unpainted sides of the box (more information on varnish in Chapter 4).

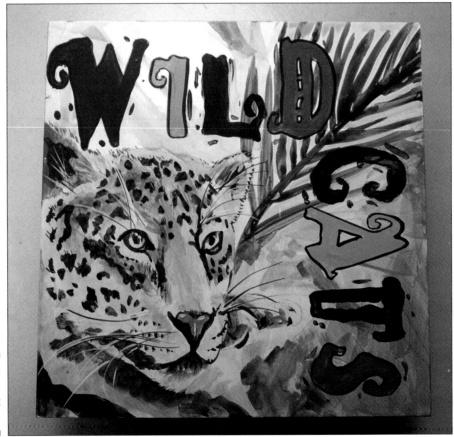

Figure 14-7:
Finished
wildcat
box top.

Coasters

How about some coasters to go inside the box? This project contains four coasters: leopard, panther, tiger, and lynx. Paint each of their little faces similarly to the box-top cat (which is also a leopard).

Detailed step-by-step photos are shown for the leopard's face. Paint the panther, tiger, and lynx with very similar steps, but using similar colors and appropriate pattern drawings. Using just the beginning and ending photos, paint the other cats like you do the leopard.

Leopard coaster

Follow these steps to make the leopard coaster:

1. **Transfer the drawing in Figure 14-8 using graphite paper and a ballpoint pen.**

 Head to Chapter 6 for more on transferring drawings.

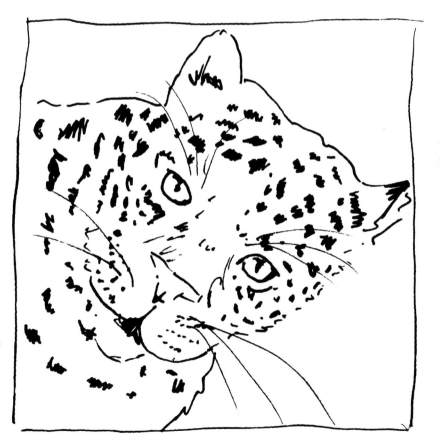

Figure 14-8:
Leopard drawing to transfer for painting.

2. Base coat the leopard face with a #4 round brush and Yellow Ochre and then color dark areas, such as under the chin, with Burnt Sienna. Let dry.

3. Continue to develop shadows in the face, including the nose, eyes, and mouth, with Burnt Sienna (see Figure 14-9). Let dry.

Figure 14-9: Develop shadows in the face.

4. Develop detail areas, including eyes, ears, spots, nose, mouth, and whiskers, using a liner brush (Figure 14-10).

Use the same colors as in the "Wooden wildcat box" project earlier in the chapter.

Figure 14-10: Develop details in the face.

5. Finish details and hair highlights with the liner brush (Figure 14-11).

Figure 14-11:
Paint the
details for
the leopard.

6. For the background, swirl together Green Umber, black, and enough water to make it as transparent as you want (Figure 14-12a).

7. Make the background around the face dark to provide nice contrast (Figure 14-12b). Let dry.

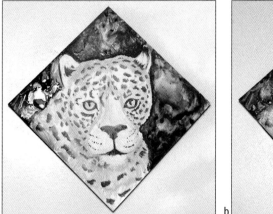
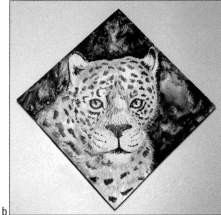

Figure 14-12:
Paint in
the back-
ground (a);
darken the
background
near the
face for
contrast (b).

a

b

8. Use a liner brush to paint white whiskers and hairs over the background (Figure 14-13).

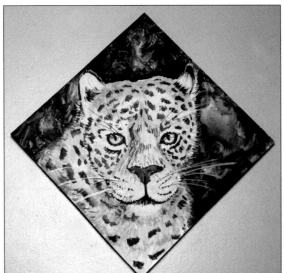

Figure 14-13:
Paint in
white
whiskers
and long
hairs.

Panther coaster

To paint the panther coaster:

1. **Use graphite paper and a ballpoint pen to transfer the pattern in Figure 14-14.**

 Chapter 6 contains instructions for transferring a drawing.

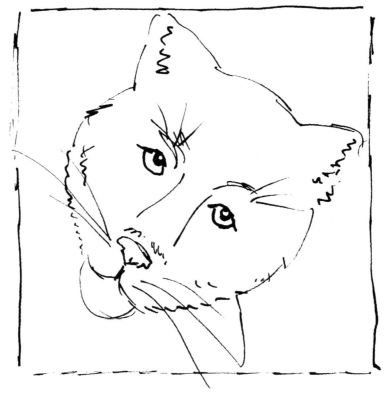

Figure 14-14:
Panther
drawing to
transfer.

2. **Mimic the highlights in Figure 14-15 by using pure black, Prussian Blue, and white.**

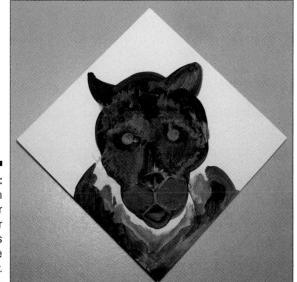

Figure 14-15:
Paint in
the lighter
areas for
highlights
on the
panther.

3. **Paint shadow areas with black. Let dry.**

4. **Repeat Steps 4 through 8 from the preceding "Leopard coaster" section.**

The final coaster appears in Figure 14-16.

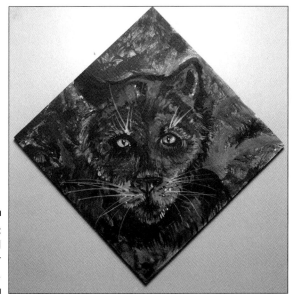

Figure 14-16:
The final
panther
coaster.

Tiger and lynx coasters

The tiger and lynx coasters use all the same colors and steps as the leopard, but the patterns and details change (Figure 14-17a is the pattern for the tiger, and Figure 14-17b is the pattern for the lynx). The tiger needs some orange paint, which you can mix with red and yellow or get a Cadmium Orange.

Figure 14-17: Transfer these images and paint the coasters with the same colors as the leopard.

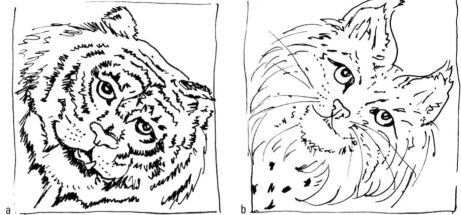

a

b

Paint the tiger and lynx in similar steps and with the same colors as the leopard. Add some pure orange to the tiger's base coat.

TIP

Animal patterns and faces are great subjects and can be painted on a lot more than boxes and coasters. I participate in a couple of mask charity auctions each year. The cats' faces are fun to paint on masks and are always a favorite with the buying public. The mask in Figure 14-18 was a blank white plaster cast to start with. A first coat of acrylic gesso sealed the plaster, and then I painted the face in steps similar to Figure 14-8. Because this mask was a lion, he got more hair lines with a liner brush, and no spots. I glued a beaded, fringed trim around the edge. After the painting was done, I painted it with triple-thick glaze to make a shiny finish like ceramic.

Grape Art: Painting Grapes on a Violin (Yes, Really)

Lately, the trendy thing is to get artists to paint on different surfaces and then sell the finished items to raise money for charities. I think this year alone I painted a trunk, a drum, several masks, Christmas ornaments, and the violin shown in Figure 14-19a. I was a bit apprehensive about painting a musical instrument, but the founding organization acquired an instrument that was long past its playing prime due to a massive crack.

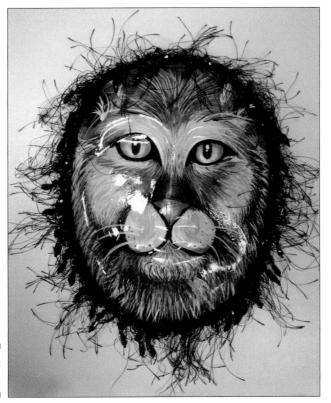

Figure 14-18:
Lion mask.

I chose to paint grapes on the violin because the lady who asked me to do it had just had me paint her kitchen in a medieval vineyard theme. Figure 14-19b shows the matching kitchen. I gilded the edges of the violin with gold leaf and sprinkled mica chunks into the leaves for added sparkle. This violin was so worn that it needed no special preparation to accept paint, but if you are working on a shiny varnished surface, like a violin may be, give the surface a light sanding to provide some tooth for the paint to adhere better.

Painting grapes is easy, quick, and satisfying. You can add them to a wine rack or personalize a bottle of wine to give as a gift:

1. **Get a foam dauber.**

 You can get daubers in many sizes and brands at craft stores. I used Plaid's *dot brush,* a ½-inch sponge rubber circle mounted on a 3-inch wooden dowel handle. If you can't find these applicators at a craft or paint store, you can just use a circle of sponge rubber without a handle.

2. **Prepare your palette with two values (light and dark) of purple paint.**

 You can buy two purple paints or mix a red and blue you have on hand to create your own purple and then lighten half of it with white.

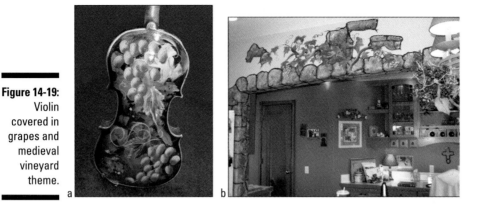

Figure 14-19:
Violin covered in grapes and medieval vineyard theme.

a b

3. **Dip opposite halves of the dauber in light purple and dark purple and then place the dauber on the surface, wriggle it a little (as if fine-tuning a radio dial), and lift it straight up.**

 To make oval grapes, pull the dauber in one direction to elongate the circle (Figure 14-20).

Figure 14-20:
Use a dauber to paint a grape.

4. **Repeat Step 3 to paint a cluster of grapes.**

 When you repeat the next grape place the lights and darks so that they alternate and show up to their best advantage — light side of one grape against the dark side of another grape (see the example for placement).

5. **Add greenery as desired.**

 Paint leaves with a flat brush as loosely or detailed as you want. Use a liner brush to paint swirling tendrils.

Wall Art: Painting a Mural

Acrylic paint works well for murals. Last summer, some friends and I painted the entire upstairs of a local church with Biblical scenes for a children's area (Figure 14-21a). Kids can hardly wait to go to church with those fun decorations around. Likewise, kids' rooms are great places to paint murals. Invite the owner of the room to help you decide what images he or she wants to see come to life. I recently painted some kids' rooms — one child wanted a cowboy on his wall, and his brother asked for a rock star in space. Without their help, I would never have thought up those, um, combinations.

Figure 14-21:
Wall murals let you think big.

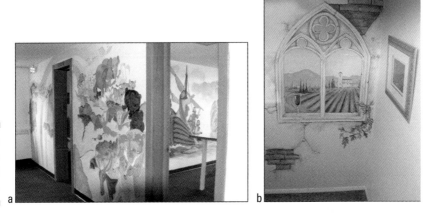

a b

I once surprised a co-worker with a mural at work when she returned from a trip to Tuscany. Rather than a blank wall, you now see an inviting Italian fantasy (Figure 14-21b). You may want to check with your boss before you get started, though.

The following steps give you the basics to get started on your own mural:

1. **Make sure the wall is clean.**

 For a relatively clean wall, wash it down with soap and water. Invisible oil from handprints will make paint not want to adhere, so it is important to rid the wall of these. If the wall was painted some time ago, give it a scrubbing. Wash it down with TSP (trisodium phosphate), available at the paint store or sometimes in a well-stocked grocery store's cleaning section.

2. **Prepare the surface.**

 Prime the wall and make sure any damage, such as holes, are spackled and primed.

 Any surface texture will work, but bumpy surfaces, such as rough concrete and textured wall, will make the job twice as difficult to cover. Charge double or avoid them.

3. **Gather size-appropriate supplies.**

 Because most murals are huge, you probably need to get bigger paint applicators. Sponge rollers, sponge paint sticks, and synthetic sea sponges are inexpensive and work well.

 Cover the floor with a tarp for spills and drips.

4. **Paint the wall one solid color in latex interior or exterior paint.**

5. **Paint your mural masterpiece like any painting only bigger.**

6. **Varnish your finished mural if desired.**

 I've never put a protective varnish on a wall mural when finished, but if you want yours to last forever, you may want to roll on a clear acrylic sealer. See Chapter 4 for more on varnishes. A good UVLS varnish is always necessary for outdoor work to protect against sun exposure, as well as the elements.

Art to Wear and Carry: Painting Fabric and Other Materials

You can paint the projects in this chapter on garments and other fabrics, as well as on wood or walls. Just be sure to add *fabric painting medium* to acrylic paint to ensure the painted garments remain washable. One of the main advantages of using fabric medium is that acrylic paint makes a stiff film on fabric, and many times the paint doesn't absorb well into the fibers. The special medium increases absorbency and creates a softer feel after you launder the material. (I'm not sure why, but paint washes out if you deliberately paint it on without a medium, yet it stains permanently when you spill it accidentally. It's the law of accidental chemistry, I guess.) Plaid makes a product called FolkArt Textile Medium and suggests mixing one part medium to two parts paint. Golden makes GAC 900 for fabric painting; use equal parts of this medium and paint.

After painting, you can heat set the material with an iron or in a dryer and then wash it. Just follow manufacturer's directions on labels for different brands of products to ensure the proper steps to make your painting as permanent as possible. If the fabric is lightweight, iron it first on freezer paper to make it flatter and easier to paint. You can also put your fabric in an embroidery hoop to create a tighter surface to work on.

And just what garment should you paint? Dharma Trading Co. (www.dharma trading.com) is a great source for blank garments to paint on, and its catalog reads like a how-to book.

Purses are fun to paint. They come in a variety of materials: fabric, wooden cigar boxes, metal — you name it. I found some great blank wooden purses made by Judy's Stone House Designs (www.judysstonehousedesigns. com). They're a bargain and even come with a beaded handle. I transformed one purse (style CBP-010) into a carrying case for my binoculars to go bird

watching (Figure 14-22). On each side is a different bird — ones I saw my first year of hanging out with Audubon types.

Another fun shape for Valentine's Day (or any other time) is Judy's model CBP-009, shown in Figure 14-23. See how different it looks with different designs? To paint the red heart, I first base coated the entire purse with gold acrylic paint and then painted a layer of Plaid FolkArt eggshell crackle medium over the whole surface. After the medium dried, I painted the purse with red acrylic paint. As that layer dried, the red layer cracked, letting the gold peek through. You can use any color combination. Just remember that the first color becomes the color of the cracks. Finally, I painted the pinstriping (like on automobiles) by using a liner brush and a steady hand.

Always let the last layer dry before adding more paint. That way, if you don't like something you've just painted — like a wiggle that was supposed to be straight — you can simply wipe it off with a damp paper towel and try again without smudging the earlier layers.

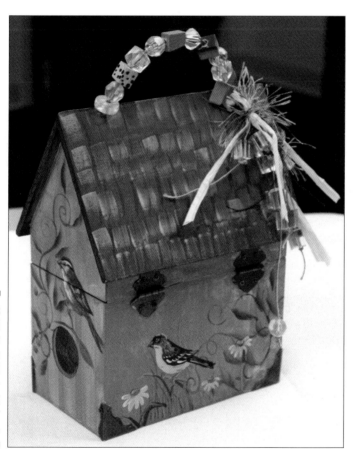

Figure 14-22: Painted wooden purse transformed into bird-watching binocular case.

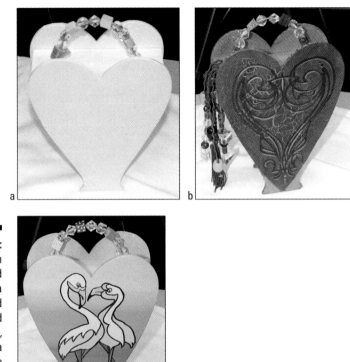

Figure 14-23:
An
unfinished
purse (a), a
pinstriped
painted
purse (b),
and a
flamingo
painted
purse (c).

This flamingo purse (shown in Figure 14-23c) is a fun project:

1. **Remove all hardware from the purse.**

 If you want to keep the metal parts clean, remove them with a screwdriver before painting. The purse in this example has hinges and a clasp. By removing them, you don't have to be so careful painting around them (which never works, by the way). The handle on this purse isn't attached when you buy it. You can unscrew the end of it, remove the beads, and paint them separately. After they dry, reassemble and attach the handle to the painted purse.

2. **Sand the purse, wipe away the dust, and cover it with wood sealer.**

 For a real professional finish, repeat this step a second time.

3. **Base coat the purse, paint the inside, and let everything dry.**

 Using a ½-inch flat brush, I blended three colors of acrylics: Plaid FolkArt 656 Metallic Blue Sapphire on the bottom, Plaid FolkArt 481 Aqua in the middle, and DecoArt Winter Blue on the top. I painted two coats to get it as smooth as possible (see tips on blending paint in Chapter 11). Paint the inside of the purse whatever color you want.

4. **Use graphite paper to transfer the design in Figure 14-24.**

 Head to Chapter 6 for instructions on transferring drawings. Figure 14-25 shows the drawing transferred to the base-coated purse.

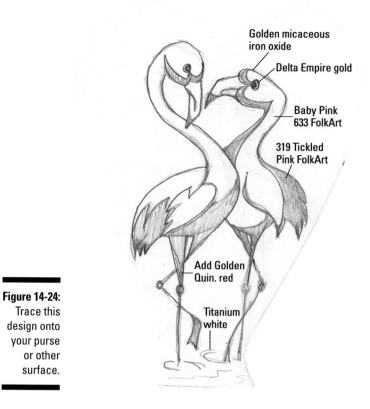

Golden micaceous
iron oxide

Delta Empire gold

Baby Pink
633 FolkArt

319 Tickled
Pink FolkArt

Add Golden
Quin. red

Titanium
white

Figure 14-24:
Trace this
design onto
your purse
or other
surface.

Figure 14-25:
Drawing
transferred
onto a
purse.

5. **Paint the flamingos and let them dry (see Figure 14-26).**

 Using a round #5 brush, paint the light pink (Plaid FolkArt 633 Baby Pink) and dark pink (Plaid FolkArt 319 Tickled Pink). Add Golden Quinacridone Red to one of the pinks and paint the legs. The eye is a thick dot of Delta Empire Gold. Paint the beaks yellow or gold.

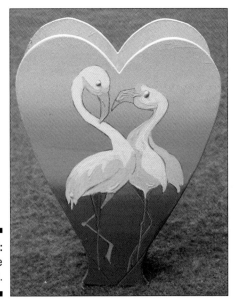

Figure 14-26:
Paint the
flamingos.

6. **Use a liner brush and black paint to outline the flamingos and waves and then use black and white for the eyes.**

 Paint some *C* lines to represent the water ripples below the feet. Paint an eye pupil on top of the gold eye by making a black dot first and a smaller white dot on the eye.

7. **Seal the purse with a finish.**

 I coated the purse by using a 1-inch sponge roller and some glossy acrylic varnish. Because a purse has to stand up to a lot of touch and abuse, you may want to give it two coats of varnish. Figure 14-23c shows the final purse.

Rock On: Painting on Rocks and Stone

Need free canvas? Look outside your door — rocks probably abound. I remember painting rocks as a child — we made all kinds of bugs and animals, and it was a blast. Take a kid rock hunting for suitable, paintable rocks, and you can enjoy nature and their imagination for hours. No special preparation is required besides giving them a good rinsing to get dirt off. Figure 14-27 shows a little mouse that I painted on a rock. If you want to paint your own, follow these steps:

1. **Base coat the rock with acrylic paint.**

 In the case of the mouse, he was painted with white on the bottom and gray on the top.

2. **After the base coat dries, you can add details, texture, hairs, eyes, nose, ears, mouth, and whiskers.**

3. **Glue a rubber-band tail on the back.**

He makes a cute paperweight. He could be varnished for extra protection.

I also like to paint curled-up cats on big, smooth river rocks. They make great doorstops or paperweights.

Painted rocks are great practice and sell well at craft fairs.

Figure 14-27:
A mouse
painted on
a rock.

Heavy Metal: Painting on Steel

Any metal can also be painted with acrylic paint. You can buy metal shapes or metal furniture and paint them however you like. Walnut Hollow (www.walnut hollow.com) recently released a line of metal products. Frames, lunch boxes, and jewelry are just a few of the items you can choose from.

Most metal requires no preparation other than cleaning. If the surface is really shiny, you can sand it lightly to give it *tooth* (a rough surface) that the paint can grab. Let the neighborhood know where an artist lives by painting your mailbox with your favorite subject. I cut up metal sheets into shapes

using a plasma torch, sand-blast them, and either let them rust or paint them with acrylic paint. Figure 14-28 shows some fish I made in this manner. I let the paint flow and dry and then detailed it with spots. I used spar varnish for a hearty outdoor final finish.

A couple of weekends ago my husband and I made this bench, shown in Figure 14-29a, from the metal panels off an old John Deere beet digger that was used to harvest sugar beets. I painted on a scene of him using the equipment when it was in better shape. When finished the bench was coated with gloss spar varnish to juxtapose the newly made bench in contrast to the rusty, old metal. For your enjoyment, here are some steps to make this bench:

1. **Buy a piece of farm equipment for $150,000.**

 I like the John Deere green beet digger.

2. **Use the equipment for 30 years to toil in the field digging beets.**

3. **Give up on farming and dismantle the equipment.**

4. **Cut the equipment up with torches into manageable sizes and shapes.**

5. **Weld the pieces back together using beet digging disks as the sides.**

6. **Use acrylic paints to create a landscape of farming sugar beets on the back of the bench.**

 You can see a close-up of this landscape in Figure 14-29b.

7. **Varnish with gloss spar varnish to make the bench shiny new and seal in its rusty past.**

8. **Sit back and relax on the bench and be glad your farming days are over.**

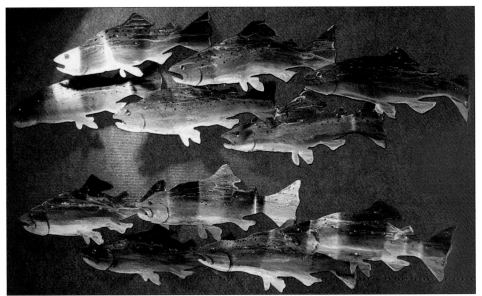

Figure 14-28:
Acrylic-
painted
steel trout.

Figure 14-29: Bench welded from farm equipment (a); close-up of the painting of digging beets (b).

a

b

Odds and Ends: Faux Stained Glass, Bricks, and Candles

The projects included here are more ideas to whet your artistic whistle. By now you should be convinced that acrylic can be used on any surface, but if not, here are some more options.

Faux stained glass

Thick acrylic paint peels off glass or a disposable paint palette when dry. This property is great for cleaning the palette, but it can also make peelable paint. That means you can make sheets (or *skins*) and cut shapes out with scissors, or you can actually shape the skin on the palette. These skins are flexible and waterproof.

This section contains three variations of skins. You may find them inspirational for discovering many more variations. The first one, shown in Figure 14-30a, was done by simulating handmade paper by using fiber paste. I put beads and confetti (which shows up in a printed photograph) in the paste while still wet, but you can put something more subtle into the paste.

Figure 14-30: Sheets of acrylic paint that are independent of a substrate.

a

b

To recreate Figure 14-30a (or something like it), follow these steps:

1. **Tape a 2-inch square on a disposable palette.**

 The tape works as a mask to keep the shape neat. I used white artist's tape, but masking tape or painter's tape would work too.

2. **Use a palette knife to thoroughly mix two tablespoons of fiber paste with a pea-sized scoop of Naples Yellow Hue acrylic paint and spread the colored paste into the masked-off square until it's about the thickness of a penny.**

3. **Embed small items into the wet fiber paste and then peel off the tape while the paste is still wet.**

 I placed handmade paper bits, beads, and star confetti into it.

4. **Using a ¼-inch flat brush, pull the paste away at the edges in little feathery strokes.**

 This technique makes it look like handmade paper with a *deckled* (ragged) edge.

5. **Let the paste dry — overnight if possible.**

 The next day, the paint sheet peels right off the palette.

Punch a hole at the top corner and tie a ribbon through for an ornament to hang.

I made Figure 14-30b the same way, except I used glass bead gel and left the edges straight, with no feathering. I applied more glass bead gel over the embedded material to make them a little more subtle. I may cut up this shape and make jewelry out of it.

This next skin in Figure 14-31 could be made in any shape. You could place it in a window as a suncatcher.

1. **Draw a columbine flower on the disposable palette with a permanent marker.**

2. **Paint thick black acrylic paint over the outline using the liner brush.**

3. **Let it dry overnight.**

4. **Fill in the areas within the outlines with acrylic paint mixed with glass bead gel.**

 Use white paint for the interior petals, purple for the larger outside petals and yellow for the center. Paint should be the thickness of a penny.

5. **Let it dry overnight again.**

6. **Peel off the paper.**

There are craft acrylic paints that mimic stained glass. DecoArt makes paint that's transparent. Put two colors in an area and use a toothpick to stir and swirl the colors before they dry — your project will look like marbled glass.

Figure 14-31:
An acrylic
suncatcher
made only
of acrylic
paint.

Painted brick

Sometimes a historical building has to be demolished to make way for the future. When this happens near me, I get bricks from the demolition and paint the building in its heyday right on the brick. It makes a really nifty memorial to the architecture. History buffs, building owners, and museums love to have this type of memento on their shelves. No special preparation is needed. Varnish when finished.

Painted candles

Waxy surfaces, such as candles, resist acrylics, but by adding candle wax medium, you can make the paint stick to even wax. DecoArt makes a product called Candle Painting Medium that allows acrylic paint to adhere to candles and soaps.

To make your own painted candle creation, follow these simple steps:

1. **Mix equal amounts of medium and acrylic together.**
2. **Prepare the surface of the candle by cleaning with rubbing alcohol.**
3. **Paint your design.**

With this method, you can apply any of the projects in this chapter to a candle or a bar of soap.

Part VI
The Part of Tens

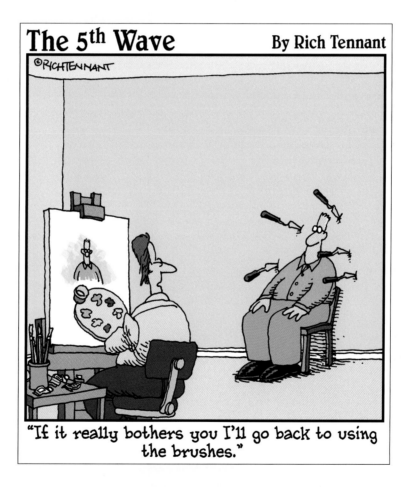

The 5th Wave By Rich Tennant

"If it really bothers you I'll go back to using the brushes."

In this part . . .

The chapters here give you tips on quick ways to figure out what to paint and how to get ideas for more paintings.

Chapter 15

Ten (Plus One) Genres: Figuring Out What You Want to Paint

In This Chapter
▶ Checking out different categories of paintings
▶ Selecting subjects to paint

A genre is a general category for a style of art; typical painting genres include landscapes, *still lifes* (arrangements of stationary items), and *life paintings* (paintings of humans or animals).

Many artists specialize in one genre and become known for a particular specialty and style; and as far as succeeding as a professional artist goes, that's a good strategy. However, it's not for everyone — I, for one, enjoy painting everything.

In this chapter I give 11 examples of the kinds of things I usually paint. The list is just to get you started, and you should certainly add to the list as you brainstorm your own ideas. I have yet to run out of subjects to paint, and you won't run out either if you combine this list with your own interests.

Landscape

A *landscape* like the one in Figure 15-1 depicts any kind of outdoor scene, such as a desert, mountains, a prairie, hills, skies, or a forest. One of my favorite things to do is paint on location, also known as *plein air;* the French coined this term (meaning "outdoors") for the Impressionists after the invention of paint tubes allowed painters to take paint with them rather than be stuck in the studio preparing paint fresh. *Pure* landscape artists paint only natural elements and don't include wildlife, people, or buildings.

Nature

Other outdoor close-up elements — like flowers, trees, even insects — make great paintings. Because flowers interest so many people, *florals* (paintings that feature them) are incredibly popular. Take extra time to make your floral special with an interesting composition or exquisite detail so it goes beyond being "just another flower painting." (See Chapter 9 for more on composition.) Go to the park and observe all the elements waiting to be painted: birds,

ducks, close-ups of plants — and don't forget turtles, frogs, and lily pads. Figure 15-2 showcases columbine flowers.

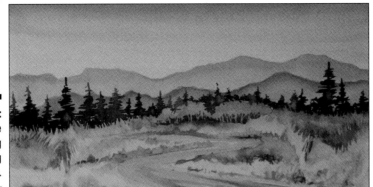

Figure 15-1: A landscape painting featuring mountains.

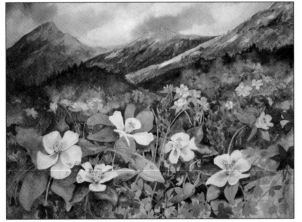

Figure 15-2: A nature scene showcasing columbine flowers and a landscape background.

Water Scenes

My astrological sign of Cancer renders me a water sign, which may account for my love of painting water. Rivers, lakes, ponds, waterfalls, reflections, and any kind of running water are challenging subjects to paint, but remembering a couple of tips can make them fun subjects for you, too:

- ✔ **Still water reflects the sky and its surroundings.** If the sky is blue, the water will be too. If the water is surrounded by green and brown trees, paint your water green and brown. Nature has just unified your color composition for you!

- ✔ **Rapidly moving water has a lot of white thanks to splashing.** Because white is the reflection of all colors, feel free to put a variety of subtle color in the white for even more vivacious waves. Figure 15-3 gives you an example of these painted churlish rapids.

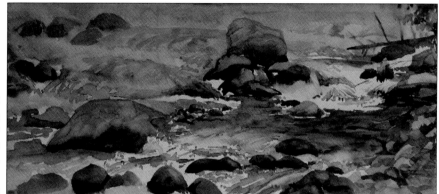

Figure 15-3:
Rapid water in a river is full of white splashes.

Feeling land-locked? What's a better subject than a *seascape* — oceans, boats, and lighthouses? Seascapes provide you with infinite composition and design opportunities — you can always find exciting colors and shapes in a marina. Figure 15-4 is a seascape featuring boats at Fisherman's Wharf in San Francisco. Note how the horizontal line of the ocean contrasts with vertical ship masts and lighthouses. (Head to Chapters 8 and 9 to read more about design and composition, respectively.) Plus, artists love old, weathered subjects, and the seashore provides that as well.

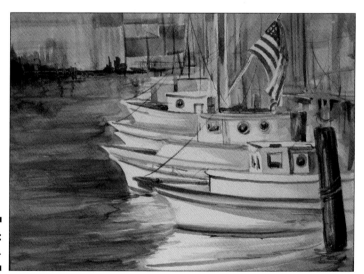

Figure 15-4:
A seascape.

Weather

Painting isn't just for fair weather scenes; look for all types of activity in the sky indicating seasonal change, wind movements, clouds, rain, and storms. If you like a particular area, why not paint a series of seasons in the same location? It may not be as exotic as the tropics, but plants near you still undergo changes throughout the year. Figure 15-5 shows a winter scene at the confluence of

the Platte and Poudre Rivers. Or paint the same scene at different times of the day, observing how the lighting changes, like Monet did by painting a hayfield at various intervals from sunrise to sunset.

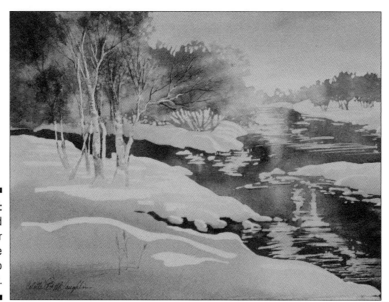

Figure 15-5:
Snow and winter scenes are great to paint.

Fantasy

Perhaps you have an interest in another realm that features winged creatures, aliens, dragons, mermaids, unicorns, or angels (or all of the above). Paint it! The great thing about fantasy painting: No one can tell you that what you painted isn't what the subject looks like — it's your fantasy. The angel symbol in Figure 15-6 was an attempt to depict beauty, femininity, and a guardian spirit.

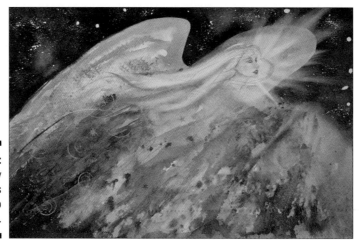

Figure 15-6:
Fantasy paintings have no limits.

Abstract

Sometimes you need no subject at all. Just enjoying color, shape, and other art elements is enough for nonrepresentational, experimental, and collage works of art. And abstract work is more popular than you may think: When a local psychiatric hospital was looking for artwork, it didn't want recognizable subjects that may trigger patients' painful memories. Instead, it sought calm abstracts. The inspiration of Figure 15-7 was as simple as fall leaves. Some of the leaves are realistic, but the rest of the painting is about color, shape, and texture.

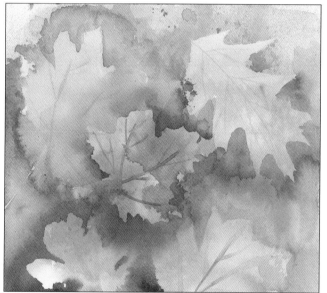

Figure 15-7:
The motif is leaves, but the execution is abstracted.

People

Want more life in your painting? Add people and crowds to the scene. Street scenes without people look abandoned. Faces and bodies in artwork seem to intrigue viewers; adding some to your work may attract more sets of eyes. The tuba player in Figure 15-8 caught my eye and made a great study of reflections.

A recognizable painting of a person is called a *portrait* (though you can also paint portraits of other recognizable subjects, such as houses or pets). Nudes are called *life drawings* — if you take a life drawing class, be prepared for some skin. Learning to draw people is difficult. If you can draw them, you can draw anything. If you really enjoy people, try a figure painting/drawing class (and check out *Figure Drawing For Dummies* by Kensuke Okabayashi [Wiley]).

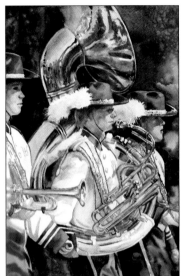

Figure 15-8:
A portrait of a tuba player.

Animals

I love wildlife. I spend lots of hours observing animals and birds in the wild, zoos, aquariums, sanctuaries — just about anywhere I can watch and capture pictures of them. I painted the giraffe in Figure 15-9 at the zoo, but generally speaking, animals are often easier to paint from photographs because they're pretty active models in person (okay, in animal).

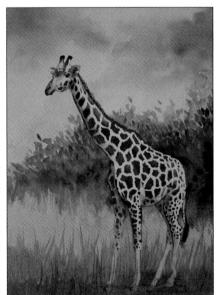

Figure 15-9:
Giraffes and other animals make great painting subjects.

Storytelling

If you tell a story in your painting, you may be making a move from fine art to *illustration*. Art versus illustration is a fun debate; personally, I think the great illustrators of the past and present are some of the finest artists around. I also believe involving the viewer by telling a story makes your painting more interesting, so definitely consider exploring this genre. What story should you tell? History, the military, mythology, religion, royalty, the human condition, hunting — it can be just about anything. For example, the Civil War soldiers in Figure 15-10 tell the story of western expansion in the 1800s. I actually observed these reenactment soldiers in South Dakota and loved their look. Use your imagination; if you need a jump-start, try to illustrate something from a favorite book.

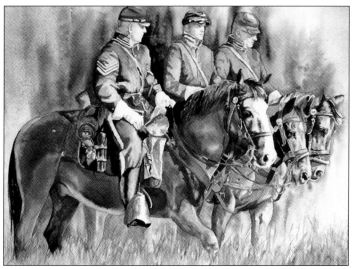

Figure 15-10: These Civil War soldiers tell a story that's part of history.

Architecture

Another favorite subject of mine is manmade constructions: barns, cityscapes, bridges, cabins, and cottages. If you're ever unsure whether it's okay to use something in your art, just ask; the owner is usually flattered, but that's not always the case. For instance, a photographer landed in hot water for photographing the Music Hall of Fame in Detroit and then printing and selling posters to the public. The owners of the building argued that they had paid for the design and owned the likeness of the building, so the photographer shouldn't be able to profit from it. Ultimately, though, a court decided that the artist could use anything in view to make an artwork. I, for one, always ask permission to paint on location.

A public building like the Greeley Courthouse shown in Figure 15-11 is no problem for permission and a place of civic pride for a community. The problem comes in the complexity, which is also part of its attraction. I waited a long time before I was ready to tackle this magnificent building. Choose buildings

that interest you and you feel up to painting. Start with simple cabins and cottages and work your way up to public monoliths.

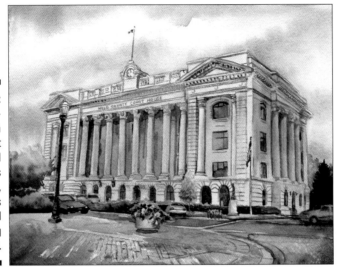

Figure 15-11: Architecture, such as that displayed in this courthouse, provides wonderful painting subjects.

Combinations

Sometimes a painting gets it all — a person riding a horse to the barn in a beautiful landscape near a stream — and that's okay. You certainly should make such *combination* paintings, mixing whatever genres you like. (Figure 15-12 combines human, animal, and fantasy elements.) Often, creating a combination painting is a matter of necessity — your landscape painting needs a center of interest, so you add a barn or an elk. In fact, you may find that you have a hard time *not* putting a building in a landscape. Adding flora and fauna can also help you pump up the detail.

Figure 15-12: Combine any of the pure genres for an interesting hybrid painting.

Chapter 16

Ten Ways to Get the Creative Juices Flowing

. .

In This Chapter

▶ Getting a jump start when your inspiration stalls out

▶ Moving your skill up to the next level

▶ Observing other artists and evaluating their success

. .

Whether you're just beginning your art career, looking for inspiration, or wanting to grow as an artist, the tips in this chapter are great ways to kick your painting up a notch. And who doesn't want that?

Paint What You Know (And Know What You Paint)

I've always heeded the old piece of wisdom "paint what you know." It's good advice. To make an interesting painting, you need to be interested in your subject matter. Love to cook and eat? Make a still life and include your favorite foods. Like sports? Try painting a dramatic moment in a game or match. Enjoy the outdoors? Paint a landscape of the area you admire. Do your homework and research your topics — it should be fun because, after all, you're already interested, right? If you paint something realistic inaccurately, you can be sure some expert will happily point it out to you someday. If that happens, don't be offended; instead, ask her more questions and learn further. She may review your next painting — or buy it. Meet other people by joining an interest group and then commemorate your new knowledge with your art. That way, you become the expert and share your knowledge with your audience.

Take a Class

Whatever your price range or time commitment, there's a class for you. Find an artist you like who gives art lessons; check out art supply stores and cooperative galleries to find art teachers. A community college or recreation center in or near your town may also offer low-cost classes, and the Internet has loads of online classes if you live too far away to travel to a class. A weekly class gives you guaranteed paint time, forces you to concentrate, and makes you accountable to others to produce art. Another option is a day-long

or week-long workshop — they're going on all the time, all over the world. *The Artist's Magazine* puts out an annual issue listing art workshops all over the world. My best learning came from week-long workshops by well-known artists. On the higher end of the scale, I often treat myself to a "painting vacation" by learning from someone I admire. It boosts my skill level and gives me something to look forward to all year.

You may want to be a great painter, but taking as many drawing classes as you can is also a great idea. All art starts with drawing, and it's a skill that needs constant practice and refinement. Draw every day. Fill up sketchbooks. Jot down ideas for paintings. Collect shapes, figures, and other bits and pieces that you can use in a painting. Whatever your interests are, sketch them in your book. Later, when you need ideas, go through your sketchbook for inspiration.

Travel

Change is good, and traveling forces a change in environment. You get exposed to different stimuli — new landscapes bring new ways of seeing. Often artists are so inspired by their new surroundings that they want to make travel paintings to commemorate the trip. Boats fascinate a desert dweller, and cactus may be big news to an East Coast resident. Sometimes just seeing with new eyes makes you observe things that others who see the object daily take for granted.

Take lots of photos when you travel so you can continue on your new painting path when you get back home.

Look Close to Home

You don't *have* to travel to find something interesting to paint. Some award-winning paintings have featured subjects found in the artist's home; I remember a national award-winner that was a picture of the artist's bathroom, featuring the sink and antique floor tile. Talk about painting what you know — who knows your place of residence better than you do? My best sellers tend to be paintings of my own town, and not just because I live in a tourist mecca either. Art patrons *also* want what they know.

Artists have made places famous just by rendering them in great artworks. Cities and towns are hip to this phenomenon and often invite artists to come paint in their area, hosting *plein-air* (a French art term meaning "outdoors") competitions. These contests are a great way to promote places. One of the best-known and highest-paying competitions is the Paint the Parks100 competition sponsored by PaintAmerica, which allows you to choose any of America's 390 national parks as your subject matter. The contest chooses the 100 paintings that best represent the beauty and significance of the parks. The entry fee is $40 or $50 (depending on when you enroll), but the grand prize is $10,000. The Grand Canyon Association also makes a purchase award of $4,000. The contest features a miniature competition, too — these paintings must be less than 180 square inches (length multiplied by width). Top miniature prize is $5,000. The paintings go on a national tour, so watch for an exhibition near you. You can find all the rules and even the exhibit online at paintamerica.org.

Work in a Series

A *series* is a group of paintings exploring the same theme. Do you like one of your paintings? Make another one that's similar, and then another one. By working in a series, you're able to work deeper on a theme — the first piece may present the expected approach to the topic, but the subsequent ones can explore and stretch to something unexpected, until you may do one that's a prize-winner. How many paintings do you need for a series? Well, one is a masterpiece (naturally), two is a *diptych,* three is a *triptych,* and because I can't think of a name for four or more I'll say four is a series. Technically, it's a diptych or triptych when the two or three paintings are meant to be hung together as one whole painting, so you could have a miniseries of two or three also.

Buy New Art Supplies

Sometimes inspiration hides at the art supply store. New paper, a new brush, professional paint in a new color, or trying out a new medium can all be catalysts to get some creative juices flowing. Go to the supply store and just see what's new. Ask the manager what the latest exciting trend is. Stores in larger cities often have free programs and newsletters to share ideas and demonstrate new products.

I recommend supporting your local art store first — keep them in business. But if you don't have an art supply store nearby, look for supplies on the Internet. Some online stores great for both supplies and information include www.dickblick.com, www.jerrysartarama.com, www.meininger.com, and www.cheapjoes.com. Subscribe to an art magazine like *American Artist* or *International Artist* and read the ads in the classified section.

Join a Club

Look for an art association or guild that meets monthly. These groups often have Web sites and newsletters that are filled with opportunities for learning. Don't be shy — get involved. Such clubs often have meetings that offer demonstrations, critiques, and group exhibits. A program like that may give you a new idea, teach a new technique, or just make you think in a new way. Meeting with other artists also gives you like-minded folks to go to museums or art openings with or just bounce ideas off.

Take Video Lessons

You can enlist a top artist to come teach a private lesson in your own home at any time and on any budget. All you have to do is get a video, DVD, podcast, or YouTube clip of an art lesson — you can watch, rewind and rewatch, paint along with, and fast forward through it as much as you want. Most libraries also have art programs you can check out, and many art clubs own their own art video libraries. The Internet of course sells countless art videos from art magazines,

art supply manufacturers, and artists. Several television networks offer art how-to shows that you can watch on the air or often purchase copies of. You can find some excellent DVDs at Creative Catalyst Productions (www.ccpvideos.com). Artists Network (www.artistsnetworkshop.com) is also a great resource. You can subscribe to access videos for six months at a time or purchase them permanently.

Buy or Borrow Books

Books are great sources of learning. As your skills progress, you can reread and absorb different parts of each lesson all over again. You can read the lovely book in your hands quickly, but give yourself time to absorb and practice its information; after all, I spent 30 years acquiring the stuff I've included here.

I love to look at pictures in books. Sometimes I even read one. Visual people need visual stimulation with lots of pictures. Study the compositions, value patterns, and techniques. Start a loaner library with your local artists. If your club doesn't want to house books, most libraries have great art books. If your library doesn't have a good art section, see if they would like some donations. Have the local arts group give them some books each year to build the collection.

A wonderful source of art books is North Light books. They offer a club to join for discounted books at www.northlightbookclub.com.

Visit Galleries and Museums

See more art, always. Observe what came before you by visiting museums, and keep tabs on what's happening now at galleries. Both places are full of people who love to talk about their passion for art. Analyze pieces of art that you like and try to determine why you like them. What design elements did the artist choose to make dominant? What color schemes did he employ? Did he add a center of interest or use a composition value pattern? Why did a particular artwork catch your attention from across the gallery? Hopefully, you see something that gives you a new perspective and inspires you to create.

Many areas offer a regular event — often on the first Friday of each month — for patrons to visit galleries for extended hours and treats. Gather a group of friends and fellow artists and make it a regular field trip.

Index

• A •

absorbent ground, 224
abstract art
 art element use, 211–222
 finding ideas, 207–210
 movements, 205–207
 painting genre, 12, 287
 planning, 229–230
 products and techniques for, 223–229
 projects, 82–84, 230–234
 sending messages in, 211–222
 word use, 211
abstract art elements
 balloons, 213–214
 bent vertical, 222
 conflicting diagonal lines, 213
 diagonal direction, 216
 diminishing perspective, 220
 expanding perspective, 219
 explosion, 212
 horizontal lines, 218
 implosion, 212
 mountain pyramid, 216
 pointed arches, 215
 rainbow arches, 218
 rhythmic curves, 214–215
 rhythmic horizontal lines, 221
 rounded arches, 216–217
 spiral colors, 214
 upright flames, 221
 upward spray, 220
 vertical lines, 217
 waterfall, 218–219
 zigzag lines, 212–213
Abstract Expressionism, 206
acetate, 89
acid-free mat board, 28–29
acrylic enamel, 41–42
acrylic glaze, 45
acrylic medium. *See* medium
acrylic paint, advantages of, 7–9, 159
additives, 42, 180

adhesive, for collage, 241–242
aerial perspective, 172, 181–182
alcohol, adding to paint, 73
alternation, 133, 134
Ampersand (supplier), 256
analogous color plan, 121
analogous colors, 110
animals (painting genre), 12, 288
apples (still life project), 96–100
apron, 34
architecture (painting genre), 289–290
Art For Dummies (Hoving), 207
artist trading card (project), 66–70
Artists Network (Web site), 294
atomizer, 80

• B •

backer board, 65
backgrounds, with aerial perspective, 181–182
balance
 asymmetrical (informal), 125
 color, 125–126
 dots, 126, 127
 line, 127
 shape, 128
 size, 128
 symmetrical (formal), 125
 texture, 126, 127
 value, 126
 volume, 129
base coat, 58
bending medium, 44
binder, 25, 36
black, 108–109
blank space, 146
blending
 to create depth, 94–96
 oil-inspired painting, 185
 for smooth transition, 93–94, 95
 technique, 59
blue, 106–107

board
 acid-free mat, 28–29
 foam, 29
 gator, 29
 illustration, 29
books, 294
brick, painted, 279
brown, 104–105
brush
 dot, 267
 essential collection, 22–23
 ferrule, 17
 flats, 19–20, 23
 hairs, 18–19
 handle, 18
 liner, 19, 23, 55
 rounds, 19–21, 23
 rubber band, 171
 shape, 19
 size, 19–21
 substitutes, 21–22
 texture, 184–185
brush case, 24
brush holder, 24
brush maintenance
 avoiding damage, 23–24
 prepping new brush, 23
 repair, 25–26
 replacement, 26
 storage, 24–25
 washing, 24
brush stroke
 crisscross, 52–53
 description, 51–52
 dry brushing, 54–55
 grip for drawing edges, 168–169
 holding a brush, 52
 line work, 55
 scaffito, 18, 55–56, 185–187
 scumbling, 53
 stippling, 54
 streak, 185–186

• C •

cadmium, 109
candles, painted, 279–280
canvas paper, 27, 28

canvas, prepping, 27–28, 30–31
cartoon, 91
cheapjoes.com (online store), 293
cheesecloth, 78
chemical names, 109
classes, 291–292
cleanup supplies, 34
clear tar gel, 226–227, 228
clouds, painting, 164–168
clubs, 293
coasters (project)
 leopard, 261–264
 panther, 264–265
 tiger and lynx, 266
cobwebs, 78–79
collage
 background surface, preparing, 240
 copyright issues, 250
 description, 13, 237
 direct transfer, 246–248
 finishing, 253
 images, adding, 245–251
 layering in paint, 244–245
 layering with paper, 241–243
 project (southwestern cliffs), 251–254
 supplies, 237–238
 themes, 238–239
 transferring drawings, 249–250
color
 analogous, 110
 balancing, 125–126
 black, 108–109
 blue, 106–107
 brown, 104–105
 complementary, 110
 contrasting, 129–130
 as design element, 123
 dominance of, 138
 green, 106
 mat, 64
 mixing, 111–112
 orange, 104
 primary, 111
 red, 103–104
 secondary, 111
 temperature, 115–117, 138
 tertiary, 111
 violet, 107
 warm and cool, 115–117

white, 107–108, 159
yellow, 105
color bias, 111–113
color bridge, 50–51, 118
color exercises
 one-color, 113–115
 three-color, 117–118
 two-color, 115–117
color plan
 analogous, 121
 complementary, 119
 description, 118–119
 full wheel, 122
 split complementary, 120
color shift, 38
color wheel, 50, 110–113
comb, filbert, 184
combination paintings, 290
compatibility, paint, 39
competitions, 292
complementary color plan, 119
complementary colors, 110
composition
 analysis of, 151–156
 blank space, 146
 critique checklist, 155
 description, 143
 edges, 150
 focal point, 144–145
 guidelines, 148–151
 horizon line, 146, 147
 keying a painting, 151–152
 mood, 146–148
 odd numbers, 149
 patterns, 154, 155, 156
 shadows, 151
 simplifying, 148
 tangent, avoiding, 149
 threes, thinking in, 152–153
conservation glass, 65
Constructivism, 206
contests, 292
contrast
 color, 129–130
 lines, 131–132
 shape, 131
 size, 132
 texture, 131

value, 130
volume, 132–133
copyright, 250
core shadow, 94–96
cracking, resistance to, 9
crackle paste, 223–224
cradled board, 63, 180
Creative Catalyst Productions (Web site),
 294
creativity, methods for fueling
 books, 294
 buying new supplies, 293
 classes, 291–292
 clubs, 293
 painting close to home, 292
 painting what you know, 291
 series work, 293
 travel, 292
 video lessons, 293–294
 visiting galleries and museums, 294
crisscross (brush stroke), 52–53
cropping viewfinder, creating, 207–209
Cubism, 206
curing, 204

• D •

deckled edge, 243
decorative art, 255
depth
 blending to create, 94–96
 as design element, 124
 simulating with shadows, 188–191
design
 alternation, 133, 134
 balance, 125–129
 contrast, 129–133
 direction, 134–137
 dominance, 137–141
 elements, 123–125
 principles, 124–141
 repetition, 133
 variation, 133
Dharma Trading Co. (supplier), 270
diagonal (direction), 135
dickblick.com (online store), 293

diptych, 293
direct transfer, 246–249
direction
 diagonal, 135
 horizontal, 134
 lines, 136–137
 shapes, 137
 texture, 136
 vertical, 135
dominance
 color temperature, 138
 description, 137
 dots, 138–139
 line, 139–140
 shape, 140
 size, 140–141
 texture, 139
 value, 138
 volume, 141
dot brush, 267
dots
 balancing, 126, 127
 as design element, 124
 dominance of, 138–139
Dover Publishing (supplier), 250
drawing
 blending with paint, 93–96
 classes, 292
 enlarging sketches, 86, 88–90
 graphite transfer, 92
 thumbnail sketches, 86, 87
 tips for improving, 93
 tracing paper use, 90–91
 transferring for collage, 249–250
Drawing For Dummies (Hoddinott), 85, 93
dripping (painting technique), 79–80
dry brushing (brush stroke), 54–55
drying time, 8, 38, 179–180
dust cover, 65

● *E* ●

edge
 brush grips for drawing, 168–169
 deckled, 243
 description, 165
 hard, 150, 166
 lost, 150, 167–168
 soft, 150, 166–167
 tree, painting, 169–170

emphasis, 137. *See also* dominance
enamel, 41–42
encaustic, 228
enlargement
 copy method, 89–90
 eyeballing, 89
 grid method, 89, 90
 projection, 90
 proportion, 86, 88–89
etching glass, 32
experimenting, 71–72
explosion, 154, 212

● *F* ●

fabric painting medium, 31, 270
fabric, painting on, 31, 270–274
fading, 9, 38
fantasy (painting genre), 286
Fauvism, 206
faux encaustic, 228, 229
ferrule, 17
fiber paste, 224, 225, 249
Figure Drawing For Dummies (Okabayashi),
 287
filbert comb, 184
finish, 9, 37–38, 204
flat brush, 19–20, 23
florals, 283
flow enhancer, 44
fluid acrylics, 80, 159
fluorescent paint, 41
foam board, 29
focal point, 144–145
FolkArt Textile Medium, 270
foreground, 172–173
frame, choosing, 63–64
Free Digital University (Web site), 250
fugitive, 38
full wheel color plan, 122
Futurism, 206

● *G* ●

galleries, visiting, 294
gallery wraps, 63
gator board, 29
gel medium, 45, 186

genres
 abstract, 12, 287
 animals/wildlife, 12, 288
 architecture, 289–290
 collage, 13, 237
 combinations, 290
 fantasy, 286
 landscape, 12, 283, 284
 mixed media, 13
 nature, 283–284
 people, 12, 287–288
 specialization by artist, 13
 still life, 12
 storytelling, 289
 water scenes, 284–285
 weather, 285–286
geometric shape, 124
gesso, 30–31, 39, 184, 223, 241
gilding, 30
glass
 conservation, 65
 etching, 32
 painting on, 32, 277–279
glass etching cream, 32
glaze, 44–45, 60–61, 188–189
glazing chart, 60–61
glazing liquid, 180
glitter, 41
glossy finish, 37–38, 204
glow-in-the-dark paint, 41
grape art (project), 266–268
graphite paper, 92, 183
green, 106
grid method, for enlargement, 89, 90
grisaille, 114
ground, absorbent, 224
gum arabic, 25, 36

• *H* •

hairs, brush, 18–19
hanging, 65–66
hard edge, 150, 166
heavy matte gel, 228
highlight, 94–96
Hoddinott, Brenda
 Drawing For Dummies, 85, 93
hologram, faux, 250–251

horizon line, 146, 147
horizontal (direction), 134
Hoving, Thomas
 Art For Dummies, 207
hue, 39, 110
husky dog (project), 191–195

• *I* •

icons used in this book, 4
illustration, 289
illustration board, 29
impasto, 37, 186, 187
implosion, 154, 212
Impressionism, 206
inspiration, finding, 10, 291–294
interference paint, 40, 245
iridescent paint, 40, 245

• *J* •

jerrysartarama.com (online store), 293
Judy's Stone House Designs (supplier),
 270–271

• *K* •

key, 151–152
knife, palette, 21, 22, 56–57

• *L* •

landscape
 edges, 165–169
 layering paint, 172–173
 painting genre, 12, 283, 284
 project, 174–178
 sky, 161–165
 trees, 169–171
landscape orientation, 162
layering
 collage in paint, 244–245
 collage with paper, 241–243
 paint for perspective, 172–173
 painting technique, 59–60
life drawings, 287

light, reflected, 94
lightfastness, 9, 38
liner brush, 19, 23, 55
line(s)
 balancing, 127
 conflicting diagonal, 213
 contrasting, 131–132
 as design element, 124
 direction using, 136–137
 dominance of, 139–140
 horizontal, 218
 rhythmic horizontal, 221
 vertical, 217
 zigzag, 212–213
liquid, adding to paint, 73–74
lost edge, 150, 167–168

• *M* •

mars, 109
mask, 266, 267
mat, 9, 64–65
mat board, 28–29
matte finish, 37–38, 204
matte fixative, 32
medium, 42–43, 44, 46, 160, 186
meininger.com (online store), 293
metal, painting on, 32, 275–277
metallic paint, 245
mineral pigment, 36
Minimalism, 207
mixed media (painting genre), 13
molding paste
 heavy, 225, 226
 light, 224, 225
monochrome, 114
mood, 146–148
mounting, 65
movement. *See* direction
movements, overview,
 205–207
mud, 112
mural, 269–270
museums, visiting, 294
music, while painting, 11
musical instrument, painting on, 266–268

• *N* •

nature (painting genre), 283–284
negative painting, 173
negative shape, 124, 128, 173
neutrals, 114
nonobjective art, 205. *See also* abstract art
nonrepresentational art, 205. *See also*
 abstract art
North Light (art book supplier), 294
nudes, 287

• *O* •

odd numbers, 149
oil paint, 179
oil-inspired technique
 backgrounds with aerial perspective,
 181–182
 corn project, 198–203
 drying time, extending acrylic paint,
 179–180
 fall corn still life project, 195–198
 husky dog project, 191–195
 overlapping, 183
 simulating depth with shadows, 188–191
 surface, choosing and prepping, 180–181
 texture creation, 184–188
 varnish, 204
Okabayashi, Kensuke
 Figure Drawing For Dummies, 287
opaque paint, collage use, 244
open time, 159
orange, 104
organic shape, 124
orientation, paper, 162
overlapping, 183

• *P* •

paint
 adding stuff to, 72–74
 for collages, 244–245
 descriptions, deciphering, 109–110
 history of acrylic, 36
 oil, 179
 watercolor, 159

paint properties
 binders, 36
 compatibility, 39
 drying time, 8, 38, 179–180
 effect on price, 35
 finish, 37–38
 grades of paint, 36–37
 hue, 39
 lightfastness/fading, 38
 pigments, 36
 thermoplasticity, 9
 viscosity, 37, 186
paint thinner, 43
paint types
 enamel, 41–42
 fluorescent, 41
 glitter, 41
 glow-in-the-dark, 41
 interference, 40, 245
 iridescent, 40, 245
 opaque, 244
 transparent, 244
paintamerica.org (Web site), 292
painting techniques. *See also* brush stroke;
 specific techniques
 adding stuff to paint, 72–74
 base coating, 39, 57–58
 blending, 59
 cobweb and cheesecloth use, 78–79
 dripping, 79–80
 glazing, 60–61
 layering, 59–60
 under painting, 39, 57–58
 palette knife use, 56–57
 plastic wrap use, 76–77
 sponges and rollers, 75–76
 spraying, 80–82
 stenciling, 81–82
 wet-into-wet, 59
Paint the Parks100 competition, 292
palette
 description, 33
 disposable, 33
 nonporous, 34
 setting up, 49–51
 stay-wet, 34, 51
palette knife, 21, 22, 56–57
paper, collage
 attaching to surface, 241–242
 layering with, 241–243

painting, 242, 243
 tearing, 242–243
paper towels, 34
paste
 crackle, 223–224
 to create canvas texture, 184
 description, 46
 fiber, 224, 225, 249
 heavy molding, 225, 226
 light molding, 224, 225
pastel, 39
people (painting genre), 287–288
perspective
 aerial, 172, 181–182
 diminishing, 220
 expanding, 219
 layering paint for, 172–173
photograph, copying using tracing paper, 91
phthalocyanine, 109
pigment, 36
plastic, painting on, 32
plastic wrap, 76–77
pointillism, 124
polymer emulsion, 36
portrait, 12, 287, 288
portrait orientation, 162
primer, 30–31
projector, 90
projects
 abstract art, 82–84, 230–234
 apples, 96–100
 artist trading card, 66–70
 candles, 279–280
 coasters, 260–266
 combination technique abstract, 82–84
 corn, 198–203
 fall corn, 195–198
 faux stained glass, 277–279
 grape art, 266–268
 husky dog, 191–195
 metal bench, 276–277
 mural, 269–270
 purse, 270–274
 rock painting, 275
 sketchbook, 14–16
 southwestern cliffs collage, 251–254
 still life, 96–100, 195–198, 198–203
 watercolor-like landscape, 174–178
 wildcat box, 256–260

proportion, 86, 88–89
public domain, 250
purse, painting on, 270–274

• *Q* •

quinacridone, 109

• *R* •

rag content, 29
rainstorm, painting, 163–164
rake, 54, 185
red, 103–104
reflected light, 94
Remember icon, 4
repetition, 133
representational art, 205
retarder, 44, 180
rock, painting on, 275
rollers, sponge, 76
rounds (brush type), 19–21, 23
rubber band brush, 171

• *S* •

salt, adding to paint, 72–73
sand, adding to paint, 74
scraffito, 18, 55–56, 124, 186–187
scumbling (brush stroke), 53
sea sponge, 76
seascape, 285
semi-gloss finish, 204
series, 293
shade, 110, 114
shadows
 consistent, 151
 core, 94–96
 creating with glaze, 188–189
 depth creation, 94–96, 188–191
 shaping, 189–191
shape
 abstraction of, 209–210
 balancing, 128
 contrasting, 131
 as design element, 124

direction using, 137
 dominance of, 140
SID (support induced discoloration), 31–32
simplification, 148
size
 balancing, 128
 contrasting, 132
 as design element, 124
 using dominance, 140–141
sketchbook (project), 14–16
sketches
 enlarging, 86, 88–90
 thumbnail, 86, 87
 tracing paper use, 90–91
 transferring onto dark background, 183
skins, 277–278
sky, painting translucent, 161–165
soap, undercoating with, 170
soft edge, 150, 166–167
southwestern cliffs collage (project),
 251–254
spattering, 170
split complementary color plan, 120
sponge applicators, 21, 22, 75–76
spray bottle, 34, 80
spraying (painting technique), 80–82
stained glass, faux, 277–279
stamping, 228–229
steel, painting on, 275–277
stenciling, 81–82
still life
 genre, 12
 projects, 96–100, 195–198, 198–203
stippling (brush stroke), 54
stone, painting on, 275
storytelling (painting genre), 289
streaks, 185–186
stress, art as relief, 10
stretcher bars, 27
style, finding yours, 11, 12
subject matter, choosing, 291
subordination, 137. *See also* dominance
suncatcher, 278–279
sunset, painting, 162
supplies
 brush maintenance, 23–26
 brushes, 17–23
 buying new for inspiration, 293
 cleanup, 34

collage, 237–238
palettes, 33–34
setting up, 49–51
surfaces, 27–33
support induced discoloration (SID), 31–32
surfaces
boards, 28–31
brick, 279
candles, 279–280
canvas, 27–28, 30–31
canvas paper, 27, 28
clayboard, 255–266
collage, 237–238
fabric, 31, 270–274
glass, 32, 277–279
metal, 32, 275–277
musical instrument, 266–268
picking and prepping, 27–33, 180
plastic, 32
rocks and stone, 275
terra cotta, 32
walls, 33, 269–270
wood, 31–32, 255–266
Surrealism, 206

• T •

talent, developing, 9–10
tangent, avoiding, 149
Technical Stuff icon, 4
temperature, color, 115–117, 138
terra cotta, painting on, 32
texture
balancing, 126, 127
with cobwebs and cheesecloth, 78–79
collage, 240
contrasting, 131
as design element, 124
direction of, 136
dominance of, 139
with gel medium, 45, 186
gesso use to create, 184
impasto painting, 186
implied, 184
paint viscosity, 186
paste use to create, 184, 186
with plastic wrap, 76–77

scraffito, 186–187
with streaks and blends, 185–186
texture brushes, 184–185
themes, collage, 238–239
thermoplasticity, 9
thinning paint, 42–44, 160–161
threes, thinking in, 152–153
tint, 38, 114
Tip icon, 4
toning the canvas. *See* under painting
tooth, 275
top coating, 32
tracing paper, 90–91
transfer
direct, 246–249
drawing into pastes or mediums, 249–250
drawing onto dark background, 183
drawing using graphite paper, 92
transparent paint, collage use, 244
travel, for inspiration, 292
trees, painting, 169–171
triptych, 293
trompe l'oeil painting, 184
Try-It icon, 4

• U •

under painting, 39, 57–58, 114
UV protection, 204

• V •

value
balancing, 126
contrasting, 130
description, 115
as design element, 123–124
dominance of, 138
one-color exercise, 114–115
patterns, 191
variation, 133
varnish, 61–62, 180, 204
vertical (direction), 135
video lessons, 293–294
violet, 107
violin, painting grapes on, 266–268

viscosity, paint, 37, 186
volume
 balancing, 129
 contrasting, 132–133
 as design element, 124
 using dominance, 141
Vorticism, 206

• W •

wall art, 269–270
walls, painting on, 33, 269–270
Walnut Hollow (supplier), 275
Warning icon, 4
washing, brushes, 24
water
 applying to painting, 73
 use to thin paint, 43
water container, 34
water scenes (painting genre), 284–285
watercolor paint, 159
watercolor technique
 advantages of acrylic paint over
 watercolor, 159

for landscape edges, 165–169
layering paint, 172–173
project, 174–178
for sky, 161–165
for trees, 169–171
wave (brush), 185
weather (painting genre), 285–286
weight, 125
wet-into-wet, 59
white, 107–108
wildcat box (project), 256–260
wildlife (painting genre), 12, 288
wood, painting on, 31–32, 255–266
workability, 39

• Y •

yellow, 105

BUSINESS, CAREERS & PERSONAL FINANCE

Accounting For Dummies, 4th Edition*
978-0-470-24600-9

Bookkeeping Workbook For Dummies†
978-0-470-16983-4

Commodities For Dummies
978-0-470-04928-0

Doing Business in China For Dummies
978-0-470-04929-7

E-Mail Marketing For Dummies
978-0-470-19087-6

Job Interviews For Dummies, 3rd Edition*†
978-0-470-17748-8

Personal Finance Workbook For Dummies*†
978-0-470-09933-9

Real Estate License Exams For Dummies
978-0-7645-7623-2

Six Sigma For Dummies
978-0-7645-6798-8

Small Business Kit For Dummies, 2nd Edition*†
978-0-7645-5984-6

Telephone Sales For Dummies
978-0-470-16836-3

BUSINESS PRODUCTIVITY & MICROSOFT OFFICE

Access 2007 For Dummies
978-0-470-03649-5

Excel 2007 For Dummies
978-0-470-03737-9

Office 2007 For Dummies
978-0-470-00923-9

Outlook 2007 For Dummies
978-0-470-03830-7

PowerPoint 2007 For Dummies
978-0-470-04059-1

Project 2007 For Dummies
978-0-470-03651-8

QuickBooks 2008 For Dummies
978-0-470-18470-7

Quicken 2008 For Dummies
978-0-470-17473-9

Salesforce.com For Dummies, 2nd Edition
978-0-470-04893-1

Word 2007 For Dummies
978-0-470-03658-7

EDUCATION, HISTORY, REFERENCE & TEST PREPARATION

African American History For Dummies
978-0-7645-5469-8

Algebra For Dummies
978-0-7645-5325-7

Algebra Workbook For Dummies
978-0-7645-8467-1

Art History For Dummies
978-0-470-09910-0

ASVAB For Dummies, 2nd Edition
978-0-470-10671-6

British Military History For Dummies
978-0-470-03213-8

Calculus For Dummies
978-0-7645-2498-1

Canadian History For Dummies, 2nd Edition
978-0-470-83656-9

Geometry Workbook For Dummies
978-0-471-79940-5

The SAT I For Dummies, 6th Edition
978-0-7645-7193-0

Series 7 Exam For Dummies
978-0-470-09932-2

World History For Dummies
978-0-7645-5242-7

FOOD, GARDEN, HOBBIES & HOME

Bridge For Dummies, 2nd Edition
978-0-471-92426-5

Coin Collecting For Dummies, 2nd Edition
978-0-470-22275-1

Cooking Basics For Dummies, 3rd Edition
978-0-7645-7206-7

Drawing For Dummies
978-0-7645-5476-6

Etiquette For Dummies, 2nd Edition
978-0-470-10672-3

Gardening Basics For Dummies*†
978-0-470-03749-2

Knitting Patterns For Dummies
978-0-470-04556-5

Living Gluten-Free For Dummies†
978-0-471-77383-2

Painting Do-It-Yourself For Dummies
978-0-470-17533-0

HEALTH, SELF HELP, PARENTING & PETS

Anger Management For Dummies
978-0-470-03715-7

Anxiety & Depression Workbook For Dummies
978-0-7645-9793-0

Dieting For Dummies, 2nd Edition
978-0-7645-4149-0

Dog Training For Dummies, 2nd Edition
978-0-7645-8418-3

Horseback Riding For Dummies
978-0-470-09719-9

Infertility For Dummies†
978-0-470-11518-3

Meditation For Dummies with CD-ROM, 2nd Edition
978-0-471-77774-8

Post-Traumatic Stress Disorder For Dummies
978-0-470-04922-8

Puppies For Dummies, 2nd Edition
978-0-470-03717-1

Thyroid For Dummies, 2nd Edition†
978-0-471-78755-6

Type 1 Diabetes For Dummies*†
978-0-470-17811-9

* Separate Canadian edition also available
† Separate U.K. edition also available

Available wherever books are sold. For more information or to order direct: U.S. customers visit www.dummies.com or call 1-877-762-2974.
U.K. customers visit www.wileyeurope.com or call (0)1243 843291. Canadian customers visit www.wiley.ca or call 1-800-567-4797.

INTERNET & DIGITAL MEDIA

AdWords For Dummies
978-0-470-15252-2

Blogging For Dummies, 2nd Edition
978-0-470-23017-6

**Digital Photography All-in-One
Desk Reference For Dummies, 3rd Edition**
978-0-470-03743-0

Digital Photography For Dummies, 5th Edition
978-0-7645-9802-9

**Digital SLR Cameras & Photography
For Dummies, 2nd Edition**
978-0-470-14927-0

**eBay Business All-in-One Desk Reference
For Dummies**
978-0-7645-8438-1

eBay For Dummies, 5th Edition*
978-0-470-04529-9

eBay Listings That Sell For Dummies
978-0-471-78912-3

Facebook For Dummies
978-0-470-26273-3

The Internet For Dummies, 11th Edition
978-0-470-12174-0

Investing Online For Dummies, 5th Edition
978-0-7645-8456-5

iPod & iTunes For Dummies, 5th Edition
978-0-470-17474-6

MySpace For Dummies
978-0-470-09529-4

Podcasting For Dummies
978-0-471-74898-4

**Search Engine Optimization
For Dummies, 2nd Edition**
978-0-471-97998-2

Second Life For Dummies
978-0-470-18025-9

**Starting an eBay Business For Dummies,
3rd Edition†**
978-0-470-14924-9

GRAPHICS, DESIGN & WEB DEVELOPMENT

**Adobe Creative Suite 3 Design Premium
All-in-One Desk Reference For Dummies**
978-0-470-11724-8

**Adobe Web Suite CS3 All-in-One Desk
Reference For Dummies**
978-0-470-12099-6

AutoCAD 2008 For Dummies
978-0-470-11650-0

**Building a Web Site For Dummies,
3rd Edition**
978-0-470-14928-7

**Creating Web Pages All-in-One Desk
Reference For Dummies, 3rd Edition**
978-0-470-09629-1

**Creating Web Pages For Dummies,
8th Edition**
978-0-470-08030-6

Dreamweaver CS3 For Dummies
978-0-470-11490-2

Flash CS3 For Dummies
978-0-470-12100-9

Google SketchUp For Dummies
978-0-470-13744-4

InDesign CS3 For Dummies
978-0-470-11865-8

**Photoshop CS3 All-in-One
Desk Reference For Dummies**
978-0-470-11195-6

Photoshop CS3 For Dummies
978-0-470-11193-2

Photoshop Elements 5 For Dummies
978-0-470-09810-3

SolidWorks For Dummies
978-0-7645-9555-4

Visio 2007 For Dummies
978-0-470-08983-5

Web Design For Dummies, 2nd Edition
978-0-471-78117-2

Web Sites Do-It-Yourself For Dummies
978-0-470-16903-2

Web Stores Do-It-Yourself For Dummies
978-0-470-17443-2

LANGUAGES, RELIGION & SPIRITUALITY

Arabic For Dummies
978-0-471-77270-5

Chinese For Dummies, Audio Set
978-0-470-12766-7

French For Dummies
978-0-7645-5193-2

German For Dummies
978-0-7645-5195-6

Hebrew For Dummies
978-0-7645-5489-6

Ingles Para Dummies
978-0-7645-5427-8

Italian For Dummies, Audio Set
978-0-470-09586-7

Italian Verbs For Dummies
978-0-471-77389-4

Japanese For Dummies
978-0-7645-5429-2

Latin For Dummies
978-0-7645-5431-5

Portuguese For Dummies
978-0-471-78738-9

Russian For Dummies
978-0-471-78001-4

Spanish Phrases For Dummies
978-0-7645-7204-3

Spanish For Dummies
978-0-7645-5194-9

Spanish For Dummies, Audio Set
978-0-470-09585-0

The Bible For Dummies
978-0-7645-5296-0

Catholicism For Dummies
978-0-7645-5391-2

The Historical Jesus For Dummies
978-0-470-16785-4

Islam For Dummies
978-0-7645-5503-9

**Spirituality For Dummies,
2nd Edition**
978-0-470-19142-2

NETWORKING AND PROGRAMMING

ASP.NET 3.5 For Dummies
978-0-470-19592-5

C# 2008 For Dummies
978-0-470-19109-5

Hacking For Dummies, 2nd Edition
978-0-470-05235-8

Home Networking For Dummies, 4th Edition
978-0-470-11806-1

Java For Dummies, 4th Edition
978-0-470-08716-9

**Microsoft® SQL Server™ 2008 All-in-One
Desk Reference For Dummies**
978-0-470-17954-3

**Networking All-in-One Desk Reference
For Dummies, 2nd Edition**
978-0-7645-9939-2

**Networking For Dummies,
8th Edition**
978-0-470-05620-2

SharePoint 2007 For Dummies
978-0-470-09941-4

**Wireless Home Networking
For Dummies, 2nd Edition**
978-0-471-74940-0